# 35mm
# PANORAMA

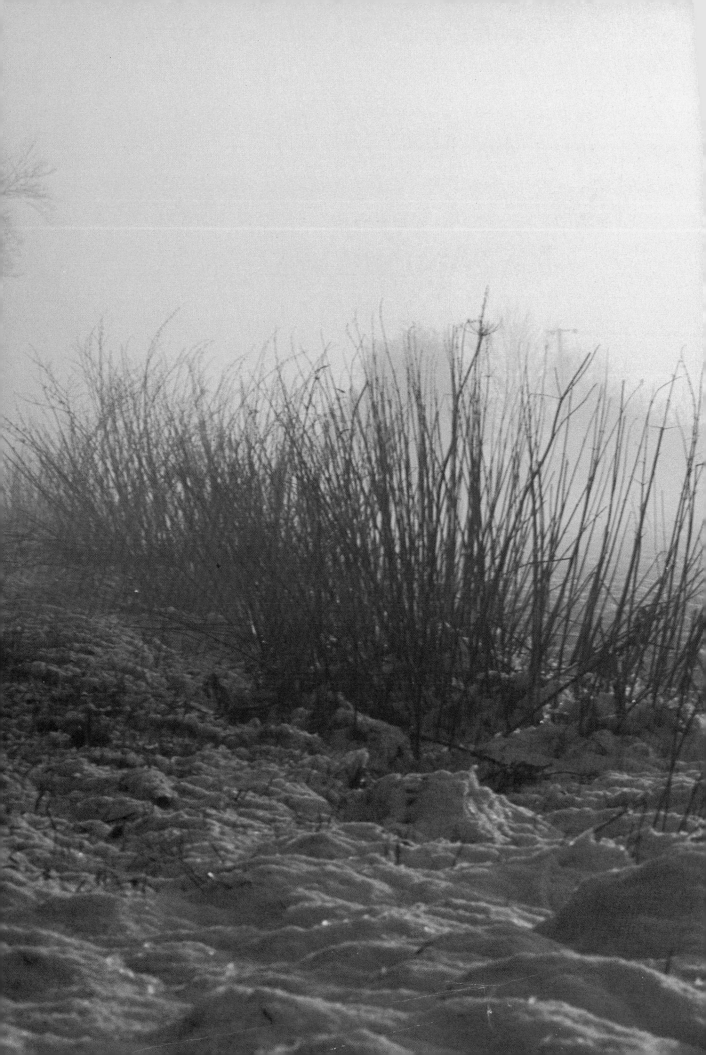

# 35mm
# PANORAMA

## Roger W. Hicks

*Also featuring
the photography of*

## Tim Hawkins
## Frances E. Schultz



David & Charles
Newton Abbot    London

*Also by Roger Hicks*

Techniques of Colour Photography
Practical Glamour Photography
The Book of Calendar Girl Photography
Great Ocean: An Authorised Biography of
His Holiness the Dalai Lama (with Ngakpa Chogyam)
A History of the 35mm Still Camera
Comet Catastrophe
Pictures that Sell (with Ray Daffurn)
The Medium Format Handbook
Long Stays in America (with Frances Schultz)
Portrait Photography

*Dedication*

**"For Colin Glanfield"**

*Cover photographs by* Frances Schulz (*front*), and
Roger Hicks and Tim Hawkins (*back*)

British Library Cataloguing in Publication Data

Hicks, Roger, *1950–*
The 35mm Panorama.
1. Photography – Landscapes    2. Single-lens
reflex cameras    3. 35mm cameras
I. Title
778.9'36    TR660

ISBN 0-7153-8930-0 h/bk
    0-7153-9292-1 p/bk

Book designed by Micheal Head
Photographs © photographers credited in captions
Text © Roger W. Hicks 1987

First published 1987
Second Impression 1988
Paperback edition 1988

Typeset by Typesetters (Birmingham) Limited
Smethwick, West Midlands
and printed in Singapore
by Saik Wah Press
for David & Charles Publishers plc
Brunel House   Newton Abbot   Devon

Distributed in the United States by
Sterling Publishing Co, Inc,
2 Park Avenue, New York, NY 10016

# CONTENTS

# ACKNOWLEDGEMENTS

My first and greatest thanks must go to Frances Schultz, for her help, encouragement and support and for the use of so many of her photographs. Likewise, Tim Hawkins deserves my most heartfelt thanks for allowing me access to such a tremendous range of his work. In addition to pictures by Frances, Tim and myself, there are also two pictures by Dick Painter in the book, and one by Cath Milne; I should like to thank them also.

After that, I should like to thank Mr and Mrs W. A. Schultz, for their repeated hospitality in California; Drs B. and L. Collins, for the same; Mr and Mrs K. Schultz, for the same; Mr and Mrs C. E. Truscott, for hospitality in Delaware; Herb Agid, of the Riviera Camera Store, Redondo Beach, Los Angeles, for the use of his cabin in the Gold Country; Krik Schultz and Paul Bell, for hospitality in San Francisco; Mr and Mrs D. Schultz, for hospitality in Tennessee; Mr and Mrs F. Fisher, for hospitality in Boston; Anne Stuntz, for hospitality in New York City; Mr and Mrs Barber, for hospitality in Cornwall; Colin Glanfield, for advice on this and many other projects; and Jaguar Cars Inc, in New Jersey and California, for the loan of two of the best cars in the world, which allowed me to travel extensively and in comfort in the western United States.

# A NOTE ON CAPTIONS

All photographs are credited with the photographer's name: to save space, Tim Hawkins is TH, Frances Schultz is FES, and I am RWH. Wherever relevant, the location of the picture is given next (unless it has already appeared in the caption), followed by camera type, lens, and film stock, abbreviated as follows: ER is Ektachrome 64; EN is Ektachrome 100; KR is Kodachrome 64; and PKR is Kodachrome 64 Professional. Some of the shots attributed to KR and PKR may in fact have been shot on KD and PKD (Kodachrome 25 and Kodachrome 25 Professional respectively), but as we very rarely use it and can rarely tell between it and KR/PKR, we shall let that pass.

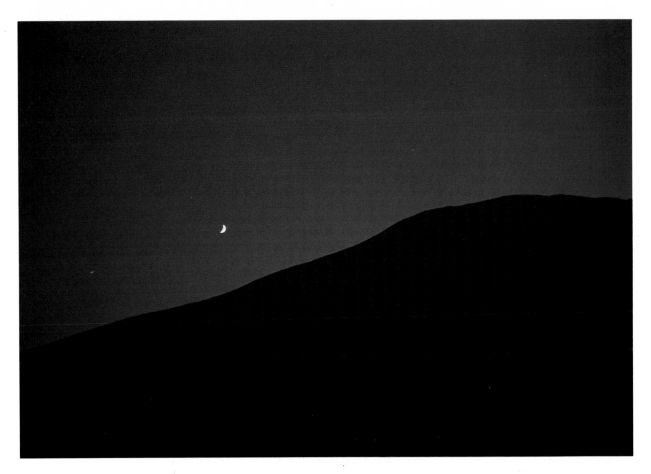

I have not differentiated between the various Nikons and Nikkormats which Tim and Frances use, or between the M-series Leicas that I use: we usually can't remember which cameras we used, and there is little point in making it up. For the record, Tim uses mostly FE2s, with some FM, F, and F3; Frances uses mostly Nikkormats and Fs; and I use M2s, M3s, and M4s. By the same token, because we do not record the exposures we use, I have not made those up either. It may come as a shock to some readers to realise that inventing exposure information (and indeed camera and lens information) is standard practice in photographic books. Lens information is from memory, and may not always be accurate, but it is probably 90 per cent correct.

I **Hill and moon, Wales** The great advantage of 35mm is that you can carry it around with you anywhere. This is my favourite picture of all the pictures that I have ever taken, and it was shot with a pre-war Leica IIIa that I carried in the pocket of my business suit. I saw it and shot it in a few seconds, guessing the exposure, as I was leaving a factory in the Welsh valleys where I was working as an audit assistant (*RWH: 5cm f/3.5 Elmar: 3M 50 ASA film*)

# PREFACE

Some photographic books lend themselves to an 'instruction manual' approach: do this, do that, do the other thing, and you will come up with the goods.

Landscape photography is not like that. It is so much a matter of personal preference that even gentle guidelines can inspire fierce opposition. *Technically*, there is a great deal of 'hard' advice that can be given, and that is what fills most of the first half of the book, up to Chapter 4. *Aesthetically*, all that is possible is a series of examples, and a framework for discussion, which may or may not fit in with your view of landscape photography.

Even if you disagree with almost every word I say, and dislike almost every picture between these covers, I hope that you will still find the book interesting, just because it does offer a framework within which you can analyse your work, and that of other people. In my own landscape photography, it took me a very long time to work out what it was that I liked, and what it was that I disliked: I was so blinded with hero-worship for people like Ansel Adams, Yoshikazu Shirakawa, and Ernst Haas to realise that the only way I was going to improve my photography was by working on just that – *my* photography – and not by imitating someone else's work.

Inevitably, because landscape photography is a personal matter, there are a lot of personal examples and arguments in this book; after all, I do not know any other photographers (even my wife) as well as I know myself. Even so, I have tried to explain both *why* and *how* I took the various pictures which appear in here, and to draw as many conclusions from my own experience as I can. I have done the same with Frances Schultz's pictures, and Tim Hawkins's, based on their own descriptions. If you can apply the same line of reasoning to your own work, no matter how different it may be from mine, you may be surprised at how much you can learn.

RWH
Bristol and
Los Angeles
1986

# 1
# INTRODUCTION:
# THE 35mm PANORAMA

Like many would-be landscape photographers, I tried for many years to copy Ansel Adams. I used 5 × 4in cameras, 10 × 8in cameras, and even an 11 × 14in camera. And I never got a single landscape that I really liked.

One of the advantages of being a professional photographer and writer, though, is that you have access to a range of equipment that would be the envy of almost anyone. Some of it you buy for the business, and if you don't own something, you can hire it, or try a friend's camera, or sometimes even borrow a whole camera system from the manufacturer. It was not the equipment that was limiting me, therefore: even though I was dissatisfied with my large-format landscapes, I knew that this was not the result of technical difficulties, because I used (and continue to use) large-format cameras perfectly successfully for book illustration, advertising, and so forth. So what was going wrong?

My immediate reaction was that the sheer effort of carrying and setting up a large-format camera was simply too great. When your camera, tripod, and bag of dark-slides weigh thirty or forty pounds (and the 11 × 14in outfit weighs nearer seventy pounds), it is a strong disincentive to wander over on the off-chance, just to see if there is a picture. The really interesting viewpoints, which require scrambling over rocks and so forth, are also a lot easier with 35mm. The cost of the film is another factor: if you are shooting 10 × 8 on colour transparency film, each exposure costs about the same as a whole roll of Kodachrome. This is not too bad if you are doing it for a living, and can charge the client for the film, but when it comes to landscapes I am in exactly the same position as any other amateur, so financial considerations were important too.

So, I tried using 6 × 7cm. The results were very much better, whether I used my Linhof or my Mamiya RB67. At last, I began to feel that I was getting somewhere. It took me four or five years to make the break, and go from cut film to rollfilm, but I was so obsessed with those wonderful Ansel Adams and Eliot Porter photographs that I could not believe I could live without a big camera.

The real break came when I decided to reorganise my 35mm files, and put them in twenty-pocket vinyl sleeves instead of the drawer-type filing system which I had previously used. As I was doing this, with something like four or five thousand transparencies, landscapes kept catching my eye. After a while I started pulling them out, to make a separate file of landscape pictures. In less than an hour, I had several dozen 35mm landscapes of which I was really proud, many more than I had ever managed with cut-film and rollfilm cameras.

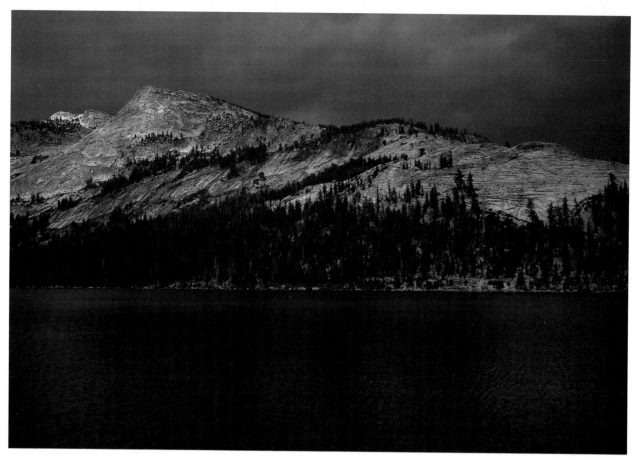

**2 Lake shore, Yosemite National Park** Although we were carrying both the Linhof Super Technica IV and the Leicas the first time we visited Yosemite National Park, my wife and I found that most of the best pictures were taken with the Leicas. The temptation was always to shoot the 'set pieces' (which we knew would sell) on the Linhof, and to use the Leicas for the more personal shots (*RWH: tripod-mounted Leica M: 280/4.8 Telyt: PKR*)

**3 Sapling, Westonbirt Arboretum** This is only a detail of a much larger scene, but it makes use of classical composition (see page 114) and it says far more about a particular place and mood than a more comprehensive shot could have done. The maxim 'less is more' often applies in landscape composition (*FES: Nikon: 50/1.2 Nikkor: KR*)

The amazing thing was that I had not really realised that I had them, because I had never taken 35mm seriously!

Now, the idea of shooting landscapes without realising it sounds crazy: if nothing else, you would expect me to notice all those little yellow boxes that kept arriving in the mail. The answer, of course, was that I had shot them almost casually, in between shooting other subjects. When I was shooting reportage pictures, I shot landscapes *as well*. When I was shooting 'library' pictures for the picture agency that handles my work in London, I shot landscapes *as well*. And like most photographers, if I go for a walk just for the exercise, I also carry my camera – my 35mm camera, of course. And what do I shoot? Predictably, landscapes.

In truth, the advantages of the 35mm camera for landscapes are exactly the same as its advantages for any other kind of photography: light weight, easy portability, ease of use, (relatively) low purchase and running costs, and a tremendous range of lenses. The only real drawback is that because 35mm is so easy to use, and 35mm film is so cheap, there is a strong temptation not to approach your photography with the same degree of care (or dedication or reverence, depending on your commitment to landscape photography) as you might exercise with a 10 × 8in camera. With a 'ten-eight', you are always conscious of having to live up to the camera; with 35mm, on the other hand, the temptation is always to be content with a snapshot.

My conversion was as sudden as St Paul's on the road to Damascus: I realised that 35mm was the medium I really wanted to use for landscape. What intrigued me was the way that everything suddenly fell into place; as another photographer said of himself, 'I

10

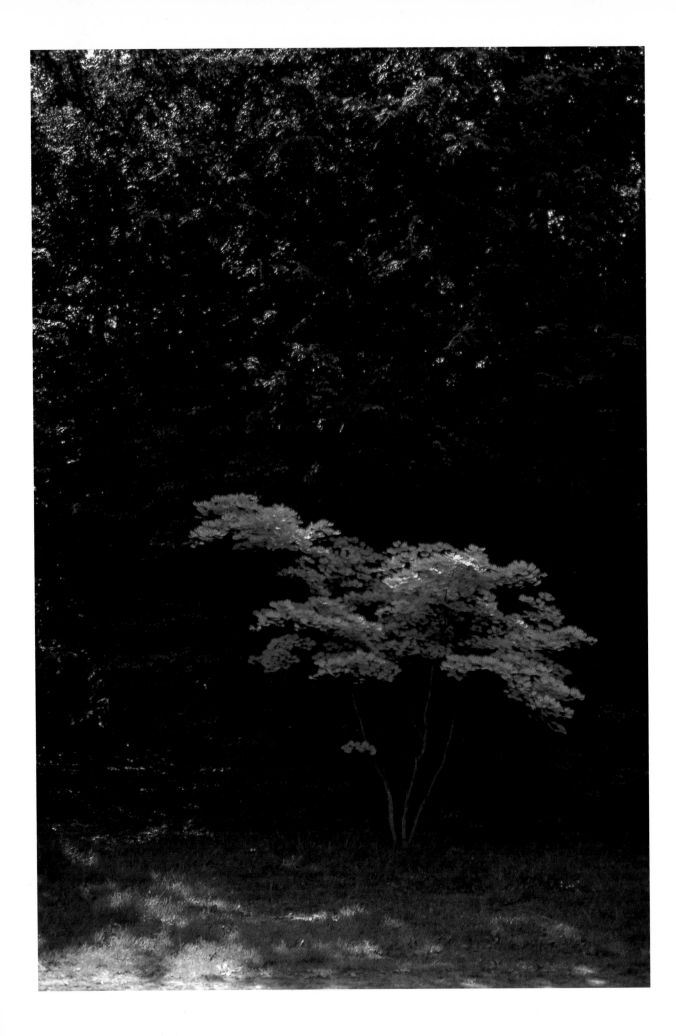

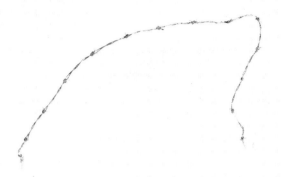

**4    Barbed wire in snow** This is another picture which one would be very unlikely to shoot with a larger camera – just a twist of barbed wire protruding from the snow. It is rather a minimalist landscape, but there is something about it which grows on you (*RWH: Yate: Nikon F: 58/1.4 Nikkor: HP4/EI 650*)

**5    El Capitan, Yosemite** 35mm can be used for any subject, even those where large format is regarded as almost mandatory. The results will not be the same as with a larger camera, but this does not mean that they will not be worth having. The grain in this picture of El Capitan in Yosemite National Park reflects the storminess of the day and the almost constant rain – and as can be seen from the tree in the foreground, the limiting factor on resolution of distant subjects is in any case atmospheric conditions rather than lens resolution and format (*RWH: Leica M: 35/1.4 Summilux: HP5/Perceptol/EI 320*)

woke up one morning and realised that I knew how to take photographs.' The techniques I had been using in my professional work suddenly made sense in the context of my landscapes, whereas before I had always been struggling with something I didn't understand: the camera had been a barrier between me and the landscapes, but now it had become transparent.

The concept of 'transparency' is a very important one. What it means is that you cease to be aware of the technicalities of what you are doing: you just do it. A good analogy is driving a car. When you first learn, it is hard work and there are many things that you consciously have to remember, but after a while, the car becomes simply a means of getting where you are going. At that point, the car has become 'transparent' – a means to an end, and one which you can handle effortlessly.

The first part of this book is about 'transparency'; about mastering camera, film, metering and processing so that you can achieve the effect that you want almost instinctively. It is not easy, any more than learning to drive a car is easy, but (again like driving a car) it is something which you can master if you want to.

Once the camera is 'transparent', you can start concentrating on the subject. It was because I was so used to using 35mm in the open that I found it much easier to shoot 35mm landscapes than rollfilm or cut-film landscapes: for me, the bigger cameras seemed more at home

12

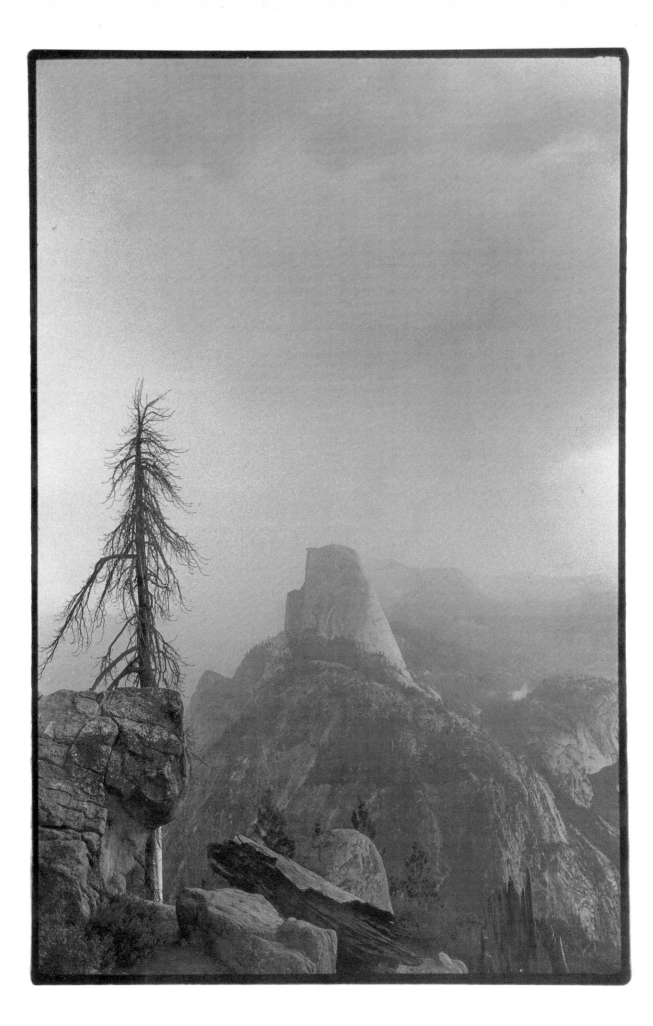

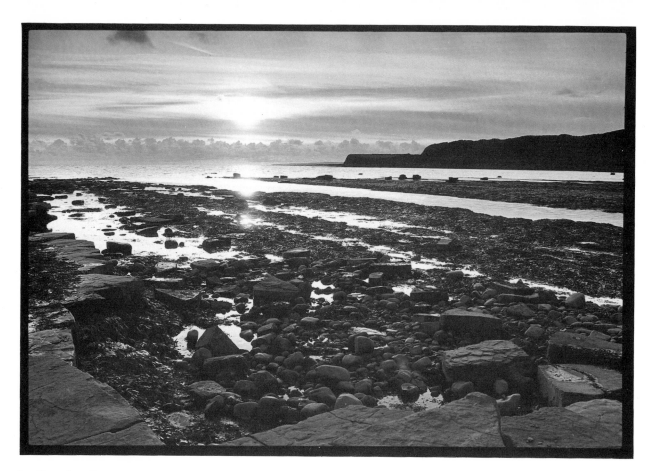

**6 Shoreline, Dorset** Difficult to reproduce in print because of its dark, moody tones, this picture nevertheless shows how 35mm can rival the quality of much larger formats with skilled processing and printing (*TH: Nikon: 35/2 Nikkor: FP4/Perceptol/EI 80*)

in the studio. I already took quality for granted in 35mm, whereas (once again) I had the awful weight of Ansel Adams's superlative quality to contend with when I was using the bigger cameras. Because I was obsessed with the Zone System and all its technicalities, the photographic process stood between me and the picture, but when I was knocking off Kodachromes for the fun of it, I could concentrate on the image. The second part of the book is about this.

Before you read either part, though, ponder upon this. Landscape photography should be fun. If you take it too seriously, it is all too easy to get obsessive about it, and to lose sight of why you took up photography in the first place. If it stops being fun, ask yourself why – and if your answer conflicts with the advice in this book, follow your own beliefs, not mine.

**7 Sun breaking through clouds, Kansas** I often find prairies and plains very difficult to photograph, but I am very proud of this picture. I was driving through Kansas when I saw it; I pulled in to the side of the road, scrambled up a railroad embankment, and shot it with a 280mm f/4.8 Telyt on a tripod-mounted Leica. The long-focus lens was essential, so this picture would have been difficult on a rollfilm camera and next to impossible with large format. The equivalent focal length on 6 × 7cm is about 600mm, and on 5 × 4in it is about 1,000mm; an 11 × 14in camera would require a staggering 3,500mm lens (*RWH: PKR*)

**8 Monsoon weather, Himalayas** One of the many advantages of 35mm is that the cameras are both reasonably waterproof and easily tucked away. Photographing monsoons in the Himalayas would soon soak a tripod-mounted camera, to say nothing of the risk of mildew on the bellows and warping the wood of a field camera, but I was able to carry my Leica under a waterproof poncho, pull it out and take the pictures, and then put it away again, all in a few seconds (*RWH: Leica M: 35mm f/1.4: PKR*)

14

# PART I

# THE SEARCH
# FOR QUALITY

# 2
# THE SEARCH FOR QUALITY

There is no such thing as 'absolute' technical quality. All we can ask for is 'appropriate' technical quality, a marriage of subject and technique that is easier to recognise than to define. The book of Ecclesiastes tells us, 'To every thing there is a season, and a time for every purpose under heaven', and this is as true in photography as anywhere else. There is a time for grain, and a time for grainlessness; a time for bright colours, and a time for subdued tones; a time for giving a little more exposure, and a time for giving a little less exposure. There is even a time for not taking photographs!

It is true, though, that some results are very much easier to achieve than others, and this is another meaning of 'quality'. As a rule, it is easier to get a soft picture than a sharp one; it is easier to get a flat, lifeless picture than one with that subtle gradation of tones that we call 'sparkle'; and it is easier to get a grainy picture than a grainless one. And even though exposure is a relative matter, it is easier to get a washed-out or too-dark transparency than one in which the colours 'sing'.

## Cameras

Logically, the place to begin our search for quality is with cameras. It is true that the choice of a camera is almost as personal a matter as the choice of a lover, and that it is impossible to lay down generalisations which will apply to everyone at every time, but there are still a few observations which are worth making.

The first is that it very rarely makes sense to keep chopping and changing. Many photographers – especially amateurs – feel that they *must* have the latest all-bells-and-whistles wonder, and change systems every two or three years. Professionals, on the other hand, tend to choose a system and stick with it, updating it and adding to it when they find that they really are being limited by their equipment. This is a much more cost-effective approach to photography in the long run. As well as all the money you save in depreciation, there is always the chance of a bargain, so that you can sometimes acquire quite specialised and expensive pieces surprisingly cheaply, especially second-hand. This is how I came to use Leicas and Nikons, and although owning two outfits in that league may sound impressive, bear in mind that it is the fruit of many *years* of dedicated bargain-hunting.

Another advantage of sticking with a single system is that you learn how to get the best out of it: like lovers, no cameras are perfect, and you have to put up with their bad points for the sake of the good ones. This is why it is best to buy into a top-flight system, even if it

**9  Wooden house, Switzerland**
This is a good example of traditional technical quality. The picture is sharp, and the tones are well differentiated. The lighting is the type beloved by the snapshotter – 'sun over the right shoulder' – and the contrast in colours between the warm reddish-brown of the house and the cool greens is very effective. It is perhaps a little 'chocolate-boxy', but that is surely appropriate for a picture shot in Switzerland! (*RWH: Leica M: 90/2 Summicron: KR*)

18

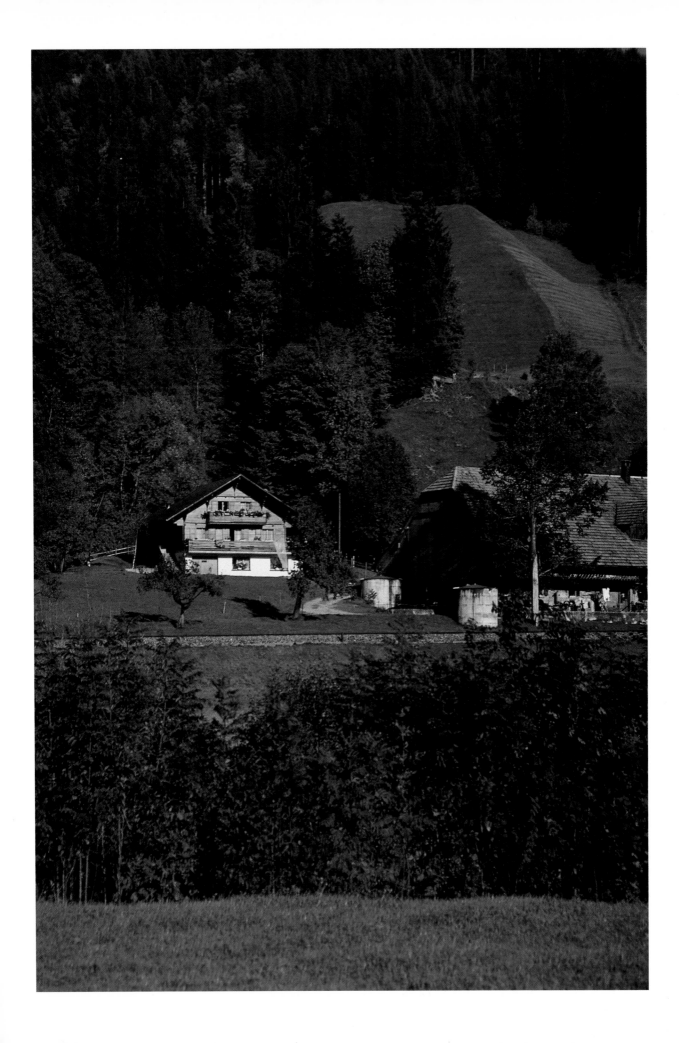

means starting off with a single second-hand body and lens, rather than going for some superficially attractive camera which will be outdated in a few years. The major systems evolve slowly, are always (or almost always) cross compatible between old and new, and have the same 'feel' and design philosophy.

On the same point, if you use more than one camera body, it is well worth having two which are identical or substantially identical – at the very least, which can accept the same lenses. If you have (say) a Nikon and a Canon, you need two sets of lenses, and you cannot simply swap one body for another in case of breakdown or if you want to use colour film in one body and black and white in the other. The only possible exception to this rule is if you use Leica rangefinder cameras, in which case you may wish to use a reflex for lenses longer than 90mm or 135mm – but even then, you can always use a Visoflex reflex housing. The time wasted in fumbling about because controls are in the 'wrong' place can be significant even if you use two bodies which accept the same lenses: I prefer Nikon Fs and my wife uses Nikkormats, and I always fumble about when I try to change speeds on her cameras.

The second generalisation – and this is one which is impossible to dispute – is that it is the lens which makes the picture, so that a camera which does not accept the very best lenses can never be the very best camera. Leitz and Zeiss lenses are generally agreed to be the very best, but unfortunately their lens ranges are very expensive and comparatively limited, at least when compared with the offerings from their two nearest competitors, Nikon and Canon.

After Leitz, Zeiss, Nikon and Canon, the choice is very much less clear-cut. Individual lenses in various makers' line-ups may be very good, but they will not compete across the board with Leitz, Zeiss, Nikon and Canon. Of the independent lenses, Vivitar's Series Ones are almost certainly the best, though the current models are rarely quite as 'state-of-the-art' (or expensive, in all fairness) as the first generation, which included such gems as the 90–180mm f/4.5 Flat Field close-focusing lens, the 90mm f/2.5 Macro, and the 200mm f/3, as well as the almost legendary 'solid cat' mirror (catadioptric) lenses. Of course, the 'solid cat' concept has been reintroduced with the 450mm focal length, and it will be interesting to see if this promising line of robust, contrasty lenses will continue.

Thirdly, no camera is any use unless it works and keeps on working, so reliability is at a premium – especially if you have to walk long distances, as you often do in landscape photography. There are few things more infuriating than finding that you have walked ten miles for a picture, only to have your camera fail on you. My own preference is for simple, mechanical cameras, because although electronic models are inherently more reliable, if they do stop, they usually do so without warning and with a thumping great repair bill – if there is anyone around who can repair them, that is. In north-western Europe and the United States, you may be all right, but try getting an electronic marvel repaired in India, even in Chandni Chowk. Also, I don't trust batteries: even fresh ones out of the pack can be flat (it has happened to me more than once), so you need to carry a *tested* spare to be sure. Having said that, the only all-electronic camera that I currently own (a Mamiya 645) has never packed up, except in 20° of frost, when the (purely mechanical)

10  **Ruined hut** In black and white, 'quality' traditionally involves a full range of tones, and fine grain. The tonality of this print is evident; and the grain is barely perceptible, even in the sky, when the original is examined at the normal viewing distance of 10in (25cm). In reproduction, only the photo-mechanical screening is evident: there is no grain at all (TH: Cornwall: Nikkon: 35/2 Nikkor: FP4/Perceptol/EI 80)

20

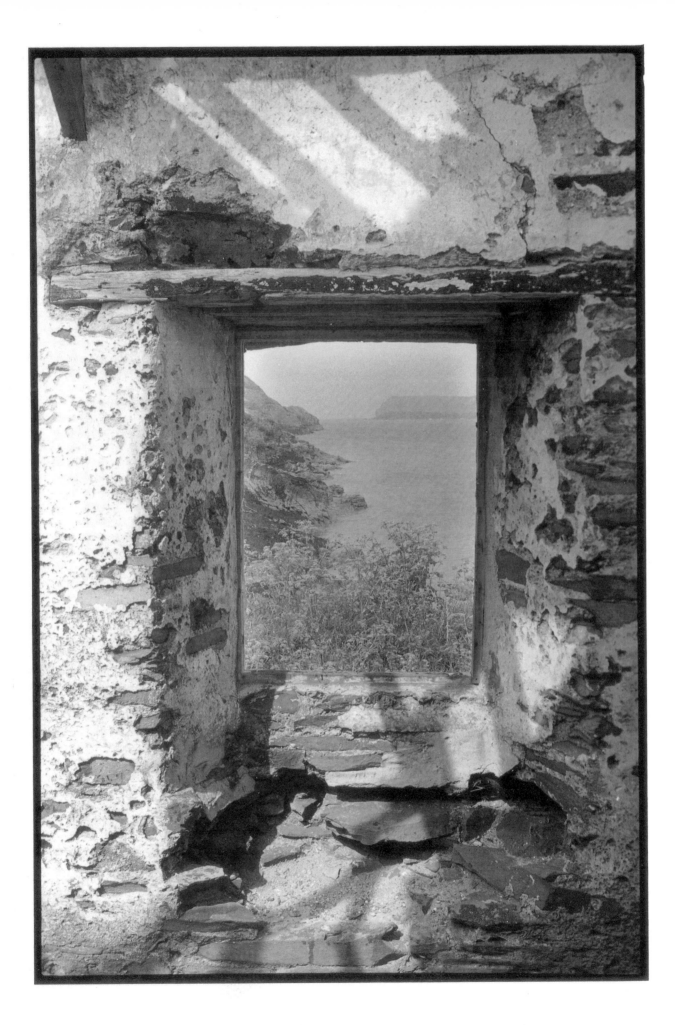

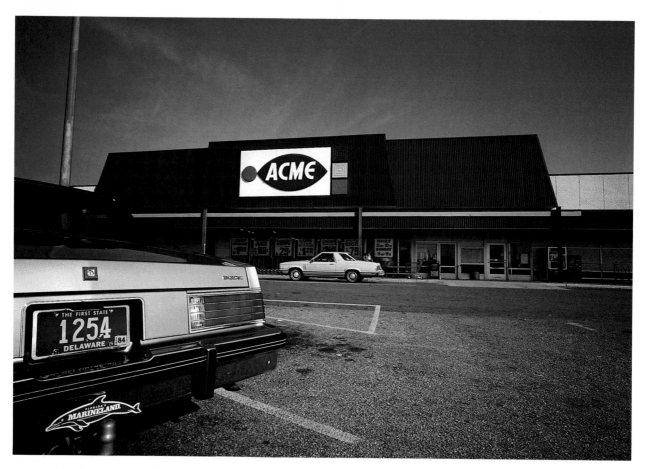

**11  Parking lot, Dover, Delaware**
If you want to use 'new wave' compositional techniques, with wide-angle distortion and chopped shapes, it is as well to go for the best technical quality you can muster. Experiment and originality often look like mere sloppiness to some people, though I like this picture very much (*RWH: Leica M: 21/2.8 Elmarit: PKR*)

frame counter stopped working. Even then, it started working again when it had thawed out. In extreme cold (−40° or below) most batteries fail altogether, however, and electronic cameras are useless.

Fourthly, there is the question of weight. There is no doubt that *most* modern cameras are lighter than *most* old ones, and you will have to decide for yourself how much weight you can take. I have a curiously schizophrenic attitude here: although I like the old Nikon F, which is one of the heaviest 'serious' cameras around – it is still used professionally, even though it was discontinued in 1973 – I also welcome the lightness of my Leicas. Then again, when I compare 35mm with my Mamiya RB67 outfit, even the Nikons seem light . . .

Fifthly, there is the size of the system. A rather cumbersome Rollei copy line ran, 'It is not so much a question of what is available – but that what is required, is available.' Maybe it sounds better in the original German, but the sentiment is irrefutable: it does not matter what lenses and accessories you can get for your camera, unless you can get the ones *you* want. Ideally, a landscape photographer might want one ultra-wide (13mm or 15mm); one extra-wide (21mm or 24mm); one wide-angle (28mm or 35mm); one 'standard' lens (50mm); and so on up through a lens from the 75/85/90/105mm group, a 135mm, a 180 or 200mm, a 280 or 300mm, something in the 400/450/500mm range, and an 800 or 1000mm lens, but I for one can neither carry nor afford such a range. Instead, I compromise on 21mm, 35mm, 50mm, 90mm, 135mm, and 280mm, and my wife uses 24mm, 50mm, 90mm, and 200mm.

Often, we carry much smaller outfits than that: I frequently carry only three lenses (21mm, 35mm, and 90mm), and I would choose the 35mm if I had to choose just one lens, probably with a 21mm as a

back-up. My wife says that she could survive with a 90mm alone, though a 35mm would be virtually essential as back-up. When I asked her what lens she would choose, though, she immediately asked, 'Professionally or for fun?' For fun, she would be quite happy with a 35–85mm varifocal, though for professional use she would be a little more cautious and stick with prime lenses. The reason for her caution is that her first 35–85mm lens (Vivitar Series One, bought new) was well up to professional standard, while the second (bought second-hand after the first was stolen) never had quite the same 'edge'.

The point about personal choice, though, brings us back to where we started: it is, in the final analysis, very much a personal choice, and you have to buy the camera that suits *you*. Ask any camera store manager, and he will tell you sad stories of people who had a windfall

*Overleaf*

**14  Lifeboat house** One advantage of printing with a black frame is that it differentiates white sky areas from white paper; otherwise, the picture may just 'peter out'. The easiest way to get a black frame is to use a negative carrier that is just slightly larger than the negative itself, and to centre the image very carefully. Typically, an image about 6 × 9in (150 × 225mm) on 10 × 8in (18 × 24cm) paper is ideal (*TH: Dorset coast: Nikon: 35/2 Nikkor: FP4/Perceptol/ EI 80*)

**15  Trees** Omitting the frame, as here, can give a rather indecisive picture which quietly bleeds off the edges in those areas where there is not sufficient differentiation between sky and the surrounding paper. A little judicious 'burning in' at the edges is a good idea to maintain the integrity of the picture (*TH: Nikon: 35/2.8 PC-Nikkor: FP4/ Perceptol/EI 80*)

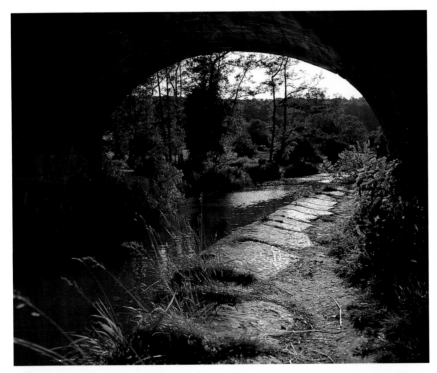

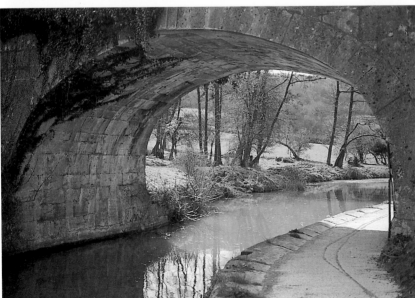

**12  Bridge, Kennet and Avon Canal** This is the only picture in the book where I have cheated and used a 6 × 7cm colour transparency. The quality is admittedly excellent, but the main reason for including it is for comparison with the black and white picture of the same scene. Not only was this shot at a better time of day (compare the angle of the light), but one of the most attractive things about the picture is the texture of the path, with the weeds growing in the foreground. The other shot, taken only a few months later, is a monument to vandalism in the name of progress (*RWH: Kennet and Avon Canal, near Bath: Mamiya RB67: 50/4.5 Sekor: ER*)

**13  Bridge, Kennet and Avon Canal** Comparing this with the colour picture of the same scene shows how black and white can capture a far larger tonal range than colour. It also shows how time of day affects a picture (the sun coming *through* the bridge is much more attractive), and how it is never wise to delay putting off a picture when you find an attractive spot. The person who concreted the path was bad enough; the idiot who rode a bicycle through the fresh concrete should be thrown in the canal! (*RWH: Leica M: 21/2.8 Elmarit: Dia-Direct*)

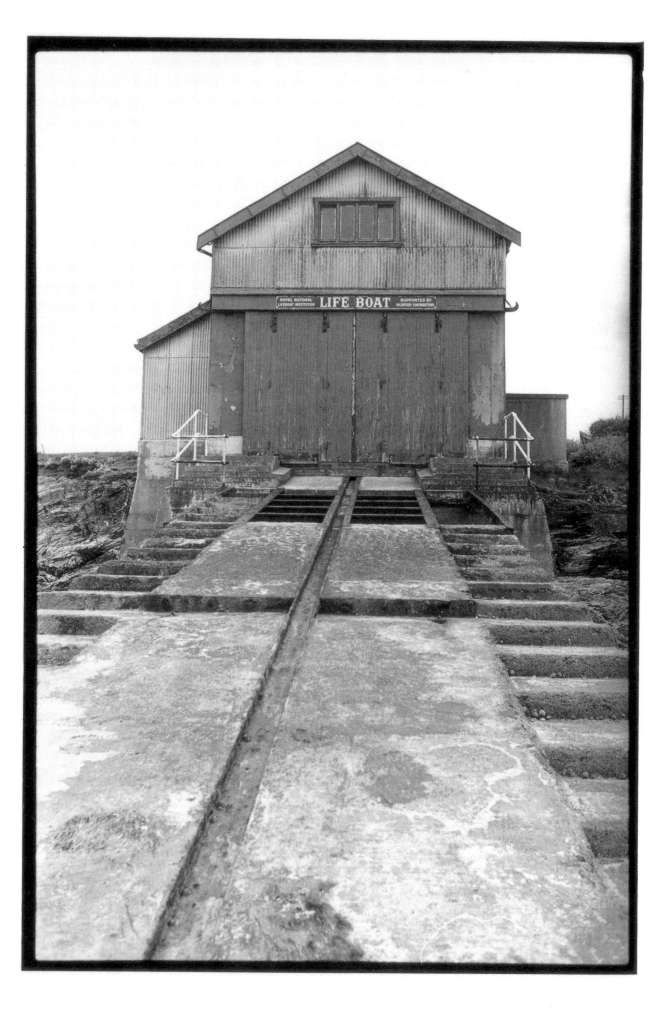

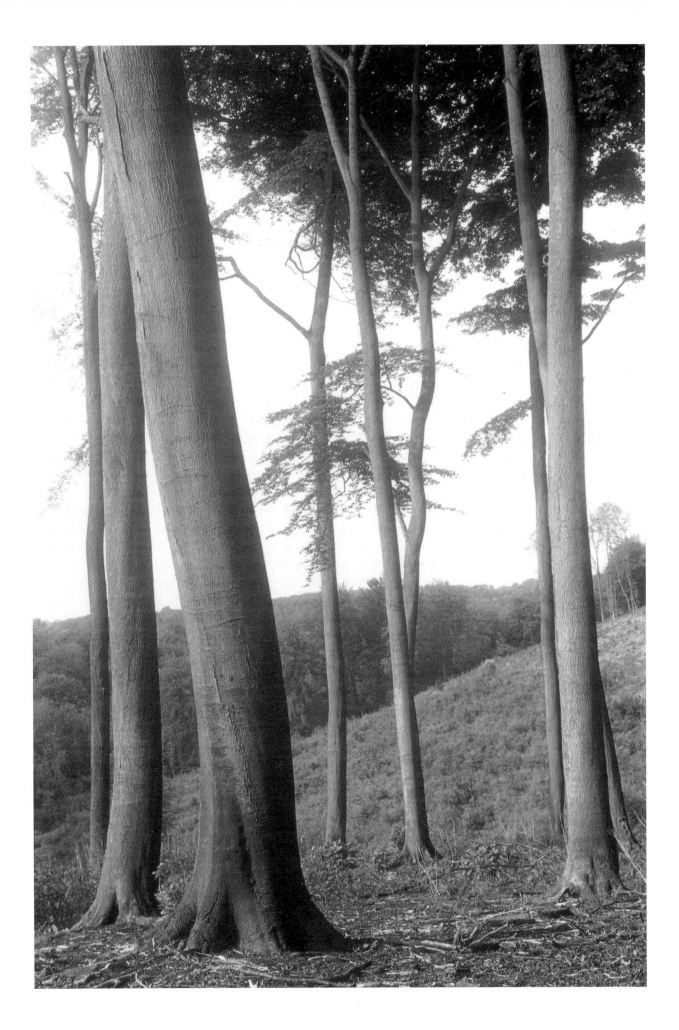

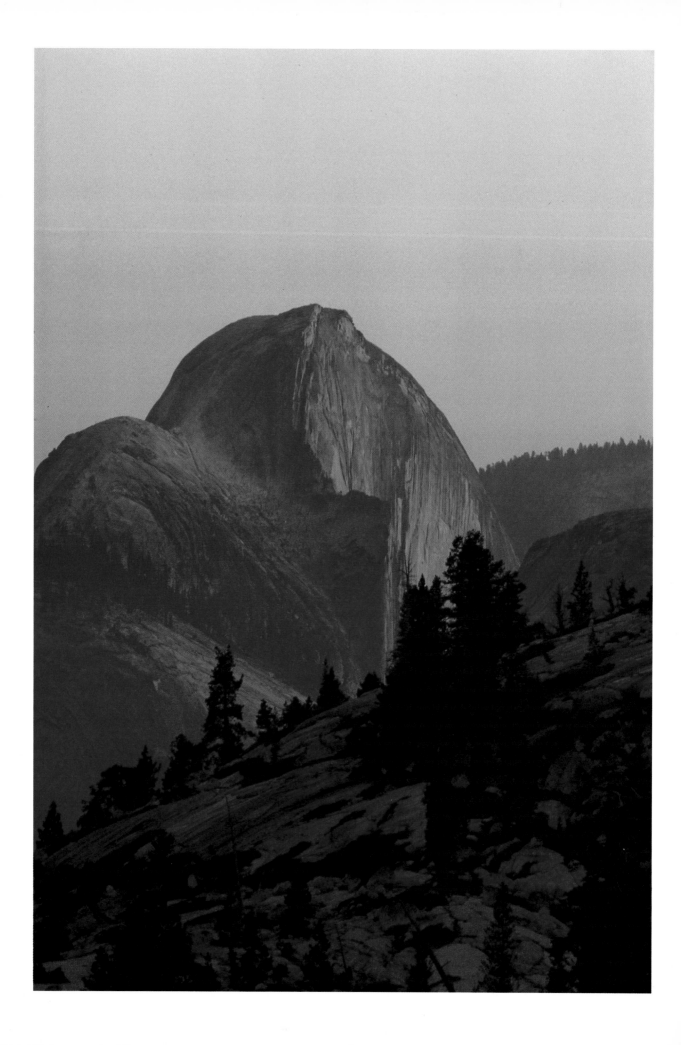

of some kind and bought the camera of their dreams, only to find that it was not *really* what they wanted, so they traded it in (at a handsome loss) a few months or even weeks later. Your only hope here is a good camera store where they have the equipment on display *and give you a chance to handle it.* This does not necessarily exclude discount merchants, but it does mean that you need to use them intelligently – for example, going on the right day of the week. In New York City, one of my favourite camera stores is Wall Street Camera, one of the kings of discount selling, and their service is first-class *if* you don't go in on a Sunday (their busiest day) and *if* they know that you are a serious buyer rather than just a 'teaser' who will waste their time.

For most people, the automatic choice for 35mm landscape photography will be a single-lens reflex; but there is an alternative, and before we go on to the ubiquitous SLR, it is worth considering. I must confess that my own personal prejudices are strong here, but I make no apology for this; if you are as well pleased with your camera as I am with mine, you must have few complaints. Of course, if you are dissatisfied with your equipment, you may be interested in what I have to say.

The serious alternative to the reflex is the rangefinder M-series Leica. It has interchangeable lenses from 21mm (15mm if you can find one) to 135mm, and with the addition of a Visoflex reflex housing can use lenses of up to 800mm. The optical quality is superb – the best there is – and the viewfinder is perfectly adequate, though not (it must be admitted) up to the standard of a good reflex when it comes to absolutely *precise* framing. Exposure control is, of course, completely manual; only the M5, the M6, and the CL have through-

**16 Three Rivers, California** Carrying two or even three identical camera bodies may look like extravagance or conspicuous consumption, but it can save a lot of time in changing lenses; often, particular lighting conditions endure only for a few seconds. As it was, I was able to grab the right camera with the right focal length pre-set to (roughly) the right aperture; if I had had to change lenses and set the aperture, I might have missed the shot (*RWH: Three Rivers, near Lemon, California: Leica M: 50/2 Summicron: PKR*)

**17 Half Dome, Yosemite** Long-focus lenses bring their own image-quality problems. A tripod is virtually essential, and even then wind can destroy ultimate sharpness. This is the sharpest of five exposures of Half Dome, in Yosemite National Park, taken at sunset. Dawn is invariably 'cleaner' than sunset, when even the faintest heat haze can take the edge off definition and there is usually more dust in the air. Likewise, you usually get clearer pictures at high altitudes, though this was shot at an altitude of some 5,000ft (*RWH: tripod-mounted Leica M: 280/4.8 Telyt: PKR*)

27

lens metering, and that only indicates the exposure, rather than sets it.

The reason why I mention the Leica first is that it is my own favourite camera, and the one which I have used for over fifteen years. It is, I admit, an unusual choice for landscape photography: the 21mm lens requires a separate viewfinder, and the 200mm, 280mm, and 400mm lenses on the Visoflex are not exactly convenient. On the other hand, it is light and supremely reliable, and I can carry half a dozen lenses and a couple of bodies without really worrying about the weight, something I cannot readily do with any SLR. Most important of all, I can lay out thirty or forty transparencies on the light table, half taken with the Leica and half with other cameras, and ask anyone to pick out the half-dozen sharpest and clearest; I would be very surprised if even one of that half-dozen was not shot on a Leica with Leitz lenses. It is true that the Leica is insanely expensive, but I used Leicas for over a decade before I bought a single new body or lens: even second-hand, they are not cheap, but you can find the occasional bargain.

With the Leica out of the way, we can go on to the reflex. For years, I have used Nikons; Tim Hawkins uses Nikons; and Frances Schultz uses Nikons and Nikkormats. Tim and Frances use more modern machines, but my own favourite is the old F, rather heavy and a little bit crude by modern standards, but incredibly reliable and (if you hunt about a bit) ridiculously cheap. The viewfinder shows 100 per cent of what appears on the film, which is more than you can say for most of its rivals, and I find that a grid screen helps in checking verticals and setting the camera up straight on a tripod. And, of course, the Nikon F accepts all the Nikkor reflex lenses made since 1959, as well as a whole raft of independent lenses, so you need never complain about lack of optical choice. Finally, because Nikons are *the* professional standard, you can always hire 'funny' lenses or even a spare body – you are almost certain to be able to find someone to rent you something – or if you want a really cheap spare body, you can always buy a Nikkormat.

This is not to say, however, that the Nikon is the only possible choice, and indeed, if I were not locked into the system, with eight lenses (collected over the years), I might seriously be tempted by Canon, who have been neck-and-neck with Nikon for years. Apart from these two obvious giants, the choice is much more difficult; one of the intriguing things about professionals is that they are inclined to be totally partisan about the camera makes they use, and totally damning about the ones they don't, so the only way to check quality is by a side-by-side test using the same film. On that basis, I would be willing to consider Contax, Leicaflex (now called Leica R-series), Minolta or Rolleiflex if cost were no option, and probably Ricoh if I had to economise. By contrast, there are at least two well-known makes which I would not touch with a barge-pole, but I am not going to name them here because I have done so in print before, and the manufacturers got very annoyed indeed. One of them would, I think, have sued me for libel if I had not produced letters from six professional photographers and two dealers: one dealer's letter was very brief, and said: 'If ****** cameras are so [unprintable] marvellous, how come I have to keep sending the [unprintable] things back under guarantee?'

18 **Tree-trunk** The tonal range which can be represented in a black and white transparency is greater than can be represented in a print, just as the tonal range which can be represented on a negative is greater than can be represented in a print, but presentation is going to be a problem unless your picture is destined for photomechanical reproduction or you actually like monochrome transparencies – something of an acquired taste (*RWH: Kennet and Avon Canal: Leica M: 35/1.4 Summilux: Dia-Direct*)

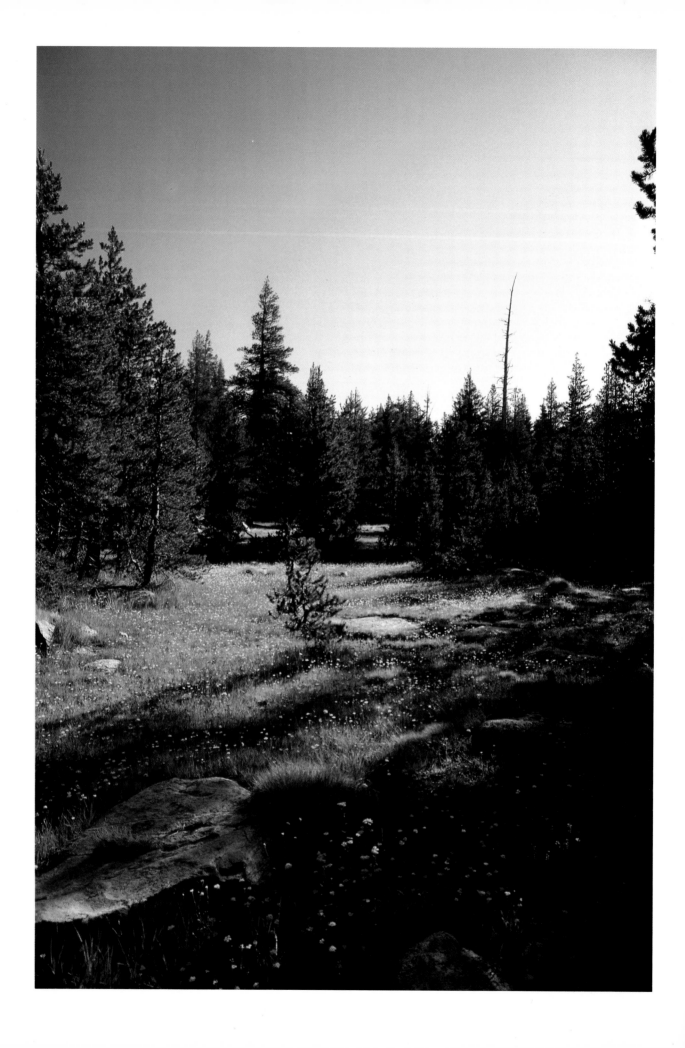

## Lenses

When it comes to lens choice, there are two things to consider. The first is optical quality, and the second is focal length. It may seem odd to put them in this order – what use is the finest lens if it is not the focal length that you want? – but it makes sense when you come to considering the individual lenses.

Ideally, you want a lens which has a high resolving power, a high internal contrast, and no distortion.

The first is easy to understand: we are all aware of line pairs per millimetre (lp/mm), and a lens which delivers (say) 96lp/mm is obviously sharper than one which delivers 48lp/mm. We should, however, treat any figures given in tests with some suspicion. To begin with, there is an enormous difference between *aerial* resolving power, and resolving power *on film*. A lens which can resolve 300lp/mm when the aerial image (the image in the focal plane) is checked with a magnifier may only produce 125lp/mm on a fine-grained black and white film, 100lp/mm on Kodachrome 25, 80–90lp/mm on medium-speed black and white film, and as little as 40–50lp/mm on fast colour negative film. Although a sharp lens will look sharper on any given film than a softer rival, only the sharpest films can fully exploit the sharpest lenses – which means that if you habitually use colour print film, you are unlikely ever to see the difference between the best lenses and the fair-to-good.

It is also instructive to look at what we mean by 'sharpness' in a print. The human eye can resolve about one minute of arc, which equates to a dark beard hair on a white surface at 3ft (1m) or to 7lp/mm on a print viewed at 10in (25cm). If we assume the standard 'ten-eight glossy', this means an 8× enlargement from 35mm, which

**19, 20  Meadow, Yosemite**
'Portrait' (vertical format) pictures often have a completely different feeling from those shot in 'landscape' horizontal format. It is sometimes necessary to make a conscious effort to break away from the 'landscape' format, which is the natural way to hold the camera and may also seem to be the natural way to frame a subject (*FES: Yosemite National Park: Leica M: 35/1.4 Summilux*)

31

in turn implies 56lp/mm on the negative *assuming a perfect enlarger lens*. Given that no lens is perfect, we should ask for something like 50 per cent more resolution on the negative than this, which gives us (at a charitable approximation) 80lp/mm. At the standard 11 × 14in (280 × 350mm) US exhibition size, we need 77lp/mm for a perfect enlarger lens, or 110lp/mm in real life. For a British 20 × 16in (500 × 400mm) exhibition print we need 112lp/mm for a perfect enlarger lens, say 150lp/mm in reality. As 100lp/mm represents the realistic maximum for most lens/film combinations, this is asking rather a lot! Admittedly, big exhibition prints are normally examined from rather further away than smaller ones, but as there is always the temptation to inspect more closely for sharpness, this gives us a realistic starting point for defining resolution.

The traditional wisdom for sharpness is of course to stop down, but here we run into the *diffraction limited* resolving power of a lens. This is the theoretical maximum resolving power, without any account of the actual quality of the lens in question. Very conveniently, for 50 per cent contrast (see below) and green light, you can get this by dividing 1,000 by the aperture, so the diffraction limited performance of a perfect f/2 lens is 500lp/mm, that of an f/4 lens is 250lp/mm, and so forth. This necessarily implies that we should never use our lenses at less than about f/8 (125lp/mm), at which point the actual on-the-film image quality is likely to start deteriorating as we stop down further. Most high-quality prime lenses (except retrofocus wide-angles) are diffraction limited by about f/4–f/5.6, so there is no point in stopping down beyond this except for increased depth of field. On the other hand, retrofocus wide-angles (which means anything wider than 50mm for most 35mm reflexes) and zooms are unlikely to reach their diffraction limit much before f/11, at which point the image quality is already below what is required for real sharpness . . .

So much for resolution: what about distortion? As practical photographers, our main concern is likely to be bowing of rectilinear lines outwards (barrel distortion) or inwards (pincushion distortion). Barrel distortion is characteristic of wide-angle lenses, and I once used a cheap model which exhibited it so badly that it looked as if the building I was photographing was about to belly outwards and collapse. Pincushion distortion, on the other hand, is characteristic of telephoto lenses. Zooms frequently exhibit both, with barrel distortion at the wide-angle end of the range, and pincushion distortion at the other end. If you never photograph buildings, you may never notice distortion – but if you do photograph buildings, you would be well advised to test your lens by photographing a brick wall before you use it seriously. Incidentally, do *take* the picture, and examine it on film: many viewfinders exhibit a modest amount of distortion which is a consequence of the field lens in the viewfinder itself, and which is not present in the actual picture.

Our third criterion, internal contrast, is the one which is least widely understood. If you think about it, though, any lens must reduce the contrast of the original test target upon which it is focused, blurring the distinction between white and black bars imperceptibly at first and then more and more as the detail becomes finer and finer. At 20lp/mm, the contrast on the film may be 98–99 per cent of the contrast in the original, but at 80lp/mm it is likely to

21 **Nikkormat with lens mounted on own tripod socket** If a lens has its own tripod socket, you should always use it. The result will be better balanced, less prone to vibration, and less likely to strain the camera baseplate (RWH)

be 60–70 per cent and at 100lp/mm it may only be 40 per cent or less. When it falls much below 40 per cent, all we see is a grey-on-grey blur. The implications for resolution are obvious, but contrast is also important when we are trying to differentiate closely spaced tones. Look at Plate 53 and you will see that the receding planes are clearly differentiated even though the tonal differences are very small: with a flary (=less contrasty) lens, these subtleties would have been lost altogether, and indeed, they are not easy to reproduce in print.

The relevance of these three criteria becomes obvious when we apply them to different groups of lenses, as follows:

*Ultrawide-angles* (wider than 20mm) are mostly only available for reflex cameras. Because single-lens reflexes are equipped with what Japanese instruction books used to call 'the flipping mirror', a *retrofocus* design is necessary. In non-retrofocus designs, the nodal point of the lens will be the same distance from the film plane as the focal length of the lens, when focused upon infinity. With a symmetrical-design non-retrofocus 20mm lens (say) 20mm thick, this would mean that there was only 10mm between the back of the lens and the film plane, and as the flipping mirror needs up to 40mm of space to flip, a retrofocus design is essential. 'Retrofocus' is, incidentally, a trade mark of the French firm of Angénieux who originated the design for 35mm, but it has become so widely used that it is now taken to refer to all lenses of this type. Put crudely, retrofocus lenses need a lot of glass and a good deal of optical wizardry to accomplish their purpose, and as a result they are rarely as sharp, as distortion-free, or as contrasty as non-retrofocus designs; or if they are, they are ruinously expensive.

In the 21–50mm range, the same continues to hold true of lenses for *reflexes*, but lenses for non-reflexes can be a good deal simpler and hence lighter, sharper, contrastier, and with less distortion. This is one of the reasons why I use Leicas, because the 21mm and 35mm lenses are so superior to their retrofocus counterparts (especially their *fast* reflex counterparts) that there is virtually no competition. It is also worth noting that although Nikon lenses are generally much

33

cheaper than Leitz ones, the 35mm f/1.4 Nikkor was at the time of writing more expensive than the 35mm f/1.4 Summilux for the M-series Leica!

Beyond 50mm, the method of construction becomes less important, as there is usually plenty of room for the flipping mirror except in the very fastest designs – and once again, the 50mm f/1 for the M-series Leica is unmatched by any reflex lens. There have been f/1.1, f/1, and f/0.95 lenses for non-reflexes (from Nikon, Leitz, and Canon respectively) but no reflex camera manufacturer has ever offered a *production* lens faster than f/1.2. On the topic of speed, it is worth noting that although you rarely need sheer speed for landscapes, there are occasions when it is useful: the Himalayan night shot (Plate 112), for example, was shot with an f/1.8 lens wide open, and the exposure was still about eight seconds!

With very long lenses, contrast becomes very important indeed, because you already have to contend with plenty of contrast-lowering atmospheric haze. Leitz chose a novel solution to this with their slow but extremely contrasty cemented doublets: a 400mm f/6.8 may be no speed king (the odd-looking speed is half a stop slower than f/5.6), but at least it is contrasty, and the same is true of the 560mm at the same speed.

All the theoretical considerations in the world, though, are worth nothing except insofar as they are relevant to taking pictures. So, what are the uses of the different types of lenses? Once again, this is a very personal matter, and all I can give in this book is three photographers' examples. Throughout the book, the different lenses used to take different landscapes have been noted wherever I can remember (or have been able to find out) what they were, but it is

22 **Grapes** The bloom on grapes is something which is surprisingly hard to capture. With any form of very fine texture, you need to come in close with 35mm and to use a first-rate lens (*TH: Nikon: 105/2.5 Nikkor: PKR*)

23 **Near Zurich** As a general rule, you should not bisect the picture with the horizon. In this case, though, there was little choice: try to imagine either more sky or more foreground, and you can see that the whole shape of the landscape would not have been conveyed in the same way (*RWH: about 20 miles from Zurich: Nikon: 50/1.2 Nikkor: KR*)

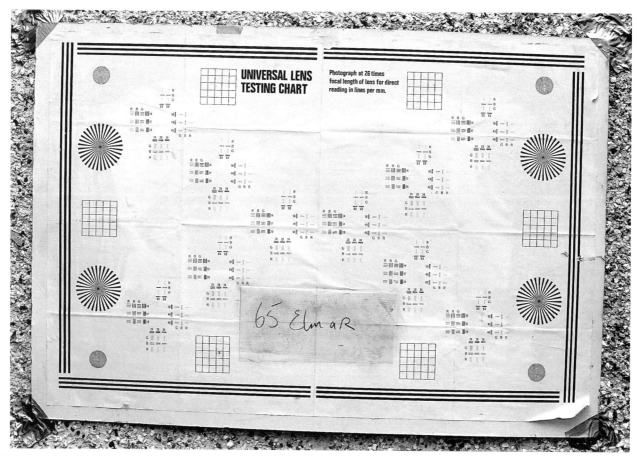

**24 Test chart** Test charts for lenses are not expensive, and can tell you a lot about the performance of your camera/lens/film combination. This battered old chart is mounted on a sheet of cardboard for convenience, and tests central and edge resolution, colour correction, distortion (pincushion or barrel) and astigmatism (with the radial targets). I put a piece of clear plastic over a clear area of the chart, on which I write with a grease-pencil the name of the lens under test – in this case, a 65mm Visoflex-fit Elmar on a Leica M2. I normally add the aperture at which it is being tested (RWH)

worth briefly running through the different types of lens and their uses here.

*Up to 24mm*

Mostly used in *very* confined spaces, whether natural (as in some of the Colorado gorges) or man-made, as in cities. Alternatively, used to emphasise foregrounds at the expense of backgrounds: tremendous looming foregrounds characterise these pictures, and it is *essential* to have a strong foreground, or the picture will be nothing. Although wide-angles seem ideal for capturing very wide panoramas, they are actually useless for this unless you do have a strong foreground. I am a great believer in the 21mm, and use it for perhaps 25 per cent of my landscapes, and Tim has a weakness for a 17mm. The only trouble, as already indicated, is that these ultrawides are either very costly, or rather unimpressive performers.

*28–35mm*

Regarded by many as the 'standard' lens, these are still subject to many of the strictures already expressed for ultrawides but do not require quite the same care in framing in order to avoid crazily converging verticals. Paradoxically, although I use my 35mm f/1.4 Summilux incessantly for everything else, I doubt if it accounts for more than 30–40 per cent of my landscapes. If I owned a 35mm shift lens, though (see page 180), I suspect that I would use it a lot more.

*50mm*

The well known 'standard'. Some people love this lens, and it is true that it is the sharpest that most people own, as well as one of the

fastest, but it is also rather undramatic, lacking the looming perspective of wide-angles or the compressed perspective and selectiveness of longer lenses.

### 85mm/90mm/105mm

A very underrated focal length for landscape and indeed any other sort of photography, the 'short tele' lens offers *just* enough selectiveness to crop out unwanted detail while still retaining sufficient speed and sharpness (and freedom from aerial haze) to give a really crisp picture. Ideal for mountain photography, or for landscapes containing people. I use a 90mm f/2 Summicron for perhaps 15–20 per cent of my landscapes, and my wife uses a 90mm f/2.5 Vivitar Series One for close on half of hers.

### 135mm

I used to think that this was a bit of a non-event, a compromise like the 50mm lens, without the intimacy of shorter lenses or the real pulling power of longer ones. Since acquiring a 135mm f/2.8 Elmarit for my Leicas, I am not so sure: the landscape in Plate 116 was a picture which could only have been taken with this focal length. The 135mm does have the advantage that it can still be hand-held with a fair degree of confidence, which is impossible with longer lenses.

### 180–200mm

A wonderful focal length, which compresses perspective dramatically and allows you to isolate details when shooting across mountain valleys. At the moment, I do not have a 200mm for my Leicas, but I use my wife's 200mm f/3 Vivitar Series One when I find the 280mm Telyt f/4.8 (half a stop slower than f/4) too long or too slow. Even at 200mm, though, there is a significant risk of camera shake (see below).

### 280–300mm

Very dramatic. I use my 280mm Telyt for up to 20 per cent of my landscapes – the proportion is increasing, too. The troubles are aerial haze (which can be used creatively, but is often a nuisance) and the difficulty of holding the camera steady, even on a tripod: a strong breeze can destroy sharpness, and I often shoot two or three exposures in the hope of getting one sharp one. I was relieved to find that this was not something which was unique to me, but that many other professionals have the same problem.

### Over 300mm

Most people regard 300mm as the longest 'general-purpose' lens for practical use, and I agree with them: anything longer is too big, too heavy, too difficult to hold still even with a tripod, (usually) too slow, and either too fragile or too expensive. Even so, long lenses are tremendous fun, and while one of my favourites is the 450mm 'Solid Cat' from Vivitar, Tim uses a 600mm sometimes. No pictures in this book were taken with anything longer than a 600mm lens.

### Perspective control lenses

Usually available as 28mm or 35mm moderate wide-angles, these are very useful (especially in architectural photography) but also very

*Overleaf*

**25  Pier 41, San Francisco** The quality of light in San Francisco is such that deeply saturated colours and a 'hard edge' approach seem natural. This is one of several pictures in the book which is 'not a landscape' to some people; what is your reaction? (*RWH: Nikon: 24/2.8 Nikkor: KR*)

**26  Church, near Lemon, California** Like the picture of Pier 41, this is another 'hard edge' picture using simple shapes and large areas of flat tone. Underexposure emphasises the flatness and intensity of the monotones, so that they take precedence over the more jumbled shapes of the surrounding shrubs (*RWH: Leica: 35/1.4 Summilux: PKR*)

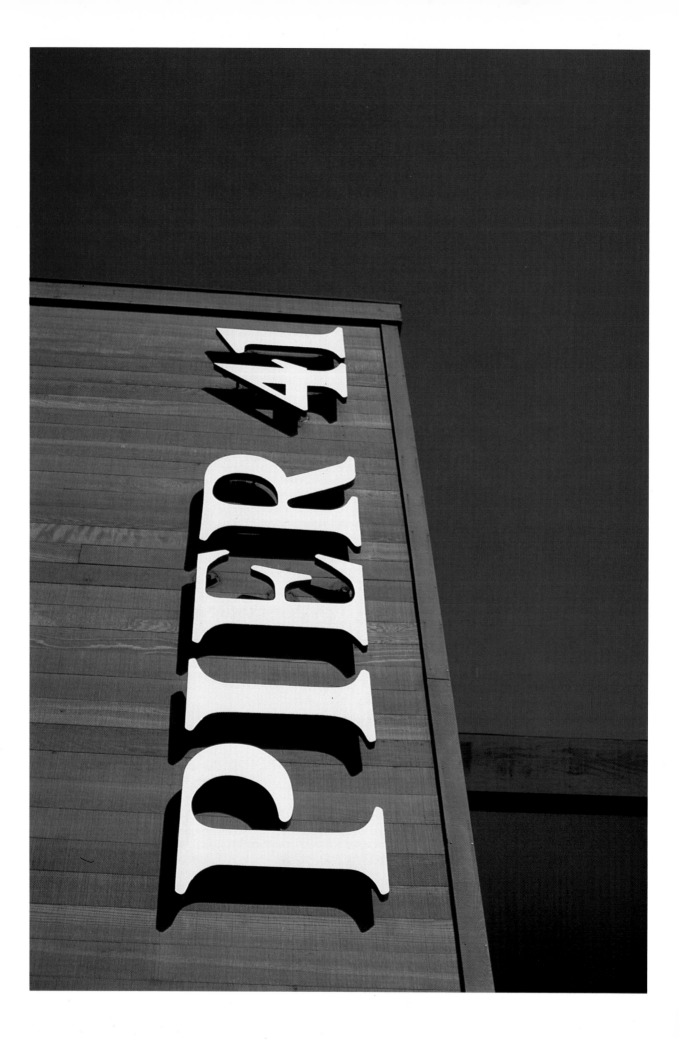

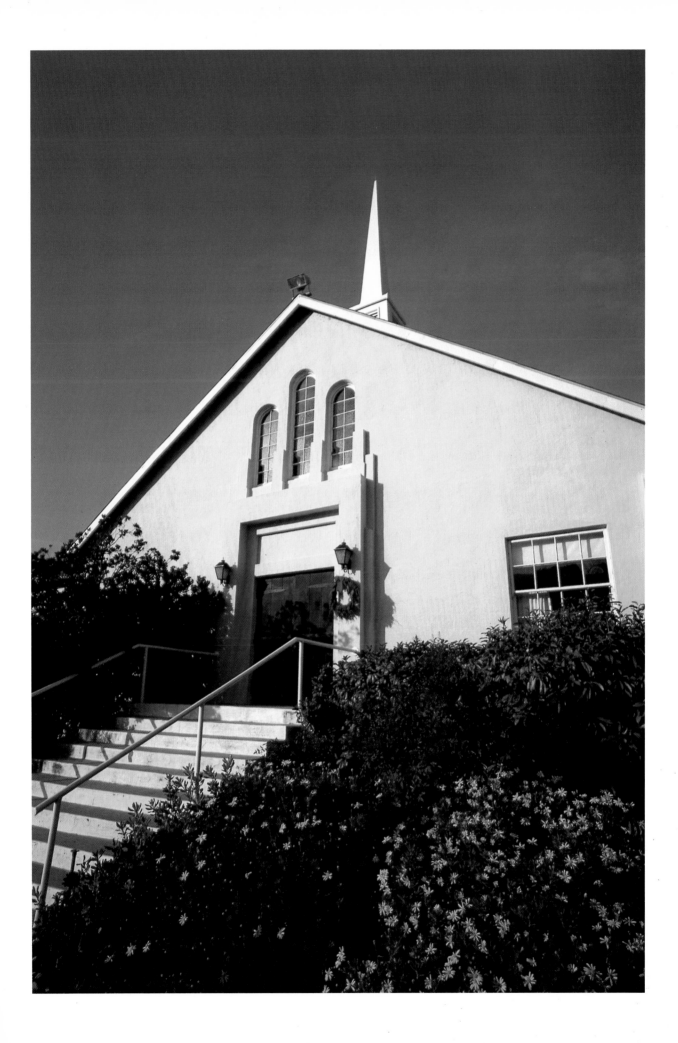

expensive. The decentring mount allows the whole lens to be moved parallel to the film plane – vertically to move the image up or down, or sideways to move the image to the left or right. It is hard to convey how useful they are until you have used one, but the way in which you can avoid converging verticals by shifting the lens vertically instead of tilting the camera is wonderful. They are also useful in some types of scenic photography, where they change the relationship of foreground and background in a way that merely raising or lowering (or tilting) the camera cannot. Canon make the most versatile PC lens (also known as 'shift' lenses), which incorporates a limited swing/tilt facility to allow control of depth of field in a receding plane *without stopping down*. If you can afford one, these lenses are well worth buying.

### Fish-eye lenses

I have never found these of much use in landscape photography, though some people seem to like them. The full-frame (corner-to-corner) type of fish-eye is much more useful than the circular-image type; the picture in Plate 152 was taken with a 16mm Fish-Eye Nikkor.

### Zoom lenses

Although zooms are very convenient, they also have their drawbacks. They are much bigger and heavier than prime lenses, so the old advertising line about reducing weight and bulk by carrying a zoom instead of a range of prime lenses is not entirely true. The only ones capable of delivering really good image quality are very expensive, and only the finest zooms ever made can begin to compare with

**27 Close-up, test chart** For some inscrutable reason, photographing the chart at 26× the focal length of the lens in use gives a direct resolution reading in line pairs per millimetre (lp/mm) on the negative. As can be seen, the targets run from 14lp/mm to 80lp/mm, and are reproduced in red, green, and blue (RGB on the chart) as well as in black. Using the different colours allows you to check the colour correction of your lens – its ability to focus all colours in the same plane. The 65mm Elmar on test resolved 80lp/mm centrally at f/5.6, and 80lp/mm at the edge by f/9.5 (halfway between 8 and 11) (RWH)

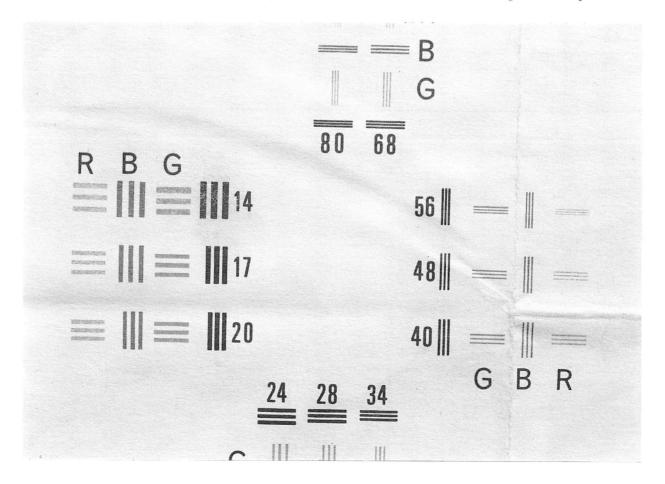

prime lenses when it comes to sharpness, freedom from distortion, and internal contrast. I only use one zoom – the old Vivitar Series One 90–180mm Flat Field f/4.5 – and am constantly astonished at the quality it does deliver. On the other hand, it is big, heavy, slow, has a limited zoom range, and was when it first came out one of the most expensive zooms on the market. I have also used two 35–85mm Series One varifocal lenses from the same maker, one of which was superb and the other of which did not have the same edge, as already mentioned.

### Teleconverters

Most professionals view teleconverters strictly as a means of getting out of trouble: if you really *need* that extra focal length and cannot justify buying or carrying anything longer than your usual longest lens, they are (just about) acceptable. A 2× converter is the most powerful you ought to consider, though, and it should come from a top manufacturer, so it will not be cheap; and you ought only to use it with the very best prime lenses, or results will be dire, because *all* faults and aberrations in the lens are doubled along with the magnification. Add to this the two-stop light loss, and the need to stop down at least two or three stops to get optimum definition, and you have problems: even with the Vivitar Series One 200mm f/3, the maximum aperture drops to f/6 and the best *working* aperture is about f/11–f/16 (f/5.6–f/8 marked on the lens), which is pretty slow. A more typical 200mm f/4 would of course become an f/8, which should be used at f/16 to get an acceptable image. A decent cheap 400mm f/5.6 lens should not cost you a fortune, especially second-hand, and it will be pretty good at f/8–f/11. With any cheap long-focus lenses, though, be very gentle with them: if they are good (and some are surprisingly good), they may be more than usually susceptible to knocks and bangs.

### Accessories

Now that we have looked at cameras and lenses, it makes sense to move on to accessories. The most basic accessories are the ones which improve your image quality, and most professionals would list two without hesitation, though they might differ as to the order. They are the lens hood (lens shade) and the tripod. Hand-held meters, the third accessory that few serious photographers would want to be without, are covered in the next chapter.

It is true that lens hoods are far less important than they were, because of multi-coating: once, when I was trying to get an illustration to show the advantages of lens hoods, I had to point a 500W lamp almost straight into the lens, and add a filter, to get the kind of degradation that would show in black and white photomechanical reproduction – and that was with a 50mm f/1.2 lens, which I thought would be a dead cert for flare. I reckoned without Nikon quality! Even so, there are occasions when a lens shade will make the difference between a crisp, contrasty shot and one that is horribly flat and flary, especially if you are using a less than first-class lens. Of course, the lens has to be sparkling clean, and this is one of the other advantages of a lens hood: it keeps dust, rain, fingerprints, etc, off the lens as well as reducing their effect if they do get on it! It also helps to protect the lens against knocks and 'dings', so the case for a hood is

*Overleaf*

**28  Jantar Mantar, Delhi, India** The Jantar Mantar in Delhi is one of a series of observatories built by Maharajah Jai Singh. In order to capture its extraordinary abstract qualities, I used a 21mm to shoot through one of the windows in the circular surrounding walls, taking great care to hold the camera as level as possible in order to avoid the kind of crazily converging vertical perspective which is all too easily obtained with lenses of 28mm or wider (*RWH: Leica M: 21/2.8 Elmarit: KR*)

**29  Garden, Seville** As with the picture of the Jantar Mantar, the camera had to be held level to avoid converging verticals in this picture of a garden in Seville. Even so, the fountain in the foreground is 'pulled' into an ellipse rather than being represented as a true circle. Such distortion near the edges of the field is inevitable when using any ultrawide lenses (*TH: Nikon: 20/3.5 Nikkor: KR*)

41

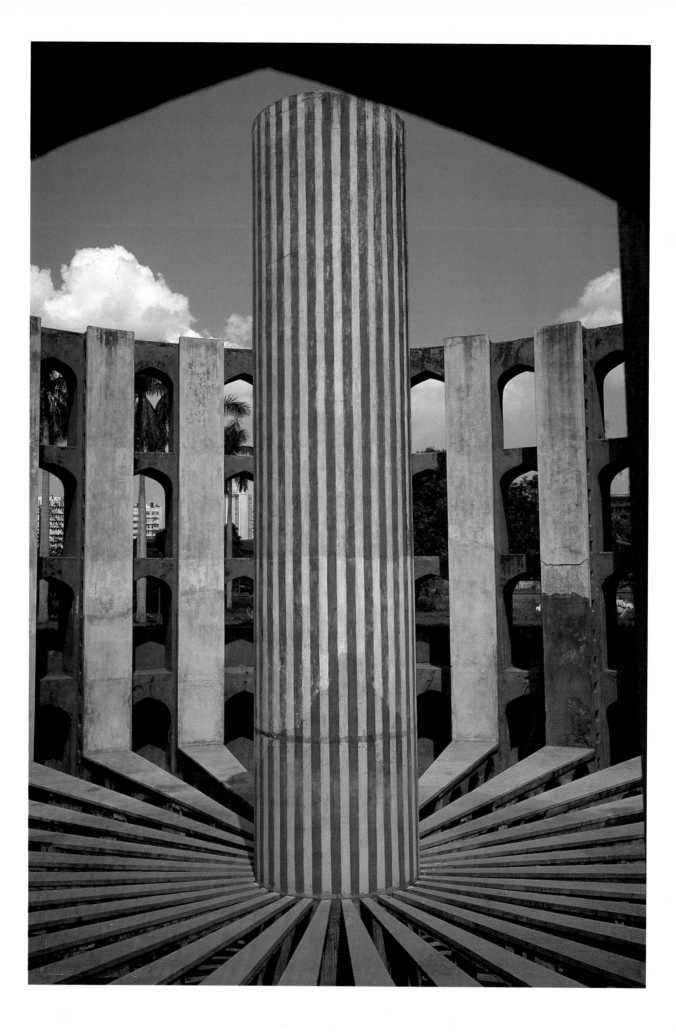

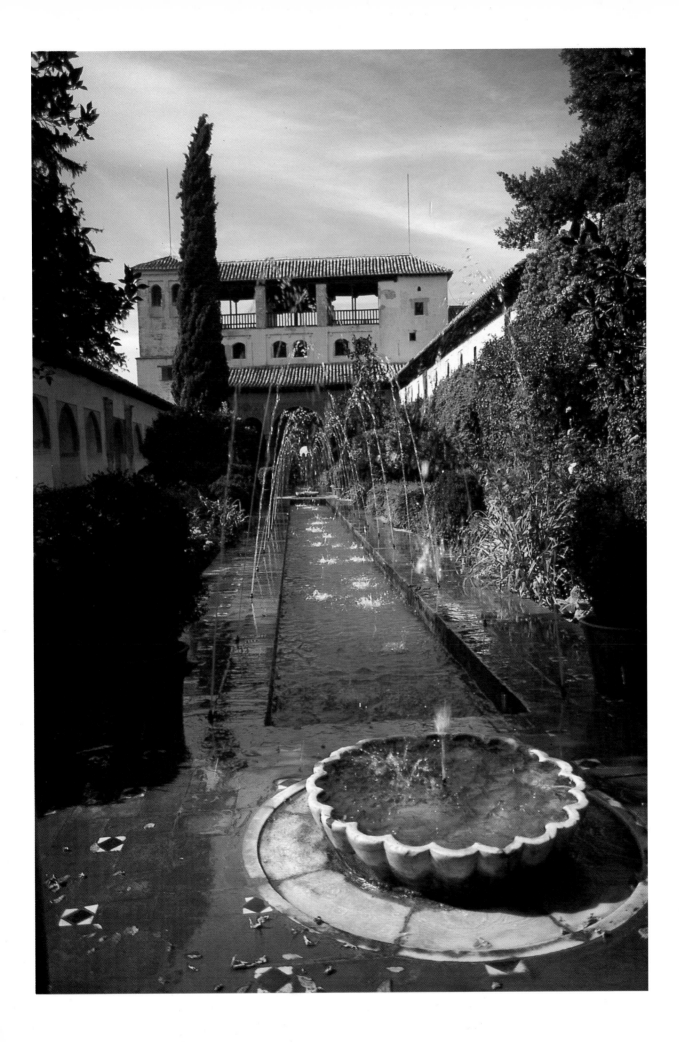

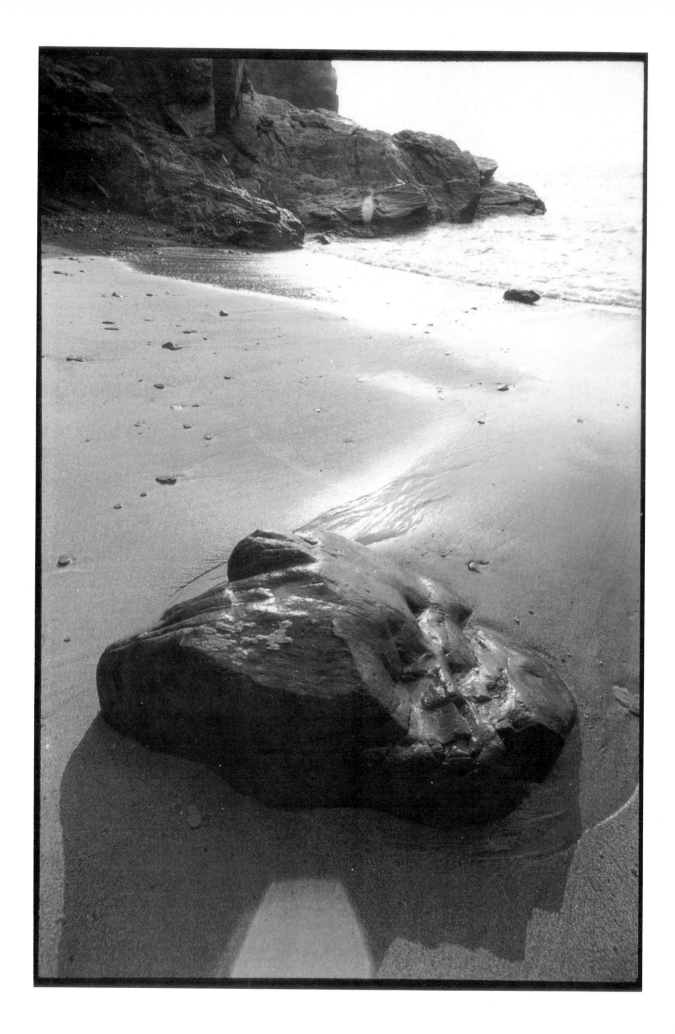

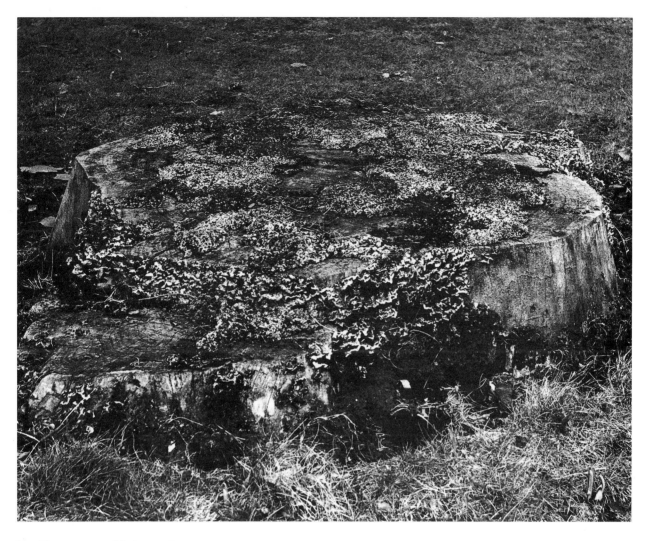

31 **Tree-stump with fungus** By contrast with the picture of the rock on a Dorset beach, almost all the fine detail in this picture is 'false' texture. The jumble of detail deceives the eye into reading film grain as textural detail; the picture is, by modern standards, quite soft (*RWH: Eastville Park, Bristol: Retina Ia: 50/2.8 Schneider Xenar: HP4/ID-11/EI 500*)

30 **Rock on beach** Apart from being an excellent example of chiaroscuro (see page 120), this is also a wonderful example of how 'real' texture (texture actually recorded on film) and 'false' texture (the grain of the film being perceived by our brains as the texture of sand and rock) can work together (*TH: Dorset coast: Nikon: 35/2 Nikkor: FP4/Perceptol/EI 80*)

*Overleaf*

32 **Desert, Utah** The strange, crenellated shapes of the Utah desert are fascinating, but they do not make a picture on their own. By including the single long-stemmed flower-like xerophyte in the foreground, the photograph is given depth. Using an ultrawide lens makes it easier to concentrate attention on the foreground, but can also diminish the impact of the background (*RWH: Leica M:21/2.8 Elmarit: PKR*)

33, 34 **Peter Tavy Inn** Effects filters, as noted elsewhere, should be used with restraint – and it is always a good idea to shoot the picture both with and without the effects filter. Here, the very subtle starburst and halation effect which occurred without any filter is arguably more attractive than the dramatic starburst introduced by the use of a cross-screen. Halation and effects of this type are typical of ultra-fast lenses; this was shot with a 50mm f/1.2 Nikkor (*RWH: Peter Tavy Inn, near Tavistock: tripod-mounted Nikon: KR*)

45

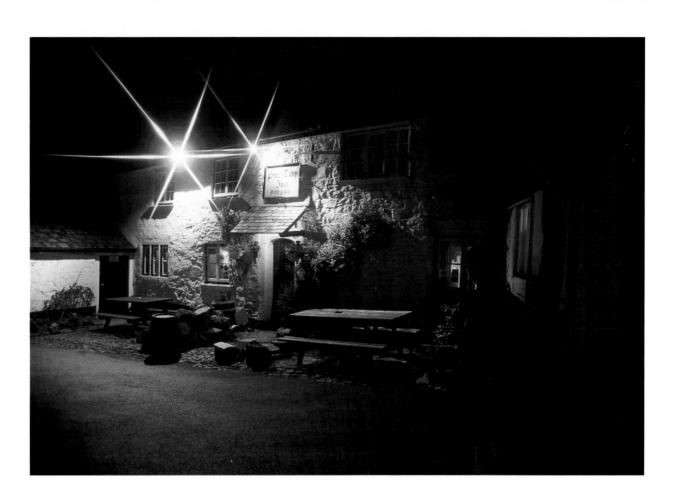

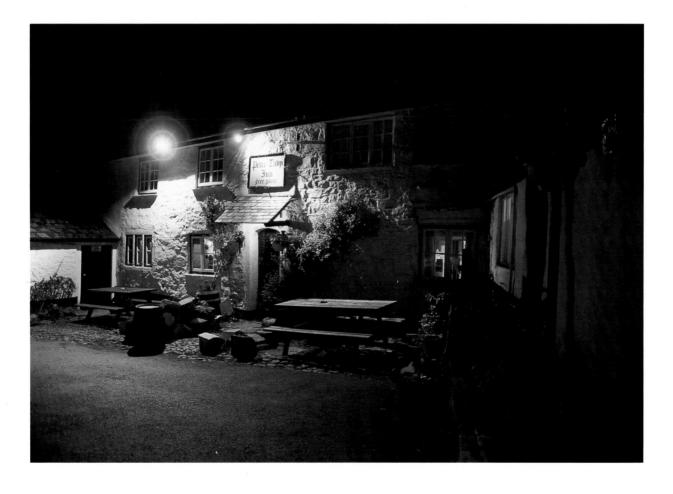

pretty nearly unanswerable. As an aside, Pentax did *not* invent multi-coating, despite their song and dance about it: Leitz used it as early as 1959.

Tripods are altogether more contentious. Certainly, there are many professionals who do not use them, because they can detract from the spontaneity of a shot, but there are many others who do – and, of course, unless you have a tripod, you do not have the option of using one! For many kinds of landscapes, especially those where you have to play a waiting game, tripods are excellent because they allow you to choose the very best camera position and then adjust it minutely, leaving the camera set until it is time to take the picture. Tripods also allow you to compose right to the edges of the view-finder, not least because your arms do not get tired, and they hold the camera in *exactly* the same place without wobbling. With longer lenses, tripods are virtually essential if you are to avoid camera shake: depending on how hard you have had to struggle in order to reach your viewpoint, you may be hard put to hold a 35mm lens steady, let alone a 135mm or a 300mm. Wherever a tripod was used to take pictures in this book, I have noted the fact in the caption; the figure, I found out when I counted the final score, was less than 10 per cent, but I suspect that there were many occasions where I did *not* get a picture because I did not have a tripod, and many others where the photograph would have been better if I had used one. Once again, this is all a part of the 'you can't take 35mm seriously' syndrome, to which I subscribed for so long. Now, I use the 35mm-plus-tripod combination a lot more.

If you use a tripod, though, get a decent one. Most amateur tripods are not worth the paper they are printed on: flimsy and wobbly when

35 **Wall** Resolution and contrast are not necessarily the same thing. This was shot with an old uncoated 5cm f/1.5 Xenon on a Leica IIIf. The resolution is quite good, but this is mostly because of the subject (an obliquely lit Victorian wall) and the fact that the film was overdeveloped and then printed on grade 5 paper. Normally, the resolution is masked by flare, which can be truly horrific in fast, old lenses. Once again, this is a good example of creating roundness by the use of light and shade, the basic meaning of 'chiaroscuro' *(RWH: Bristol: FP4/ID-11/EI 200)*

new, they do not improve with keeping. The very best amateur tripods on the market at the moment are probably Groschupp, and even then I would be inclined to use a really solid professional ball-and-socket head like the Kennett. Surprisingly, these heads cost less than four 36 exposure process-paid Kodachromes, which is hardly an extravagance. My wife and I have one each, and they have survived being banged around the world for several years without the slightest impairment of quality. I prefer ball-and-socket heads because they are smaller and lighter than any pan-and-tilt head, and more rigid than any but the most massive, but you *must* have a really solid ball with a diameter of at least 1in (25mm): most smaller heads, with the possible exception of the ruinously expensive Leitz version, simply wear out. I know: I have worn out two, both by respected German manufacturers (not Linhof or Leitz!)

Although the Groschupp is a superb tripod, and one which I would recommend wholeheartedly, for *really* solid and durable tripods you need to buy a professional model. My own favourite is the Kennett Benbo, which takes some mastering – it does not work in quite the same way as any other tripod – but which is supremely versatile (if rather heavy) and virtually indestructible. Sealed legs allow it to be used in up to 18in of water or mud; leg length adjustment is quick and positive; and the unique 'bent-bolt' action (from which 'Benbo' comes) allows it to cope with any surface, no matter how uneven, with the legs splayed independently at any angle. For an altogether lighter (though less versatile) tripod, the French-built Gitzo is very good: I also own one of these, and it is my main touring tripod for carrying on the motorcycle. The only trouble with Gitzos is that the legs dent if you drop them far enough, and this can make them hard to collapse, but you can field-strip a Gitzo and replace any part of it (even down to the fibre collars in the leg locks) independently of the others: Gitzo's motto is 'Conçu à durer, pas à jeter' – designed to last, not to throw away. I dropped mine in a mountain stream at 6,000ft once, and although I dented the leg, I was able to clean out the sand and silt in my hotel room in half an hour.

As an aside on tripod prices, the Benbo is amazingly reasonably priced in the UK, but if you buy it anywhere else in the world, it can cost you up to twice as much. The same is true of Gitzos: they are far cheaper in France than elsewhere. If you want to buy a first-class tripod, and you are travelling, it is worth remembering this.

So far, I have not mentioned miniature table-top tripods. Although these things may *look* fairly useless, it is surprising how often you can use them to steady a camera, especially in conjunction with a good ball-and-socket head. Not only will they be allowed into places where tripods are theoretically banned – the 'aerial' shot of New York City (Plate 160) was taken from the top of the World Trade Center with the help of a Leitz table-top tripod – but they can also be used in unconventional ways, such as pressed sideways against walls, or against glass windows. The Leitz 'pod is one of the best, being tremendously rigid, and it is not even particularly expensive on its own; but it does fold into an awkward-shaped package, and the Leitz ball-and-socket head costs as much as a complete Groschupp tripod.

Whatever tripod you use, it is also worth getting a cable release. There are occasions when the damping effect of wrapping your hands around the camera is valuable, but more often you will do

*Overleaf*

**36  Tree and sky, Bombay Hook, Delaware** It was actually very slight camera shake that destroyed the definition of this picture, taken in Delaware's Bombay Hook Nature Reserve, but the effect is still attractive and restful. The question is, would the picture have been better if it had been taken with a tripod? (FES: Nikon: 90/2.5 Vivitar Series One: PKR)

**37  Lake Tahoe, California** Framing a fragment of Lake Tahoe between trees and a mountain gave a better impression of its blueness than a more open shot of the water itself; it also reflects the suddenness with which you come upon the lake, almost by surprise (RWH: Leica M: 35/1.4 Summilux: PKR)

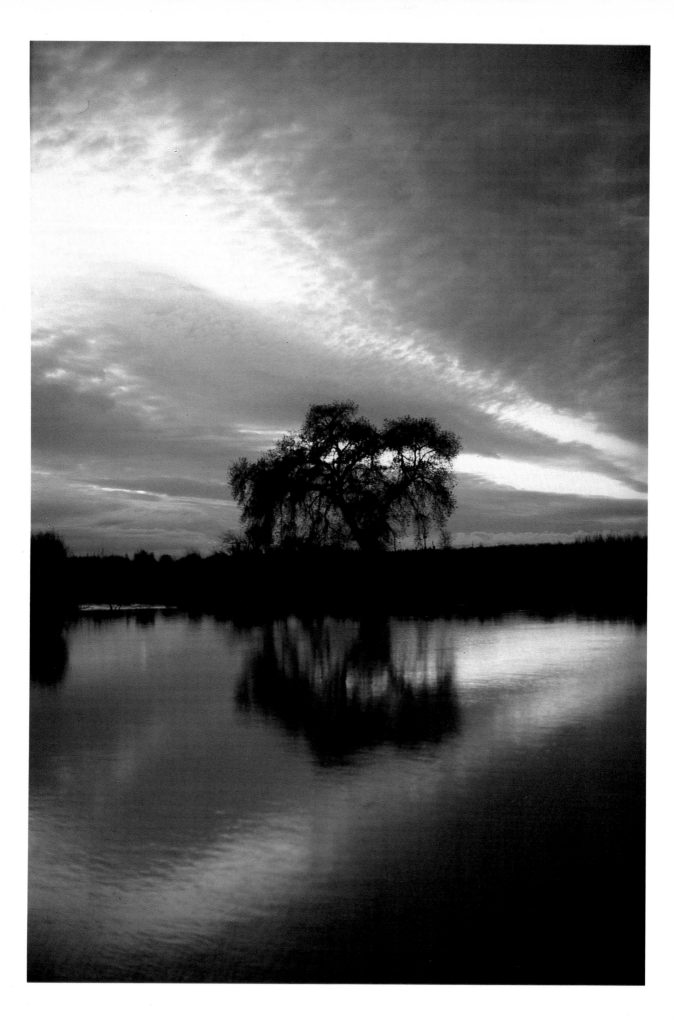

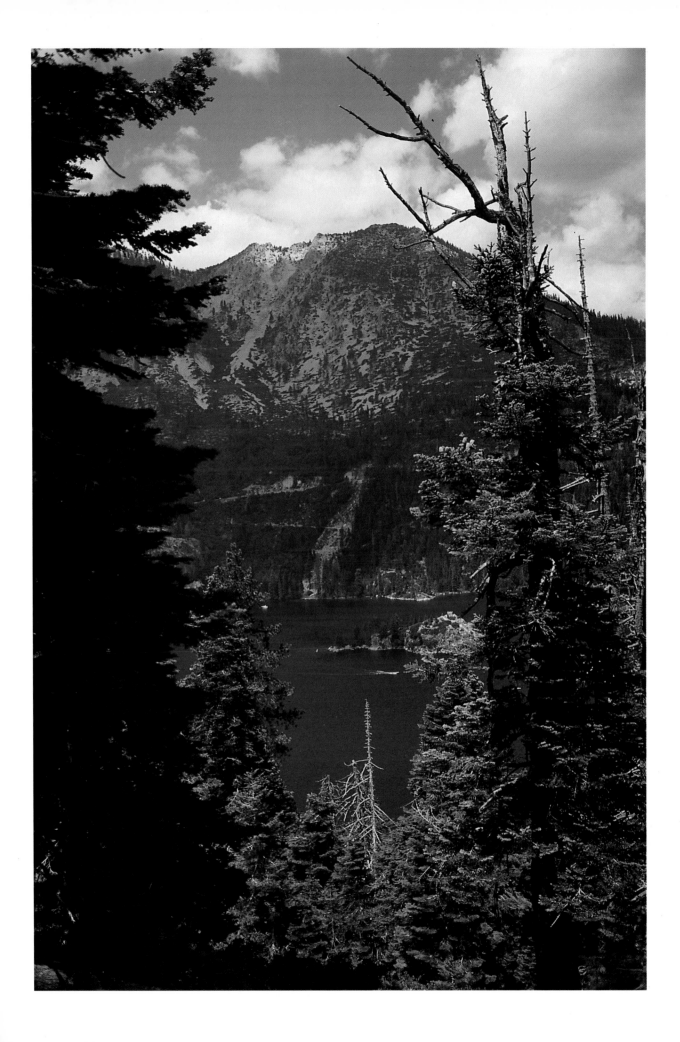

better to use a cable release for a vibration-free firing. An interesting piece of research shows that for many reflex cameras, the really long exposures (1/8sec and longer) exhibit *less* evidence of camera shake than those in the 1/30–1/125sec range, because the mirror-induced vibration has time to die away at the longer speeds, whereas at (say) 1/60sec it is present at its full ferocity. To increase the stability (and hence decrease the vibration) of a tripod, hang a heavy weight underneath: your gadget bag is better than nothing, but some landscape photographers go so far as to carry a string shopping bag to fill with rocks and hang under their tripods. Also, if you are using a physically long or large lens with its own tripod socket, use that rather than the camera's for maximum stability.

Although I have owned or borrowed numerous other types of camera support, including monopods, ground-spikes, spikes to be hammered into trees, clamp-on supports which mar furniture terribly, a wonderful (but useless) device with a strap that you were supposed to clamp around trees and gateposts and tighten with an ingenious ratchet mechanism, and rifle stocks, the only one that I have ever found really useful is a bean bag. Rested on a wall or table, a bean bag (which can literally be a cotton bag filled with beans) allows the camera to be rested more stably and with less risk of scratching than if you tried to rest it on the wall alone. Alternatively, use a pair of thick gloves, a scarf, or any other suitable item of clothing as a pad.

I said that most professionals would list the tripod and the lens shade as the basic accessories, but many would add one, two, or three filters. The first filter would be a protective UV; the second a polariser; and the third a grey graduated. Each has its advocates and its enemies, so it is worth looking at each in turn.

The protective filter saves the front glass of your expensive lens from getting dirty, scratched, etc. On the other hand, unless *it* is sparkling clean, it can also degrade optical quality, perhaps detectably: one of the Leitz representatives at Photokina told me off, gently but firmly, when he saw a filter on my 35mm f/1.4 Summilux. My own compromise is to use UV protective filters for reportage lenses, and other lenses that are in use all the time, especially in hostile conditions, but to leave them off (or remove them from) lenses used for landscape photography. In any case, I only ever use the finest quality filters: Hoya's HMC for preference (I don't believe that anyone makes *better* filters) but B+W or Leitz if I can't get the size I want in Hoya. I also buy Nikon filters second-hand if I find unscratched ones.

This point about 'sparkling clean' is one which deserves some amplification. Probably, more lenses are wrecked by over-enthusiastic cleaning than by any other cause. You should never clean a lens more often than you have to, because that is inviting scratching: your main defence should be to keep the lens clean, which means using a lens cap and a lens shade. If you do have to clean it, you should not touch it: blow the dust off with an ear syringe, which is bigger, cheaper and more powerful than a blower brush and more reliable than 'tinned wind'. If this is not sufficient, and you have to touch it, use the least abrasive medium possible, which for me means Kodak lens-cleaning tissues carried in a self-sealing plastic bag when not in use, though I will use anyone else's lens-cleaning tissues if I cannot

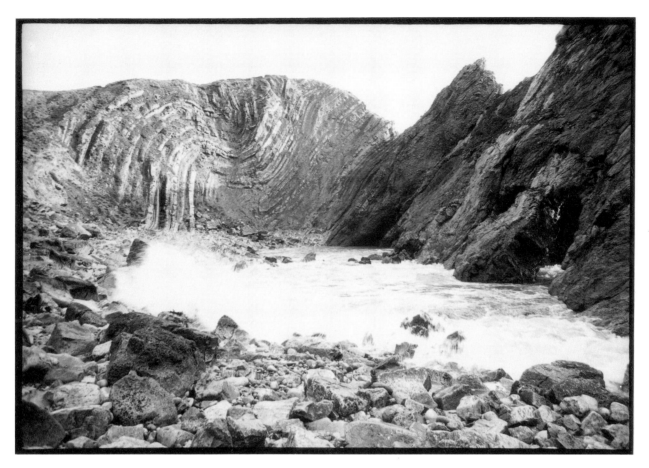

get Kodak's, *provided they are not silicone impregnated*, which is inviting disaster. For fingerprints, either lens-cleaning fluid (used *sparingly*) or Prophot's 'baby-wipes' are excellent.

The polarising filter is wonderful for increasing colour saturation, especially in blue skies, as well as for its advertised use in killing reflections. In fact, the two are closely related: colour saturation is often degraded because of imperceptible white-light scatter from coloured surfaces, which is why a polariser deepens colours so dramatically. Remember, though, that it can turn blue water to green (because it is the reflection of the sky which gives the blue appearance) and that its effect on meter readings – especially reflected-light meter readings – is unpredictable and can vary from about one stop to over two stops, depending on the light and the brand of filter. Unfortunately for me, polarising filters for rangefinder cameras are wildly inconvenient and very expensive, so I only use them on reflexes.

The grey graduated filter is the one about which I feel most doubt. On the one hand, grey graduated filters do wonders for looming, storm skies. On the other, most of them are of optically dubious plastic, and do nothing for image quality, as well as laying themselves open to over-use. I don't use them, but many photographers whom I respect and whose work I admire do use them: it's a matter of personal choice.

**38 Cove, Dorset coast** One problem with wide-angle lenses is that they seldom provide the same resolution as standard or long-focus lenses, especially at large apertures. The few that are any good are very expensive, and even then they should not be used wide open if you can avoid it (*TH: Nikon: 35/2 Nikkor: FP4/Perceptol/EI 80*)

| Filter name | Colour | Effect |
|---|---|---|
| 80-series | Blue | Conversion filters, allowing daylight-type film to be used in tungsten light. Use 80B for daylight film under photoflood lighting. |
| 81-series | Pale gold | 'Warming' filters to give a sunny effect with colour films. 81 is the weakest: 81A, 81B, 81C, 81EF increase in strength. |
| 82-series | Pale blue | 'Cooling' filters to counteract excessive warmth in colour films. Much less useful than 81-series. As with 81-series, suffixes indicate increasing strength. |
| 85-series | Amber/brown | Conversion filters, allowing tungsten-type film to be used in daylight. Use plain 85 to convert 3,400°K tungsten films to daylight, 85B for 3,200°K films. |
| FL-D, FL-W | – | Conversion filters allowing daylight film (FL-D) or artificial light film (FL-W) to be used in tungsten light. Results are only barely satisfactory. |
| ND | Grey | 'ND' – neutral density – filters are used to cut down the light without changing its colour. See text. |
| CC filters | All colours | Used in professional photography to adjust or correct colour balance – see text. |
| Y2, G2 (see text) | Yellow | 'Sky filter' for black and white photography: darkens blue skies and makes clouds stand out more dramatically. |
| | Orange | As yellow, only more dramatic. |
| | Red | As orange, only more dramatic still: darkens blue skies to near-black. |
| | Green | Lightens foliage when using black and white film. Little used nowadays. |

**39  Wall and wheel** This kind of picture, where texture is everything, might seem better suited to large format – and indeed, it might have been even more successful shot on a 5 × 4in camera. But the strong, graphic shapes 'carry' the lack of ultimate sharpness, and it is only when you look at the picture closely that you realise the wheel is not particularly sharp at all (*TH: Nikon: 35/2.8 Nikkor: PKR*)

Other filters can be divided into two types, 'correction' and 'effects', though the line is sometimes hard to draw: a lot depends on whether you are using colour or black and white. The table summarises the more useful filters. The 80-series and 85-series will be familiar to most photographers, though the 81-series is far more common in professional than amateur use; 82-series filters are little used because it is a matter of common experience that a 'warm' (golden) scene is almost invariably more attractive than a 'cool' (bluish) one. Indeed, there is a saying that colour balance is totally unimportant – so long as it's warm.

54

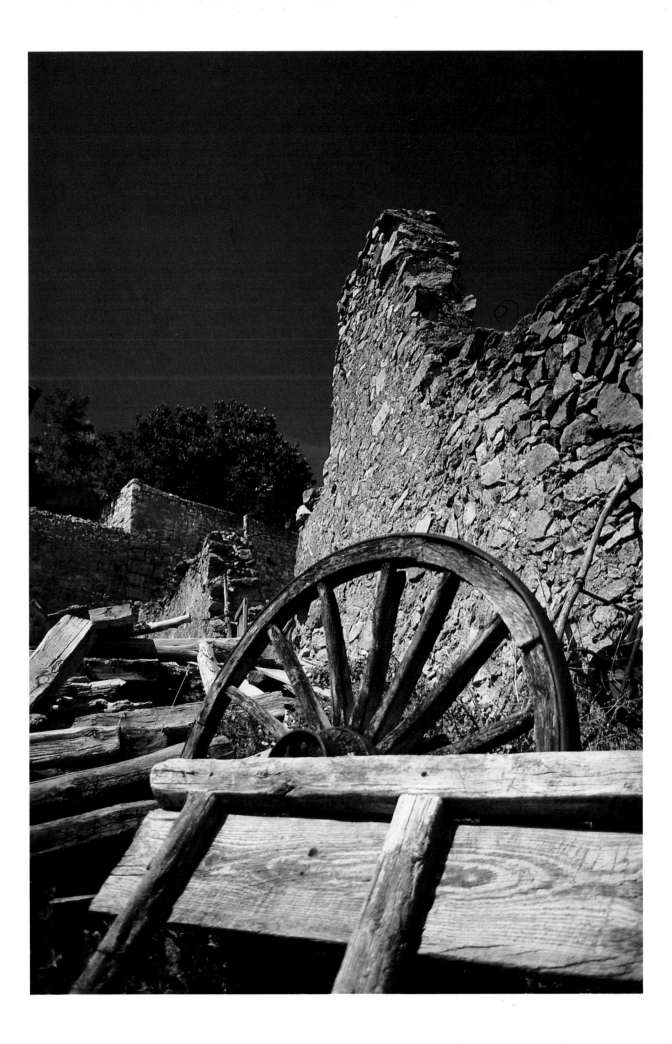

Neutral Density (ND) filters are used when you need to use a wider aperture (for selective focus) or a longer shutter speed (for creative use of blur) than would otherwise be possible. They can also be used if you have an unnecessarily fast film in your camera on a sunny day, but this is not a good idea unless you actually *want* the kind of grain and softness that fast films give: it is a better idea to change films. Focusing will be difficult, too. They are available in varying strengths: an ND × 4 requires a 4× (2 stop) increase in exposure, and an ND × 8 requires an 8× (3 stop) increase.

Colour correction (CC) filters are almost unheard of outside professional practice, but they can be extremely useful if you want to get *precisely* the colour you have in mind. They are available in the three additive primaries (red, green and blue) and the three subtractive primaries (yellow, magenta, cyan), and in strengths designated by number: the weakest normally encountered is 05, which is very pale indeed, and the strongest is normally 50, which is very strong. Thus a CC05Y is a very weak yellow, while a CC50M is a very strong magenta. They can be used additively: thus, you can create a middling green by adding a CC05G and a CC10G to get a CC15G. Normally, they are only available as gelatine filters or 'gels' (see page 137), though a few are available in glass or as gels sandwiched between glass. In landscape photography, you will normally only use weak filters (CC05) to correct colour balances, though you can use stronger filters for 'effects'.

Of the filters for black and white film, yellow, orange and red create the same effect to an increasing extent, darkening blue skies and making the clouds stand out more and more. My own preference is for orange, or a fairly strong yellow; weak yellows have hardly any effect, except with really deep blue skies, while red filters can look unnatural because they turn the sky almost black. There are no standard names for these filters, though yellow filters are sometimes marked Y2 (indicating the need for a 2× exposure increase) or G, for the German *gelb*, yellow. All but the very weakest filters require an increase in exposure, typically ranging from half a stop for weak yellows to as much as four stops for a strong red.

You may notice that there is no mention of 'trick' colour filters as first popularised by the ingenious M Coquin. This is partly because it is all too easy to use them as a substitute for vision and originality – a boring picture remains a boring picture, regardless of what filter you use – and partly because most of them are made of 'organic glass' or (as we say in English) plastic. They will do nothing for the resolution of your lens, and because 35mm is already on the very edge as far as quality goes, you can do without anything which reduces image quality.

Admittedly, there are a *very* few pictures which may be improved by the use of these filters – mainly, pictures with flat white skies. The best examples of their use, without doubt, are in Cokin's own excellent brochure/catalogue.

After filters, the only other accessory which is more or less indispensable is some means of carrying your camera. Like many professionals, I am a camera-bag freak, and my favourites (out of the dozen or more cases and carrying systems I have collected over the years) are Billingham soft bags, a Coast rucksack, a Hakuba waist-belt, and a 'photographer's jerkin'. Frances Schultz uses Billinghams too, while

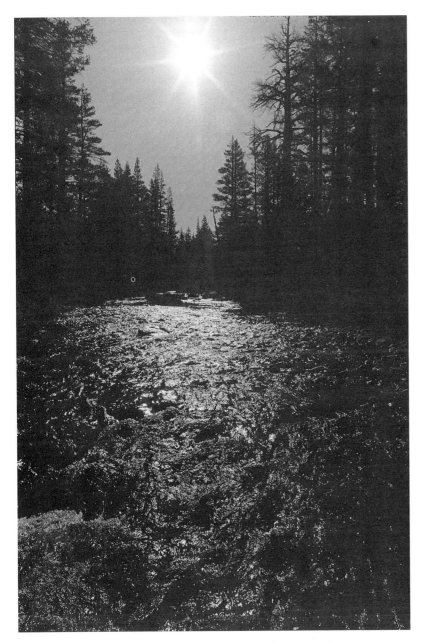

40   **River, Yosemite** There are a lot
of wide-angle shots in this book,
because that is the way I tend to 'see'.
Both Tim and I regard 35mm as the
'standard' focal length, and I use a 21mm
f/2.8 a great deal; Tim uses a 20/3.5
rather less frequently. I shot this sitting
astride a fallen log over a fast-flowing
river, stopping down to f/16 to concen-
trate on the pattern of light on the
water. The 'starburst' is the result of
the small aperture, not of an effects
filter (*RWH: Yosemite National Park:
Leica M: 21/2.8 Elmarit: HP5/Perceptol/
EI 320*)

Tim Hawkins uses Lowe-Pro; we all agreed that although these and
other top-class bags are expensive, to try to save money on camera
bags is a false economy of the worst kind. Your camera outfit is
worth a small fortune, and it is well worth protecting: as Tim put it,
'Sure, you can buy bags that look like Billinghams or Lowe-Pros, and
cost a quarter as much – but the first time it rains, you find out *why*
the professional bags cost more.' It is not just rain, either: shock
protection costs money, and so do strong straps, reliable stitching,
and solid zips or locks.

Billinghams have the big advantage that they do not look like
camera bags, at least to the uninitiated, and they are superbly made. I
prefer the waterproofed canvas versions to the Cordura ones, both
for feel (heavy Cordura may wear like sharkskin, but it also feels like
it to me) and for appearance; thieves are used to Cordura camera
bags, but not to canvas. My wife and I own three Billinghams in
different sizes, and the medium version carries all the lenses I need for
my Leicas as well as a spare body, a meter, and plenty of film.

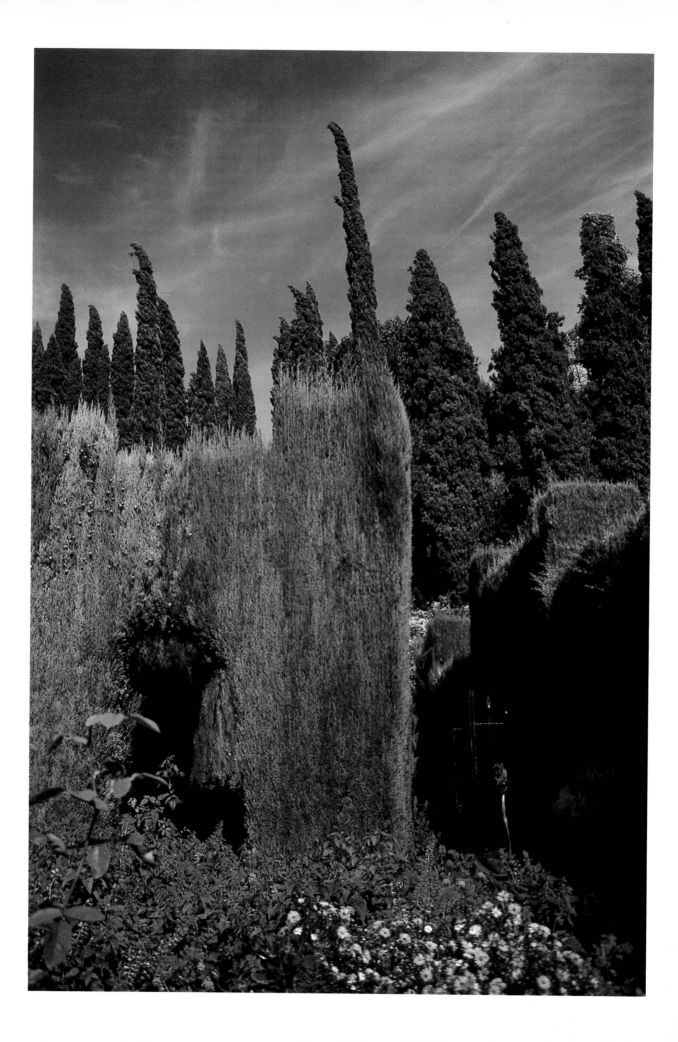

Billinghams are eminently affordable in the UK, and about three times the price in the US.

The rucksack, by Coast, is a fairly cheap padded rucksack divided into two sections: it has more room than I need, and is infinitely more comfortable than any shoulder-type bag on a long walk, but it is not particularly convenient to open and close – in fact, it is next to impossible on the move. Also, I don't use it in heavy rain.

The Hakuba waist-belt is no more than three padded compartments on a broad belt. It will carry three lenses and a few spare rolls of film, but not much else. Its big advantage is that it is extremely secure and small and easy to carry, though you have a choice of looking either pregnant or like Quasimodo when you wear it; sometimes I wear mine bandolier-fashion (in fact, come to think of it, I also have an ex-government bandolier). I used to have a much bigger waist-belt, by Camera Care Systems of Clevedon, and excellent it was too, but it was stolen in India.

The jerkin carries a tremendous amount and distributes the load very evenly, but unfortunately the model I have has to be zipped up or it is most uncomfortable. The rear pocket, for film, is really only any use for putting exposed rolls in when you are in a hurry: get back into the car, and you are punched in the kidneys by anything in it.

In addition to all these, I also use Zero Halliburton hard cases for carting equipment about when I am not using it; the classic professional approach is to use Halliburton, Rox, or Adapt-All hard cases for transport, and soft bags (or belts or jerkins . . .) when out actually working. For travel in dusty or very wet climates, consider taping over the joints in your hard case; whether you call it gaffer tape, duct tape, or belly tape, the tough, flexible silvery tape that rock musicians and photographers use by the mile is invaluable stuff.

On the subject of 'non-photographic' accessories, I also like to carry a few paper-clips (an excellent source of wire), a set of small screwdrivers for tightening any screws that come loose (Kaiser make an excellent one with interchangeable bits, which fit inside the handle), and a Wenger or Victorinox Swiss Army knife. These knives are among the most useful tools in the world, and a tremendous bargain despite the apparently stiff price: my original Wenger was getting a bit sloppy after fifteen years, so I replaced it, but the girl who begged the old one is still using it another half-decade on. I use Wenger, which is more readily available in the US, and my wife uses Victorinox, which is more common in the UK: both are excellent. The place to buy these is in Germany, where they are about half the UK price, and even cheaper than in their native land.

Other accessories? Sometimes I find that a waist-level viewfinder makes it easier to consider the subject in isolation, and encourages me to compose more carefully, so I occasionally use one of those on my Nikon Fs. Motor drives are something of a luxury, but can be convenient if you are using the camera on a tripod and want a vibration-free release and no risk of shifting the camera during wind-on, as well as for their obvious purpose of rapid shooting. A spirit-level – Linhof make a wonderful one – is something I often use with rollfilm cameras, but not often enough with 35mm: it really does make the camera much easier to level on a tripod. Otherwise, there is nothing which is really all that useful, though you would not think so to look at the accessory manufacturers' catalogues.

41 **Formal garden** As with the picture of the wall and the wheel, our brains supply much more detail and texture in this shot than is actually there, though this is by no means an unsharp picture. The very oblique light on the hedges and flowers, and the 'spotlighting' of the gate and the long-stemmed flower on the right both contribute to the impression of sharpness. Even in reproduction, though, it should be clear that this picture is not as sharp as some of the Leica shots, an inevitable penalty of using an early 43–86mm Nikkor zoom – late models are much better (*TH: Nikon: PKR*)

# 3
# FILM, METERING AND PROCESSING

All the cameras, lenses, and accessories in the world are substantially useless without film. But film cannot be considered in isolation: we must also look at metering and processing. To begin with, though, we can lay down a few generalisations about film, in the same way that we did for camera systems.

## Film

No matter what the brand, no matter what the speed, the most important thing of all is to use good, fresh, well-stored films: out-of-date stock, or film which has been badly stored, is extremely unlikely to give you the kind of quality that fresh film can. A film which will not produce the results you want is no bargain at all, no matter how cheap it is: I know, because for years I tried to use ex-government stocks, 'slightly outdated' film, and all kinds of junk. Now, I use fresh, well-stored material, and the improvement in quality is tremendous. 'Well-stored' means bought from a shop that I trust (preferably one with a high turnover, so that I know the film is fresh, quite apart from the expiry date), and then kept in its original sealed container in a refrigerator at home: there is no need to freeze film, and indeed some evidence suggests that it may be injurious to do so. Let refrigerated film warm up for two to three hours at room temperature before opening, or you may get condensation on the film surface – though this has never happened to me, and I have often clipped it a lot closer than this.

Assuming that the film is fresh, the other essential is to find a film that you like, and stick with it. In all probability, you will not want to restrict yourself to a single film, and you may use as many as four or five different kinds regularly, but the point about getting to know the films you use is a very important one. Unless you fine-tune your processing, you will never get the ultimate of which your film is capable, and unless you stick with one film (and one developer, for black and white, or one lab for colour) you are never going to be able to do that fine-tuning. The question is, which film do you choose?

It depends, of course, on personal taste. In black and white, where I have no great objection to grain, I will cheerfully use ISO 125 (Ilford FP4) and ISO 400 (Ilford HP5), but I normally *downrate* them by using Perceptol developer, which gives me an exposure index (EI) of 80 for FP4 and 250 for HP5. This apparently perverse habit gives me a smoothness of gradation and range of tones which I have never been able to match with slower films such as Ilford's Pan F and Kodak's Panatomic-X. If you want ultimate sharpness, then use either of those, or Kodak's Technical Pan with its own special

**42 Interior, ruined church** To call this a landscape is admittedly to stretch the definition somewhat; but it illustrates very well the sheer tonal range which can be recorded with good, fresh film when it is properly exposed and developed. All the tones of the Zone System (see page 72) are clearly recorded; the only real criticism is the minimal halation around the broken windows and the holes in the roof (*RWH: Nikon F: 55/3.5 Micro Nikkor: FP4/Perceptol/EI 80*)

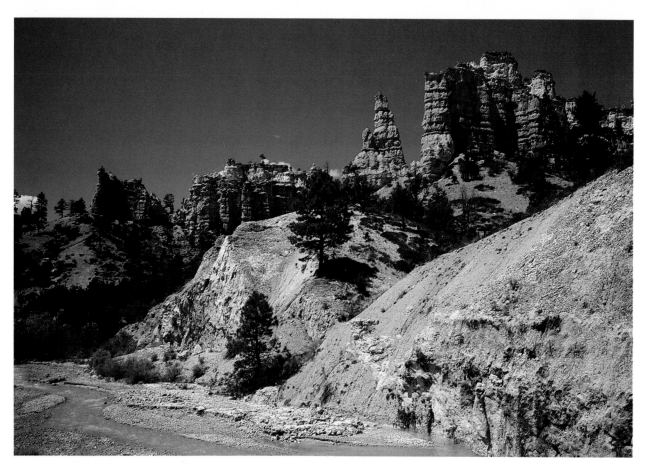

**43  Desert, Utah** Kodachrome is the perfect film if you want bright, saturated colours in sunny weather. In the desert (this is in Utah, near the Colorado border), slight underexposure brings deep, intense colours (*RWH: Leica M: 35/1.4 Summilux: PKR*)

**44  Docks, London** Nowadays, there is much less colour difference between Kodachrome and E6 films like this Kodak ISO 100 professional, but each still has its own 'colour signature'. Frances Schultz and I both prefer Kodachrome; Tim Hawkins uses both Ektachrome and Kodachrome; and all three of us prefer to stick with the films that we know, rather than experimenting (*TH: London, on the Thames: Nikon: 24/2.8 Nikkor: EN*)

developer, but do not expect the exposure latitude of the faster films. I find that the exposure latitude of ultra-fine-grain films is literally half a stop either way for ultimate quality, and I *still* don't get that wonderful gradation. I shall return to processing later.

It is also worth considering Agfa's much-underrated black and white transparency film, Dia-Direct. With its beautiful tonal range and gradation, it produces unique results at a very modest price, though unless you actually like black and white slide shows (or a few black and white slides among colour, which can be enormously effective) its main advantage is for reproduction. Several of the landscapes in this book were shot on Dia-Direct, but that is really the only way that I am ever likely to see them in print form.

In colour, I am usually less willing to accept grain. For maximum sharpness the choice is very limited – basically, to Kodachrome 25, Fuji ISO 50, and Kodachrome 64.

Kodachrome 25 is unquestionably the leader in sharpness, and for the ultimate in quality it is impossible to beat – provided you can get it properly processed. Unfortunately, Kodak processing (the only possibility readily available outside the United States) is inclined to be variable. 'Professional' material does get more careful handling, it is said, but the variations in colour are still greater than would be acceptable with an E6 film. For landscapes, this very seldom matters, but it can be a nuisance for some studio work. Kodachrome also has the disadvantage that unless you live near a Kodachrome lab, you have to send your film through the mails (with all the risks that entails) and that unless you use the professional material (when turnaround is supposed to be three days), you can wait for up to three weeks to get it back, at least at summer peak periods.

**46 Tree in snow** A full tonal range is not always the ideal. The harsh contrast of this picture conveys the bleakness of a cemetery in winter in a way that a softer, more conventionally graded picture could not do. The negative was conventionally exposed and processed, but grade 5 Ilfobrom paper made the transformation (*Cath Milne: Greenbank Cemetery, Bristol: Nikon F: 21/4 Nikkor: FP4/Microphen/EI 200*)

**45 Railway station** The rather unconventional framing here is because Tim wanted to concentrate attention on the station architecture rather than the train. The extremely low flare levels are the result of two things: the quality of the 35/2 Nikkor which Tim had on his Nikon, and the very thin emulsion of the Dia-Direct film he used. Thicker (which usually means faster) films are more prone to halation, as light is diffused actually inside the emulsion layer, as seen in the picture of the church interior (*TH: London*)

Fuji's ISO 50 material is sharper than Kodachrome 64, but not as sharp as Kodachrome 25. It does, however, have the advantage that it can be processed by your friendly neighbourhood E6 lab in two *hours*. It is slightly more expensive than Kodachrome, and it responds worse to bad storage (particularly overheating), but it is a superb film and well worth considering.

Finally, Kodachrome 64 is the professional's standby, because it is fast enough to be usable in most conditions, resists abuse very well, and is only fractionally less sharp than Fuji ISO 50: it used to be second only to Kodachrome 25.

At this point, it is worth explaining the difference between 'professional' and 'amateur' films. Basically, film speeds are subject to batch-to-batch variations of up to 1/3 stop, which means that ISO 64 film can vary from ISO 50 to ISO 80, and colour balance changes as the film gets older. 'Professional' films are aged to a particular colour balance, and then chilled to prevent further change: if you find anyone selling 'professional' film other than from a refrigerator, they are certainly not a 'professional' store. In addition, 'professional' films are either packed with a leaflet giving the true film speed, or specially selected always to have the same speed, the rejected material being reclassified as 'amateur'. Some, but not all, 'professional' films are also designed to have a lower contrast than amateur material which is important in reproduction, but less 'punchy' when compared with an amateur's slide.

**47 Castellations and temples, Benares** Although this shows the typical 'flatness' of Kodachrome exposed under any conditions other than bright sun, it also captures the misty, massive yet ethereal presence of the palaces beside the Ganges in Benares at dawn. The use of a long lens (a 200mm f/3 Vivitar Series One, wide open) has accentuated the atmospheric haze *(FES: Nikon: KR)*

**48 Pacific Coast Highway, California** Once again, Kodachrome's super-saturated colours do justice to California's Pacific Coast Highway. I used a 21mm lens to fill the foreground with yellow flowers, which contrast dramatically with the blue of the sea and sky *(RWH: Leica M: 21/2.8 Elmarit: PKR)*

With E6 films, the advantages in buying 'professional' material are not all that great, unless you propose to store the film under refrigeration and process it within a few hours of exposure. For landscape photography, in particular, the variations in both speed and colour balance are unlikely to be significant unless you are taking several pictures of the same landscape and need absolute consistency, which you will get in any case if all your 'amateur' films come from the same batch (the batch number is printed on the box). On the other hand, Fuji's ISO 50 film is only available as a 'professional' material, so it is that or nothing. With Kodachromes, the story is rather different. Not only do you get superior consistency: you lose nothing in durability (because 'professional' Kodachrome is merely specially selected 'amateur' Kodachrome), you get faster processing, as already mentioned, and the film comes back in card mounts, which are easier to write on, easier to get the film out of for reproduction, and less slithery and liable to be dropped than the plastic ones used for non-professional Kodachrome.

All of this, of course, ignores the possibility that you may *want* grain. For black and white, your best bet is either a standard fast film (HP5 or Tri-X) rated at about twice its normal speed and developed in paper developer, while for colour, the fast 3M films are wonderful – I usually order them 'push 1/3', which brings the 640T material up to EI 800, and the ISO 1,000 material up to 1,300, without any loss of quality.

There are also perfectly good reasons for using other films. For instance, the garish poster-like colours and high saturation and contrast of Orwo colour film may not be to everyone's taste, but there are subjects they might suit – and Orwo's tendency to be half a

66

stop slower than its advertised speed is easily overcome by over-exposing by half a stop. Again, many people prefer Agfa's colours to Kodak's, and their ISO 50 material is certainly a good deal more neutral in overall balance than Fuji, which always looks as though the film has been exposed through a CC05Y filter.

So far, I have ignored colour print film. There is a good reason for this. No colour print film begins to compete with colour trans-parency film for sharpness, and as it costs almost as much to make a decent print from a colour negative as from a transparency, Cibachromes seem to me to make a lot more sense if you want prints (as most of us do). If you insist on using colour print film, it only makes sense if you use professional material and get it processed at a professional lab – which is going to cost you a lot *more* than using transparency film and only printing the pictures you really want. The quality of machine prints from amateur labs is so variable that they really are not worth using if you are looking for anything like decent print quality. Throughout the rest of this book, whenever I refer to colour film, I mean colour slide film unless otherwise specified.

Whatever film you use, though, you need to expose it correctly – which immediately begs the question of what constitutes 'correct' and 'incorrect' exposure. The answer is simple: a 'correct' exposure is one which achieves the effect that you want, and an 'incorrect' exposure is one that does not – always assuming, of course, that the film is capable of achieving the result that you want. If you want a lighter, airier looking transparency, you will need to 'overexpose': if you want a darker, moodier one, do not be afraid to 'underexpose'. Many photographers habitually rate their films at different speeds from those recommended by the manufacturer, because they prefer

**49, 50  Arch in rock** Horses for courses . . . In these two pictures, Tim Hawkins has used two completely different techniques of metering, exposure, and printing. The shot showing the arch against the sky was conventionally metered using a Weston Master, and printed on grade 2 paper for detail in the sky and sea. The shot through the arch was exposed using the camera's TTL meter (plus bracketing!) and printed on grade 5 for a graphic study of the sun on the waves (*TH: Nikon: 35/2 and 105/2.5 Nikkors: FP4/ Perceptol/EI 80*)

**51 Sun through leaves** Shooting straight into the sun is a severe test of any lens and film. Here, Tim Hawkins has overexposed the picture slightly in order to create a feeling of airiness and summer warmth; the additional flare which this creates adds to the mood. This is a good example of how an apparently unpromising subject can lead to a very attractive picture (*TH: Nikon: 35/2.8 Nikkor: EN*)

**52 Mount Wilson, California** Often, creative photography involves exploring the limits of your equipment and your materials. This was shot from Mount Wilson, in California; the intention was to create a mountainscape of receding planes, reminiscent of Oriental brush-painting. Both the tonal and chromatic ranges are incredibly limited, and different films would represent them in different ways. Furthermore, a lens with high internal contrast (see page 32) was essential in order not to lose the subtlety of the tones; most zooms, for example, would have resulted in a flat washout (*RWH: tripod-mounted Nikon: 90/2.5 Vivitar Series One: PKR*)

**53 Mount Wilson, California** Compositionally less satisfying than the pink mountainscape, this picture still has something of the Orient about it – plus a layer of brown Los Angeles smog! It is a hill-top protruding through a low cloud layer, again photographed from Mount Wilson, within an hour or so of Plate 52 (*RWH: tripod-mounted Nikon: 200/3 Vivitar Series One: PKR*)

the results they get that way. For 'underexposure', look at the palm trees in Plate 67; for 'overexposure', look at the misty landscape in Plate 113.

In order to 'overexpose' and 'underexpose' at will, you must however have some kind of base exposure. This brings us first to the question of metering, and then to the question of establishing personal exposure indices.

## Metering

To begin with, you have to set your meter, whether hand-held or built into the camera, to the manufacturer's film speed: it is all that you have to go on. Then take your exposure reading (a subject to which we shall return shortly), and make your exposure. With transparencies, the matter is now simple: if your pictures are consistently too light, *increase* the film speed that you set on your meter, and if they are too dark, *decrease* it. With black and white films, there is also processing to consider – a point which we shall examine later in the chapter.

If your exposures are not consistent – that is, if some are too light, while others are too dark – your metering technique is at fault. Although modern through-lens meters are very good, they are by no means infallible. Suppose, for example, that you are photographing a snow scene. Your in-camera exposure meter is based on the (surprisingly accurate) premise that the *average* scene reflects 18 per cent of the light which falls on it. Unfortunately, a snow scene is not 'average', and it will reflect a great deal more than 18 per cent of the light falling on it – perhaps as much as 90 per cent. Your meter will still give a reading which will give you an 18 per cent grey print or transparency, however, which is the reason why so many snow scenes come out looking disappointingly murky. If they are printed automatically, the printing machine will take another 'averaging' reading, so the colour is likely to go out of whack too.

The opposite example might be a dark, moody pine-wood. This time, the scene is reflecting *less* than the 'typical' 18 per cent, so

70

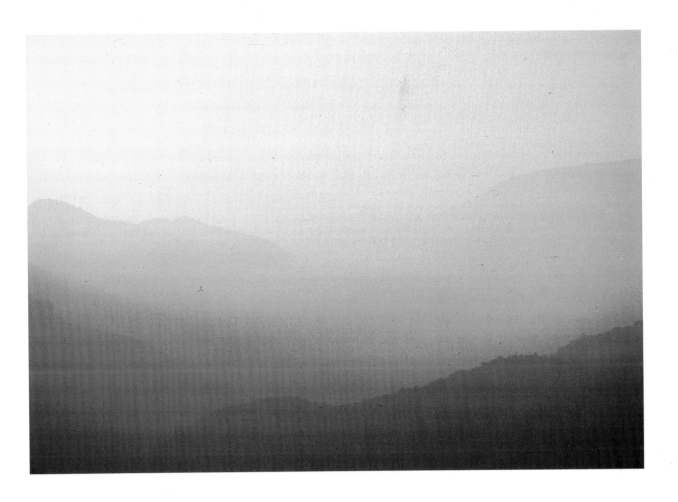

54 **Boat on Serpentine** Shooting straight into the sun, or into reflections of the sun from water, requires small apertures; and it is at small apertures that reflections from the blades of the lens diaphragm can introduce 'starburst' effects, without any effects screen whatsoever (*TH: the Serpentine, London: Nikon: 105/2.5 Nikkor: FP4/ID-11/ISO 125*)

following the meter results in a picture which is too light, typically with degraded, greenish blacks. The same would be true of a night scene, and (once again) automatic printing will only make things worse.

There are two ways around this, one complex and the other blindingly simple. The complex one was, however, devised by Ansel Adams, who was arguably the greatest landscape photographer of all time, and unquestionably one of the greatest technicians. It is the Zone System for black and white photography.

*The Zone System*
The Zone System assigns numerical values to each tone in the original picture, with one-stop differences in brightness, and these are normally reproduced as one-stop differences in density in the negative and on the print. The zone values *on the print* are given below: each tone is one stop brighter than the previous tone (ie, it reflects twice as much light), so taking Tone 1 as our starting point, we can say that Tone 2 is twice as bright, Tone 3 is four times as bright, Tone 4 is eight times, and so on up to Tone 9 which is 256 times as bright as Tone 1. The tones themselves are:

*Low tones: 1–3*
Tone 1   The maximum black of which the paper is capable.
Tone 2   The first tone distinguishable from pure black.
Tone 3   The darkest tone in which shadow detail and texture appear.

*Mid-tones: 4–6*
Tone 4   Dark mid-tones, one stop darker than Tone 5.
Tone 5   The mid-tone: 18 per cent grey by definition.
Tone 6   Light mid-tones, one stop lighter than Tone 5.

*High tones: 7–9*

Tone 7    The lightest tone in which highlight detail and texture are recorded.

Tone 8    The lightest tone distinguishable from pure white.

Tone 9    Pure, paper-base white.

There are other versions of the Zone System, some with more steps and some asymmetrical (ie starting at Tone 0 or ending at Tone 10), but the nine-tone scale is the easiest to handle because Tones 4 and 6, 3 and 7, 2 and 8, and 1 and 9 are obvious 'pairs'. It is also important to realise that there is plenty of gradation *within* these tones; certainly, 1/3 stop steps are readily discernible. Also, with the very best processing, it is possible to wring an extra step out of the photographic process, but for most people the nine-step range is all they can manage – and if it was good enough for Ansel Adams, it is good enough for me.

Nine steps represents a brightness range of 256 : 1, which is actually outside the recording ability of the paper which can only manage about 128 : 1 at the very best. In other words, the brightest highlight will only be 128× as bright as the darkest shadow on the paper, no matter how careful we are.

We can however ignore Tone 1 and Tone 9, because we have no control over them: anything which is lighter than Tone 8 will reproduce as Tone 9, and anything which is darker than Tone 2 will reproduce as Tone 1. This means that the maximum range of tones which we can meaningfully reproduce (while retaining the 1 : 1 ratio between subject tones and print tones) represents a brightness range of seven stops, 64 : 1. If our subject has a greater tonal range than this, we shall have to sacrifice either the darkest shadows or the brightest highlights – and many subjects *do* have a greater tonal range than this. Because the highlights, which are more than sixty-four times brighter than the shadows, occupy a very small part of most pictures, the general rule is to *expose for the shadows*, and let the highlights take care of themselves.

Armed with the Zone System, we can meter *selectively* from any area in the picture, and decide where we want the tones we are metering to reproduce. A whitewashed wall in which we wish to retain detail? No problem – Tone 7. Caucasian skin? Usually Tone 5½ (yes, Virginia, you can have half-tones), but can be as light as Tone 6 or as dark as Tone 5. We can also shift the tones: if we want the skin to reproduce a little darker, we just reassign it to Tone 5; if we want to lose the detail in the white wall, we reassign it to Tone 8.

The trouble is that trying to use the Zone System with a camera's built-in meter is not easy: with most 'weighted' meters, you never know exactly what you are metering anyway, and the mental gymnastics required to equate zone readings with ISO film speeds are considerable. An easy way around it, though, is to modify a hand-held meter with stick-on zone numbers, and no meter is easier to modify that way than a Weston Master (of any vintage). The main arrow becomes the Tone 5 index; then, either side of that, you stick additional indices for the other tones, at one-stop intervals. This sounds complicated, but a glance at the modified meter shows that it is not. With the meter shown (Plate 61), I can read from our white-washed stone wall, use the Tone 7 index, and get an *instant* correct reading. I can also check the other tones, to make sure that they also

*Overleaf*

**55 Dhauladur spur, Himalayas**
I have a great weakness for misty mountain shots, and what attracted me here was the gradual loss of definition and colour saturation as the valley widened and the intervening mist reduced everything to white. The very top of the picture was pure white, as may be seen, so I used the old device of overhanging foliage to establish the depth of the picture and to stop it 'petering out' at the top (*RWH: McLeod Ganj, Dharamsala, in the Himalayas: Leica M: 35/1.4 Summilux: KR*)

**56 Bandstand in snow** Snow is always a difficult subject to meter and to photograph, but here I deliberately chose a dark transparency; the grey sky imparted a grey tone to the snow, to give a leaden, oppressive feeling of cold. Neutral colour rendition is essential in a picture like this, and can only be obtained by using good, fresh film and having it processed by a reliable lab (*RWH: Castle Green, Bristol: Leica M: 50/2 Summicron: KR*)

**57 Sun reflected from water**
Metering reflections is another difficult exercise, and bracketing is the best approach. Although most people would probably only photograph reflections in bright sunlight, you can often get more interesting effects by shooting on a partly overcast day. In bright sun, the grass and reeds would have been reduced to a silhouette; here, they retain their lushness, while the colours reflected in the water make for a restful and harmonious composition (*TH: Nikon: 105/2.5 Nikkor: EN*)

73

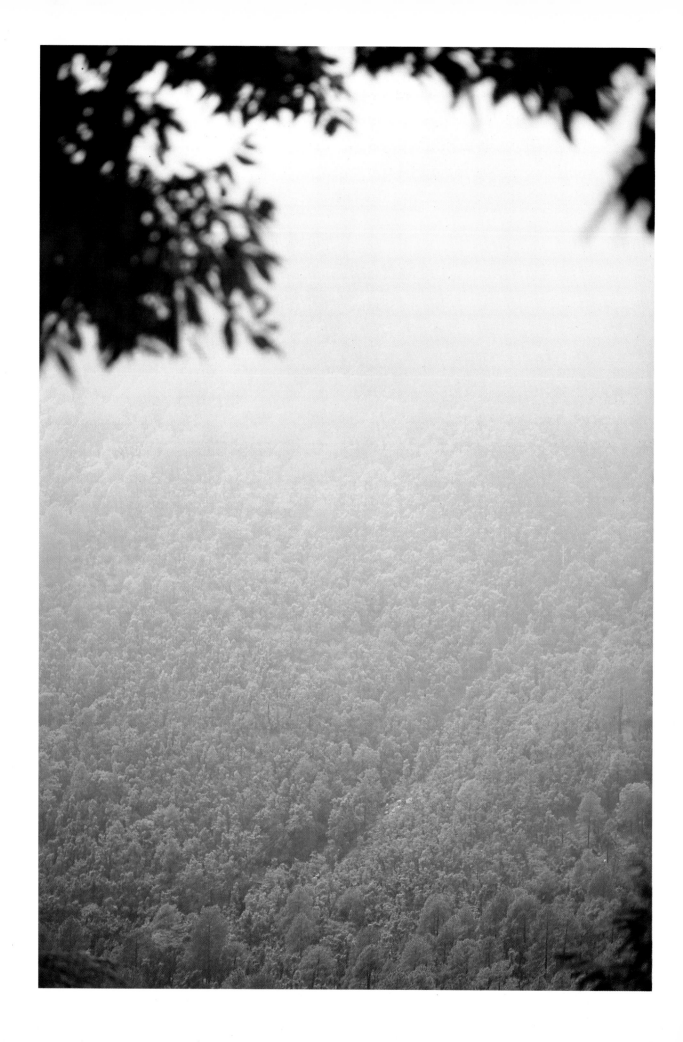

fall in the correct places. If they do not, I shall have to expand or compress the tonal range of the film during development, which is something I shall come back to later.

As already mentioned, though, the Zone System is only for black and white photography. The difficulty with colour film is that although it can reproduce at least as great a range of tones as black and white film (in fact, as chromogenic black and white films show, usually a *greater* range), it cannot reproduce *colours* across that range. In fact, the range across which colours can usefully be reproduced is as little as four stops (8 : 1). Outside this range, the colours are lost and the tones reproduce as shades of grey – or at best, as travesties of their normal selves. To make matters worse, this restricted effective range means that if you expose for the shadows, as you do in black and white photography, large areas of the picture are likely to be burned-out highlights. To get over this, you must expose for the *highlights*, and let the shadows go dark.

It is possible to use a modified version of the Zone System in colour, with Tone 7 as the lightest tone in which colour is to reproduce at all, and Tone 3 the darkest. Indeed, the Weston Master is already equipped with a still more modest version of the same thing, the A (1/2) and C (2×) marks on either side of the main (Tone 5) index: the manufacturers reckoned that anything outside this 4 : 1 range would not reproduce really satisfactorily, and they were not far from right. But now, with a fanfare of trumpets, comes the easy way to determine exposure accurately.

It is nothing more than *incident light metering*. Most hand-held meters are equipped (or can be equipped) with an incident light attachment; the one for the Weston is called an Invercone. This slightly awkward lump of white plastic allows you to measure the amount of light *falling on* the subject (hence 'incident') which is not, of course, affected by the reflectivity of the subject. The Invercone is designed to reflect all but 18% of the light falling on it, and so automatically gives you a Tone 5 (mid-tone) reading with perfect accuracy every time.

Ideally, you should take an incident light reading with the meter pointed towards the camera from the subject position. If you cannot conveniently get to the subject position – for example, if you are photographing the next mountain peak across a 3,000ft gorge – you can take a reading from the *equivalent* position. In other words, hold the meter with the same orientation relative to the subject and the camera as it would have if you were at the subject position, in the same lighting. Choose your position carefully, so that there is not (for example) a cloud over the sun, or a tree casting a shadow, in the place where you are standing, unless of course the same conditions obtain at the subject position.

The only mental gymnastics which are now required involve *increasing* the exposure slightly (by up to a stop) if you want more detail in the shadows, or *decreasing* it slightly (by up to a stop) if you want more detail in the highlights. With black and white, there is some justification for going to full-blown Zone System metering; with colour, incident light metering is infinitely easier. I have never understood why it is not more widely used.

To be on the safe side, though, I must admit that I normally *bracket* my exposures, by giving one exposure at a stop more than

the Weston indicates, and one at a stop less. This is partly laziness, in that if I thought carefully enough I could work out what exposure correction to give, but it is also partly the result of experience: I know that a 'heavy' transparency (one stop under) and a 'light' one (one stop over) will often produce results which are just as attractive and valid as the 'correct' exposure, but different. Some photographers advocate half-stop brackets, but I have always found a full stop to yield more than acceptable results, and because a full stop is the minimum necessary with modern transparency material to get a real difference (though 1/3 stop steps are detectable), I stick to that. Besides, shooting two brackets trebles your film cost; shooting five brackets (from one stop over to one under, in half-stop rests) would quintuple it. The only time that I depart from my 'one over, one under' rule is when I am shooting an unusually light subject (in which case the rule is 'half under, one and a half under) or an unusually dark one, when I bracket 'half over, one and a half over'.

Even with incident light metering, though, there are a number of riders to be added. The first is that brackets can be as useful with black and white as with colour if you are trying to record the maximum possible tonal range. The second is that if you are using colour negative film, you should always err on the side of *over-exposure*: I habitually rate colour negative films at one half of their manufacturers' recommended speeds, which gives finer grain, better colour saturation, and deeper blacks, but does lead to complaints from amateur labs (I use them for snapshots, like everyone else) that the pictures are 'overexposed'. They're not; they're correctly exposed, because they give the results I want. The third rider concerns photography at night.

58  **Sun through trees** Often old lenses produce a different effect from modern ones – our forebears used to call it a 'plastic' effect, before 'plastic' came to mean an oil-derived synthetic material. This was shot with a pre-war Leica and the often-derided 5cm f/2 Summar lens, which is wonderful for black and white provided it is unscratched (*TH: Leica III: FP4/ID-11/ISO 125*)

77

To begin with, the majority of successful 'night' shots are *not* taken at night: they are taken at dusk, when there is still enough colour in the sky to record on the film as a deep blue. This is the way that we see night, but because of the limited recording range of film, it means that we have to take pictures a lot earlier than might seem necessary.

If you take pictures during the brief period of dusk, exposure is very critical, and copious bracketing is a good idea, but if you take pictures when the sky has gone really dark, the exposure range is paradoxically enormous. This is because we can accept as 'correct' anything from a mostly black picture, with just a few lights showing, to a picture where much of the scene is as bright as day, with highlights like shop windows totally burned out. This represents an exposure variation of something like five or six stops, and only experience and personal taste can guide you in deciding what sort of picture you want.

You need something to base your exposure on, though, and many meters will not read after dark; in any case, reflected light readings are rather dubious, as they depend so much on exactly where you point your meter. One of the easiest tricks is to point the bare meter cell (ie, without the Invercone) directly at the nearest light source from the subject position, and then give *five times* the indicated exposure; this is because you are now reading incident light without the Invercone, which is designed to reflect all but 18 per cent (effectively a fifth) of the light falling on it. If you are using *only* this metering technique, you can of course set the film speed on the meter to five times the arithmetic ISO speed, say EI 320 for an ISO 64 film, but remember to reset it before you use conventional metering again.

**59 Sunset, Pacific Coast Highway**
If you want colour in the sky during a sunset, the only possibility is to meter the sky itself and to base your exposure on that. The land will inevitably go to a silhouette, but this is no great loss if you have arranged the shapes properly in the viewfinder. The main objection to this picture is the very small size of the disc of the sun, caused by using a 35mm lens: for a large, dramatic sun you need at least a 90mm lens and preferably a 135mm or 200mm. But then the sweep of the coast would have been lost . . . (FES: Pacific Coast Highway, California: Leica M: 35/1.4 Summilux: PKR)

**60 Park and lake** Even 'easy' subjects often benefit from bracketing. This is the middle exposure from three shots of the same subject, shot at one-stop intervals. The lightest would be ideal for projection, and shows the path better, but this one gives much better colour saturation in the water. The darkest gives really dramatic colours in both the sky and the water, but loses the path almost completely (RWH: Eastville Park, Bristol: Leica M: 35/1.4 Summilux: PKR)

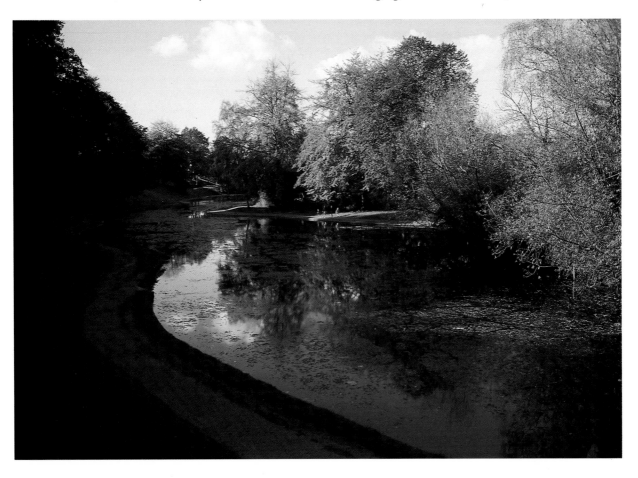

Finally, you need to be aware of *reciprocity failure*. Exposure is normally governed by the so-called 'reciprocity law', which states that an increase in aperture can always be compensated for by a decrease in exposure time, and vice versa. Although this holds good for normal exposure times, it begins to fail at very long and very short exposure times. The short ones are unlikely ever to affect us as landscape photographers, but the long ones may; typically, you might need an extra half stop exposure at one second, and as much as two extra stops at ten seconds. The exact figures vary from film to film – Kodachrome 25, for example, is remarkably indifferent to long exposure times – and they change periodically as manufacturers improve their emulsions, so there is no point in giving actual figures here. The manufacturers will tell you if you ask them, though; write or telephone. With colour films, you may also get *reciprocity colour shifts*, with variations in colour at very long exposure times. The direction and size of the shift again varies widely from film to film: some require no filtration at all at one second, and only minimal filtration at ten, while others require the use of a weak red colour correction filter (perhaps a CC05R) at one second and something rather stronger – a CC20R, maybe – at ten seconds. Others may require blue or yellow filters. Again, the manufacturers will give you up-to-the-minute information if you ask them.

## Processing – Colour

Processing, the next link in our chain, is very different according to whether you are using colour or black and white. As a simple guide, if you use colour transparency you let the lab do it; if you use black and white, you do it yourself; and if you insist on using pos/neg colour, you can do either, though my inclination would be to let the lab process the film and make proofs, then do the printing myself. If you use a lab, then use a professional one, not an amateur one: it will cost a little more for transparency processing, a lot more for colour printing, and a fortune for black and white printing, but when you compare the results with those from an amateur lab, it is worth it.

Unless you try professional labs, you may never appreciate just how good commercial processing can be. This is true for both colour prints and colour transparencies. With prints, there is simply no contest: with transparencies, the speed of turnaround, the freedom of your film from scratches, and the consistency of the processing are all likely to be very much better than you will get from the vast majority of amateur labs, and the price is not all that much greater. Admittedly, most professional labs do not mount your slides for you, but a box of 100 glassless GePe slides (the professional standard in glassless slides) costs less than half as much as a roll of Kodachrome at the time of writing, and as you are unlikely to want to mount more than 20 slides out of 36 (unless you are very, very good or very, very lucky), this hardly represents a vast expenditure.

Some people are worried that professional labs will not accept amateur work. They are both wrong and right in this. As a general rule, most professional labs do not care who exposed the film, so long as they are prepared to pay to have it processed. On the other hand, some labs have had bad experiences with amateurs, and are extremely wary of dealing with other amateurs until they have proved themselves. The two typical problems with amateurs are

**61 Zone-modified Weston III Meter** This old Weston Master III has been modified for use with the Zone System by sticking additional numbers on to the dial, as described in the text. The III is just as accurate as later meters, but the Invercone attachment is different (and hard to find), and the film speeds are scaled in Weston speeds, not ASA/ISO. Correction is easy: the Weston speed is equivalent to the ASA/ISO speed immediately above it on the dial, so set Weston 20 for ASA 25; 25 for 32; 50 for 64; 100 for 125; and so forth. (RWH)

**62 Westons, with and without Invercone** The Invercone incident light attachment for the Weston Master IV, Master V and Euro-Master snaps into the back of the meter, whether the 'trapdoor' which converts the meter for high and low levels is open or not. Readings are taken from the front scale in exactly the same way as for reflected light readings, and the same film speed is set. The later Weston meters (IV onwards) use the international ISO/ASA film speeds

*Overleaf*

**63, 64 Infra-red pictures** Metering for infra-red colour pictures is easy, though modest bracketing (plus and minus one stop) is advisable, but metering for infra-red black and white is much more difficult because the best filters are visually opaque and there is no easy way to meter infra-red light only. The filters used for these shots were a Y2 (yellow) filter for the blue picture, and a Wratten 25 (tri-cut red separation filter) for the green picture: the only way to learn the effects of different filters is by experiment (*TH: Nikon: 24mm f/2.8 Nikkor: Infra-Red Ektachrome*)

**65 Red leaves on blue sky** The only easy way to meter a subject like these red leaves is by the incident light method. Frances Schultz used a Weston Master IV with an Invercone and under-exposed by 1/3 stop (compared with the meter reading) for increased colour saturation. Imagine trying to meter this with a TTL meter! (*FES: Westonbirt Arboretum: Nikon: 90/2.5 Vivitar Series One: KR*)

complaints that the price is too high, and blaming the lab for defects which are the photographer's fault. The former requires no further comment – you get what you pay for – but the latter requires a little more explanation.

Professionals know when they have goofed, and when it is the lab's fault, because of the sheer amount of experience they have in shooting under different conditions. Amateurs, on the other hand, are often more inclined to argue, usually without foundation. Literally *never* has a lab screwed up an order of mine if I have explained correctly to them what I want, though I have been lucky: I know people who have lost sheets of 5 × 4in film when the box was opened in room lighting, and others who have had their films ruined by the lab's processing machinery breaking down, but these are gross errors and readily detectable. If the lab can show you other films which went through at the same time, and which are correctly processed, the odds are that it is you who made the mistake, not them. Look at it this way: they process literally hundreds of rolls a day for

demanding professional customers, so they *must* usually get it right if they are to stay in business!

Returning to the advantages of the professional lab, you will find that they offer services which are not available in amateur labs, the most valuable of which are *clip testing* and *pushing*. Clip testing involves literally that, clipping the first few frames (which should be specially shot) off the film, in order to check whether any speed adjustment is called for, and 'pushing' means increasing the first developer time in order to rate the film at a higher exposure index. Usually, 'push 1/3' will produce very slightly higher contrast than regular processing, with no other disadvantageous effects; 'push 2/3' will still be perfectly acceptable; and only at 'push 1' will the quality be significantly inferior to standard processing. 'Push 2' is the furthest that most photographers would care to go, and 'push 3' is the limit for most labs. The units are of course stops, so the increases in speed rating would be:

| ISO speed | Push 1/3 | Push 1/2 | Push 2/3 | Push 1 | Push 2 |
|-----------|----------|----------|----------|--------|--------|
| 50 | 64 | 75 | 80 | 100 | 200 |
| 64 | 80 | 96 | 107 | 125 | 250 |

and so forth (you can calculate the effects on ISO 100, 200, 400, and ISO 125, 250, 500 and 1,000 from these figures by simple multiplication).

It is also possible to 'pull' films in development, but this is rarely required; rarely would anyone go as far as −1 stop (halving the film speed), and most people would only go to −1/3 or −1/2 to correct small exposure errors.

When it comes to colour printing, I am an unashamed advocate of the pos/pos process, and of Cibachromes in particular. As already described, the images are much sharper than those derived from negatives, and I find the ultra-glossy Ciba surface very attractive. If you want to use the neg/pos process, feel free, but I can offer you very little advice, except perhaps to suggest that you make interpositives on a larger format from 35mm transparency originals, and print from those. Take care to control copy-neg contrast by flashing – use an ND (Neutral Density) 2.0 or 1.5 filter and the same exposure as the main exposure – or by using the contrast control unit on a Bowens Illumitran or similar electronic flash copier.

It is true that Cibas can be contrasty, but once again, you can use a fogging 'flash' exposure in the enlarger, or if you are really dedicated you can make a very weak black and white mask and print it in register with the transparency – though if I were taking that route, I would be inclined to make a 5 × 4in interpositive (with the enlarger) and mask that; but at this point, we are wandering into the realms of obsession again. Unlike black and white, there is really very little you can do to control contrast and gradation, apart from localised dodging and burning, so colour printing is mostly a matter of following the manufacturer's instructions.

To judge colour, a useful tip is to look through CC (colour correction) filters to view the final print, and then when reprinting to use *half* the filtration that makes the picture look right. In other words, if it looks all right through a CC40M, change the printing filter pack by only CC20M.

**66 Near Bathampton Water** Although a yellow filter is often known as a 'cloud filter', it will do nothing unless there is some blue sky for it to darken. On a day when the sky is predominantly white, the only way to show clouds is by very careful exposure – preferably bracketing. Exposure was determined here with a Weston Master V and an Invercone (*RWH: Leica M: 35/1.4 Summilux: Dia-Direct*)

*Overleaf*

**67 Palms, Los Angeles** A useful rule of thumb is that a shutter speed of 1/ISO film speed gives the correct exposure at f/16 in bright sunlight. With ISO 64 Kodachrome, the nearest shutter speed is 1/60sec, so I used 1/250sec at f/8 (= 1/60sec at f/16), and then underexposed by one and two stops (shutter speeds of 1/500sec and 1/1,000sec) to give super-saturated colours; I knew that the light-barked palm trees could be underexposed dramatically, and still look 'natural', while the sky would become unbelievably deep (*RWH: Leica M: 21/2.8 Elmarit: PKR*)

**68 Zurich** As explained in the text, the best 'night' shots are often taken while there is still light in the sky. The colours of sunset are often unbelievable, and (as here) they can serve as a backdrop to dramatically silhouetted buildings. The light changes very fast during sunset, so keep taking exposure readings, or rely on experience to tell you when to open up the lens as the light dies (*RWH: Leica M: specially adapted 21mm f/4.5 Biogon: KR*)

**69 Sunset, Spain** There are several advantages to using long lenses for photographing sunsets. The big, dramatic ball of the sun is the obvious one, and another is that the atmospheric haze can reflect back just enough light to give some details in the foreground just in front of the sunset – the rich purples here are incredible. This picture also illustrates the point that very cheap long-focus lenses can be highly successful: it was taken with a 300mm f/5.6 Optomax, hardly a 'glamour bottle' (*RWH: Nikon: KR*)

## Processing – Black and White

With black and white film, you will usually do far better to do your processing yourself, because you can apply the Zone System in all its glory. The idea is that you begin with the manufacturer's recommended film speed and development times, and then 'fine-tune' both until you get the best possible results. This does involve 'wasting' a certain amount of film, but it is worth it. The tuning system described here, using an Agfa step-wedge which is graduated in 1/3 stop increments for a total of $6\frac{2}{3}$ stops, is rough-and-ready by zone standards, but it works. If your camera store cannot supply a step-wedge, go to a graphic arts supplier.

Because the wedge is so small, you will need to come into the closest focusing distance on most lenses: at 18in (50cm), this degree of focusing extension means that you are effectively underexposing the film by about 1/3 stop, so allow for this by increasing the indicated exposure by 1/3 stop. This is a little confusing, but (as an aside) it is why 35mm cameras typically focus to 18in and rollfilm cameras to 36in – this is the point at which the extra extension required makes a significant difference to exposure. Take an incident light reading, and photograph the wedge at 1/2 stop brackets from −2 to +2.

Develop the film for the manufacturer's recommended time at the manufacturer's recommended temperature, *using a one-shot developer*. The reason for using a one-shot developer is that reusable developers introduce an extra variable.

You should be able to distinguish all twenty steps on at least three negatives. If you cannot, you are overdeveloping the film. If you can see all twenty steps on all nine negatives, you are underdeveloping it, though this is much less likely. In all probability, you will find that you need to reduce development by about 10 per cent, which should give you all twenty steps on five of the negatives. The middle negative of these five represents the correct exposure. Typically, you will find that this is the negative which was (according to the meter reading) 'overexposed' by 1/2 stop. In fact, you may wish to use these figures as your starting point, so consistently have I found them to apply to my own tests. This would mean rating ISO 125 film at EI 80 or 100 (it is not all that critical) and ISO 400 film at EI 250 or 320.

The effect of increasing and decreasing development, and hence increasing and decreasing contrast, is shown graphically on a $D/\log E$ curve, which plots density ($D$, on the vertical axis) against the logarithm of the exposure (hence $\log E$, on the horizontal axis). Predictably, negative density increases with exposure, so the typical shape of a $D/\log E$ curve is as shown in the diagram. You can learn a great deal from the $D/\log E$ curve, including the maximum density ($D_{max}$), the fog level ($D_{min}$), the contrast (the steeper the slope of the curve, the greater the contrast), and the way in which tones at the toe and shoulder of the curve will be compressed, but you need to be pretty dedicated before you go into this sort of detail.

Even without learning about $D/\log E$ curves, the above practical procedure will allow you to determine a fair approximation to both appropriate exposure index and appropriate development time with one or two films; if you want, you can repeat the experiment once more, with your revised film speed and revised exposure time, but you should be close enough to 'guestimate' any required changes.

Zone System *aficionados* will use much more rigorous test procedures, and batch-test each new emulsion number of film, but to me this borders on fanaticism, and I prefer to take pictures for fun. The test procedure described should give you the best *practical* exposures for any given film/developer combination, but you will need to repeat it each time you change film or developer; as already mentioned, I use FP4 and HP5 with Perceptol.

**The D/Log E Curve**

Density ⟶

Log Exposure ⟶

The *D*/log *E* curve plots density (*D*), on the vertical axis, against the logarithm of the exposure time (log *E*) on the horizontal axis. For a perfect emulsion, the *D*/log *E* graph would be a straight line: increase in density would be directly proportional to increase in log exposure, beginning with zero density at zero exposure.

But emulsions are not perfect, so the straight line only holds good for a certain range of exposures. Even where the film is unexposed, there is an irreducible minimum density, because of film-base opacity and fogging or veiling due to the action of the developer. Next, there is a short 'toe' section where density does not follow the straight-line relationship which it does in the centre of the curve. As exposure goes beyond the area in which the straight-line relationship holds good, increasing exposure brings less and less increase in density. This is the 'shoulder' of the curve, where the film has reached its maximum density or $D_{max}$, so further increases in exposure cannot increase the density. Finally, extreme overexposure can cause the density to *fall* again; this is true solarisation, not to be confused with the Sabbatier Effect or pseudo-solarisation which is caused by a brief additional exposure during development.

A good, modern emulsion will have a long straight-line portion, and a short 'toe' and 'shoulder', if it is developed properly. If the curve is more 'S'-shaped – that is, if the toe and shoulder curve a long way into the straight-line portion, this reflects a relationship between density and exposure which is not linear, and the Zone System cannot be applied. Increasing development time, and decreasing exposure, will increase the slope of the straight-line portion; decreasing development, and increasing exposure, will decrease the slope. This reflects the effect of development upon contrast: obviously, a steep slope reflects a more rapid building of contrast (and a shorter overall tonal range) than a shallow slope.

With colour films, each of the three colour-sensitised layers has its own *D*/log *E* curve, and obviously these must stay in step: if they cross over, it will be impossible to keep the colour balance constant at all exposures, and there will be irremovable colour casts.

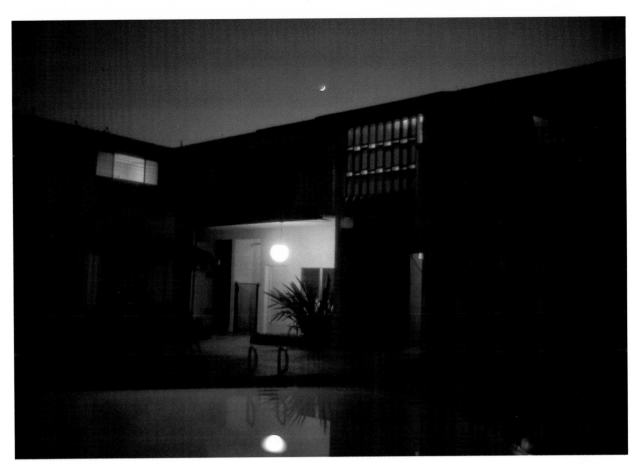

If you take this sort of trouble with your exposure, you should always get negatives that will print perfectly on grade 2 or grade 3 paper, which will save you a fortune in paper grades alone. In theory, getting the print on to the paper demands a similar range of tests, but in practice you can get excellent results by always using fresh developer at the recommended temperature and developing for *at least* three minutes. Effectively developing prints to finality in this way removes the variables inherent in 'snatching' (pulling them out of the developer before they are fully developed) and 'stewing' (leaving them in the developer for longer than usual, in the hope that they will come up a little more strongly).

It is a good idea, though, to use 'real' paper rather than resin-coated and, if you can afford it, to use one of the premium silver-rich papers: Ilford's Galerie is the acknowledged leader. These may seem expensive, but as mentioned at the beginning of the last chapter, materials are the one area in which you should never compromise. If you cannot afford Galerie, use Ilfobrom or an equivalent paper from another manufacturer. Ilfobrom is available in all grades from 1 (very soft) to 5 (extremely hard), and it has the great advantage that the speed of grades 1 to 4 is identical, while grade 5 is exactly half as fast, so you do not need to waste time making additional test-strips when you change grades.

There is obviously a temptation to use a multiple-grade (variable-contrast) paper such as Multigrade, because it means that you only have to buy the one box. There are, however, three serious drawbacks. One is that you cannot get the same contrast range as with graded paper – your range is normally something like grade 1.5 to grade 3.5 or 4. The second is that recalculating exposure as you

**71 Red sky, Los Angeles** There are times when you have to throw caution and convention to the rules, just in order to get a picture. I was returning to a friend's apartment in Los Angeles late one evening when I saw this extraordinary red sky, counterpointed by the green light in the entrance and the orange-curtained window. I didn't have a tripod, and I couldn't get an exposure reading, so I guessed the exposure at 1/2sec at f/1.4 and hand-held it. The result is technically flawed, but still (I think) very dramatic (*RWH: Leica M: 35/1.4 Summilux: KR*)

**70 Sunburst through trees** 'Starburst' filters should be used with restraint, but the weak glare of winter sun seems ideally suited to the effect. I would never have thought of doing it, but Frances Schultz did, and the result is very attractive (*FES: tripod-mounted Nikon: 90/2.5 Vivitar Series One: starburst filter: KR*)

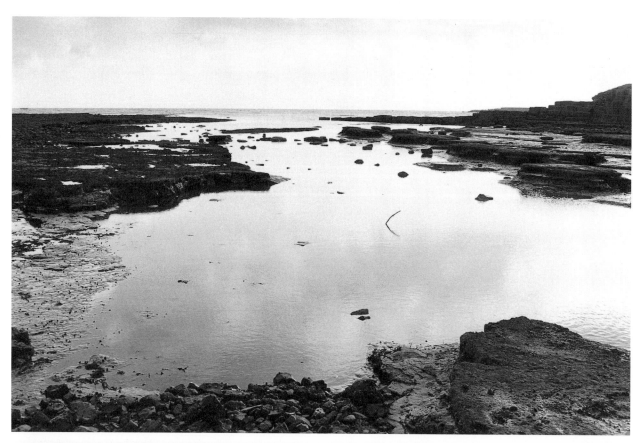

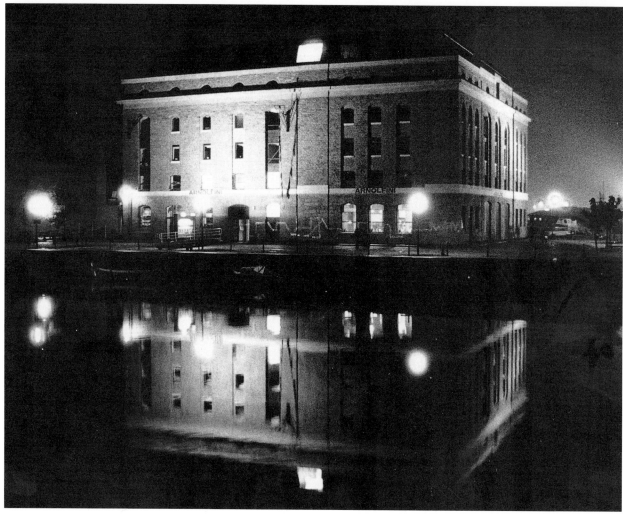

change filtration is not easy, so the temptation is to make do with a print that is almost (but not quite) right. The third is that because of the design of variable-contrast papers, the image is never as sharp as with graded paper. It also seems to me that you never get the tonal range that graded paper gives, and a number of photographers agree with me; certainly you can never hope to approach the rich, deep tones that you get with something like Galerie.

There are occasions, though, when you do not want these rich, deep tones, because the kind of print which reproduces best is not necessarily the one that looks best on the gallery wall. In particular, rich dark tones (Tones 3 and 4) tend to 'block up' into solid black on reproduction, so it is better to aim for a print which is fairly light and 'high-key' by exhibition standards. This is *not* quite the same as saying that the print should be contrasty, which is the traditional advice given for reproduction. 'Soot and whitewash' contrast may be required for old-fashioned newspaper reproduction, but for reproduction on decent paper it is a positive embarrassment. It is true that only the best half-tones (photomechanical reproductions like those in this book) can hope to reproduce the same range as an original print, so the thing to do is to avoid large areas of Tones 1–3 and to aim for the maximum differentiation of tones in Tones 3 and 4, by the selection of a different printing paper grade if necessary.

**72 Seashore** Incident light metering, allowing an extra half-stop to get detail in the rocks, solved a metering problem which would have been nigh insurmountable if attempted conventionally with a through-lens meter. The only problem with this picture is the stick in the middle of the tidepool, which looks very like a hair on the negative; I seriously considered retouching to remove it (*TH: Dorset coast: Nikon: 35/2 Nikkor: FP4/Perceptol/EI 80*)

**73 Arnolfini at night** Determining exposure in a shot like this is not easy. Few camera meters will give a reading (and if they do, it may not be reliable), you cannot get close enough to take an incident light reading, and there is no real equivalent lighting at the camera position. The only real possibilities are spot metering and guesswork, preferably with plenty of bracketed exposures. This picture, taken well after dark, was one of a series of four exposures – 1/8, 1/15, 1/30, and 1/60sec at f/1.4. The 1/30sec exposure turned out to be correct; note the flare from the lens, the first f/1.4 offered for the Nikon F. The line around the Arnolfini gallery is actually a painting entitled 'Senggye's Lament on the Subjugation of Art to Mediocrity' (*RWH: Nikon: 58/1.4 Nikkor: HP4/Microphen/EI 800*)

**74 Agfa test strip** It may not show in reproduction, but rating Dia-Direct at ISO 25 allowed every step on the Agfa test-scale to be read with ease. The reason for the slightly odd angle of the strip is that it is highly reflective, and a square-on shot is not easy without getting reflections which confuse the issue royally

# 4
# PRESENTATION

Once you have shot your landscapes, you will probably want other people to see them. You have a choice of three main methods of presentation, and many more choices of venue.

The most obvious choice of method of presentation for most people is the print. We have already looked at print sizes, and their relationship with the resolution of 35mm camera/film systems, but an important thing to reiterate here is that it is all too easy to enlarge a 35mm picture *too much*. Obviously, the print must be big enough to see, and this sets one limit to the appropriate size: the smallest one would normally consider in Britain would be half plate (4¾ × 6½in), in America 5 × 7in, and in Europe 13 ×18cm. The classic 'middle-of-the-road' size would be 10 × 8in in Britain and America, 18 × 24cm in Europe, though there is a lot to be said for A4 (21 × 29.7cm), as it matches the long, thin 35mm format better than any other *and* can be halved to A5 (15 × 21cm) for smaller prints. The largest one should normally consider is 10 × 12in in Britain, 11 × 14in in the US, and 30 × 40cm in Europe – though the last is closer to 12 × 16in than to 10 × 12in. The old exhibition sizes of 20 × 16in, 20 × 24in, 40 × 50cm, and 50 × 60cm are simply too big for many 35mm subjects, as they draw too much attention to the photographic process and not enough to the subject.

Note, though, that the *print* size and the *frame* size need not be the same. Although too small a print in too large a frame can look pretentious or just plain pathetic, a strong case can be made for a large area around a smaller picture, both to distance it from its surroundings and to concentrate attention on it. Often, a small print presented in this way will look more impressive than a much larger print mounted flush in the traditional exhibition formats. Although it is a long time since I had an exhibition – a subject to which we shall return in a moment – I think that I should now be inclined to print my pictures 'all in' on A4 paper, giving an actual image size of about 7 × 10½in, and to present them in 12 × 15in (or thereabouts) glazed frames.

The question of framing is a vexed one. Frames are expensive, and 'exhibition' prints for competitions and public exhibitions must usually be presented unglazed and unframed, mounted on card: in some cases nowadays, high-density expanded polystyrene is permitted as an alternative to card, and it is certainly easier to handle as well as making a neater job for flush-mounted prints. On the other hand, prints for home display, for a one-man exhibition, or for sale or gifts look better in glazed frames. Simple assemble-it-yourself frames of brushed natural aluminium are my favourite, though a case

**75 Tree, Yosemite National Park**
The simplicity of this picture is reminiscent of Oriental brush-painting; it is a tranquil picture, which could be framed for display almost anywhere, though it would go best in a brushed aluminium or chrome frame in modern surroundings. It could stand quite a degree of enlargement – perhaps up to 20 × 30in – because we do not necessarily expect needle sharpness in 'art' (as distinct from 'record') photography (*RWH: tripod-mounted Leica M: 280/4.8 Telyt: PKR*)

94

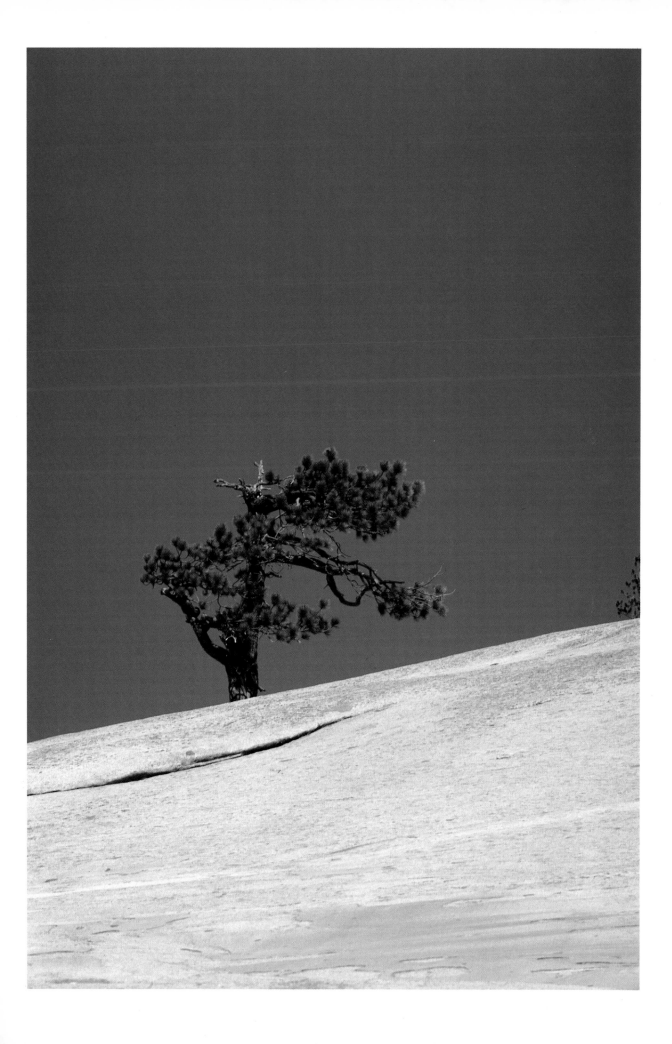

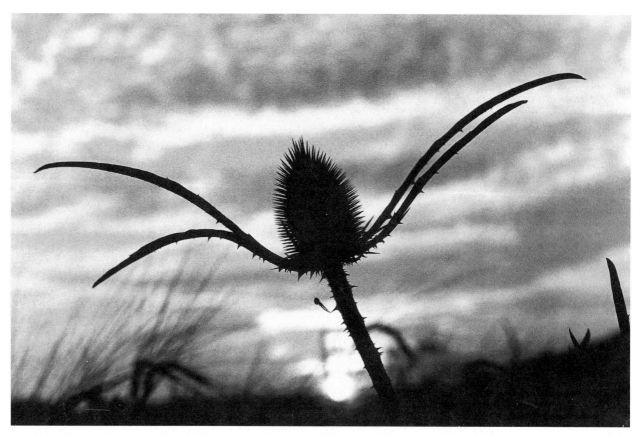

**76  Burr** The grain in this picture may not be visible in reproduction, but it is very clear in the original, even in a 6 × 9in (150 × 225mm) print. At (say) 20 × 24in it would be very dramatic indeed, and by its very roughness it would add to the prickliness of the burr. Matching technique to subject is an essential part of picture presentation (*TH: Nikon: 105/2.5 Nikkor: HP5/ID11/ ISO 400*)

**77  Rowing boat** The original photograph is hardly recognisable in this picture which was produced by sandwiching the camera negative with a texture screen and then making a sectional 30× enlargement on to lith film. The result is, however, extremely memorable; it might be interesting to try printing this picture on a metallic (copper or aluminium) support (*Dick Painter: no technical details available*)

could be made for elaborate (second-hand) Victorian gilt frames for some kinds of landscape.

Displaying framed prints is easy enough, but remember to position them low enough so that short people can see them easily (my wife is just over five feet tall, and has problems in many galleries) and light them so that there is no flare off the glass: again, check this from the point of view of a shorter person.

If you want an exhibition, you may find it easier to get one than you think. If your pictures are good enough, you can try not just local arts and community centres, but also restaurants, banks, and anywhere else that might appreciate some free art: I even had an exhibition in an up-market hamburger joint once, and although none of the prints sold, someone paid me the compliment of breaking in and stealing five of them!

As an aside here, gallery sales are probably the only way that you are likely to earn much money from landscapes, and even then you have to be lucky. Pricing is always difficult, but in the mid-to-late 1980s, typical price ranges (unframed) ran from £15 to £300 in the UK and $20 to $700 in the US. Go for the lower end initially, but do not price your work too cheap or no one will take it seriously.

The second choice, when it comes to presentation, is slides. Usually, you will only be able to show these in your own home, but if your subject matter is interesting enough (as well as your photography being good enough), you will find that all kinds of clubs, schools, and community organisations will welcome a slide show for their members. The essential things to remember are to *structure* the presentation, so that it has a beginning, a middle, and an end, and follows a logical progression; to *spot* the slides (the standard is a 'thumb spot' in the bottom left-hand corner as the slide 'reads'

**79  Zurcher Zee, Switzerland** This is a modern-looking picture which would be at its best at a modest size – 11 × 14in maximum – and displayed in clear, uncluttered surroundings. The 'starbursts' around the sun and on the sparkles on the water are the result of shooting with a 21mm f/4.5 Biogon at f/22: they are actually reflections from the lens diaphragm. The lens (from a Contarex) was specially adapted for my Leicas *(RWH: Leica M: KR)*

**78  Swamp grasses** Detectably unsharp even at 24 × 36mm, this picture is nevertheless suffused with an autumnal warmth which would make it very suitable for decoration. It is quite different in mood from the picture of the tree: it would need colour-matched surroundings, and it might look at its best in an old-fashioned study (a brown study?) *(FES: Bombay Hook, Delaware: Nikon: 90mm f/2.5 Nikkor: PKR)*

normally); and to *check* the presentation before giving any public performance, to ensure that all slides are present and correctly orientated, as well as ensuring (for example) that the room actually can be blacked out and that there is a power point near enough to use!

If you want to sell your pictures in a picture library, slides are essential. For further information on this topic, see *Pictures That Sell*, (see Bibliography) which I co-wrote with the owner of a major London library.

The third choice is publication, and this is the difficult one. Most photographic books are 'how-to' books, like this one: collections of pictures hardly ever sell, unless they are by incredibly famous photographers like David Bailey or Ansel Adams. Admittedly, some non-photographic 'celebrities' get books of truly appalling pictures published, but this is on the strength of their name, not their ability as photographers. There are also books whose subject matter compels attention, such as Lady Lucinda Lambton's *Temples of Convenience* about Victorian and other classic lavatories, but once again this is hardly the same as a collection of landscapes.

There are, however, alternatives to full commercial publication, including self-publication and publication with the aid of a grant. You could turn out 5,000 copies of your very own 96 page mono-chrome-only book for the price of a cheap new car, and if you could get anyone to buy them you could make a handsome profit: book-stores normally work on a 30–50 per cent discount off the cover price (which must be realistic), and expect you to accept as returns any books that do not sell. Grants are getting harder to come by all the time, and are normally made to cover the cost of photography

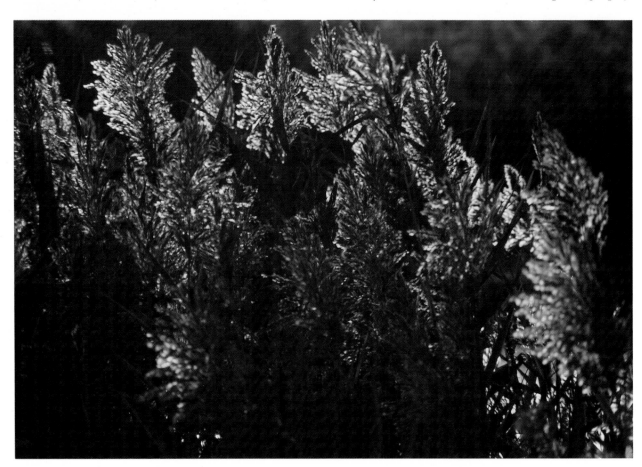

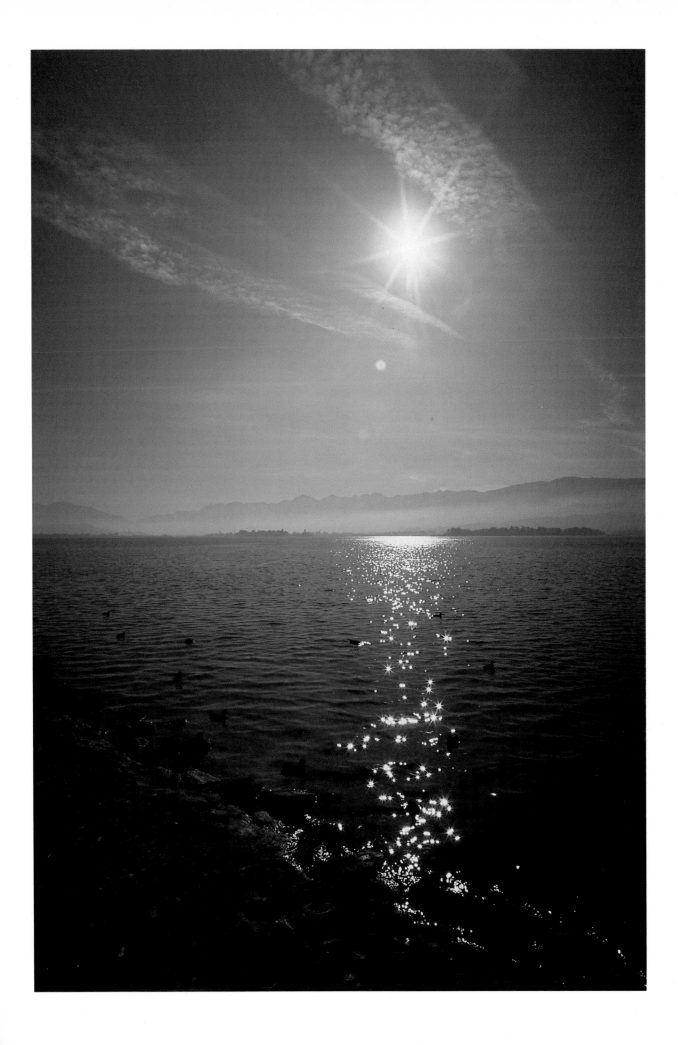

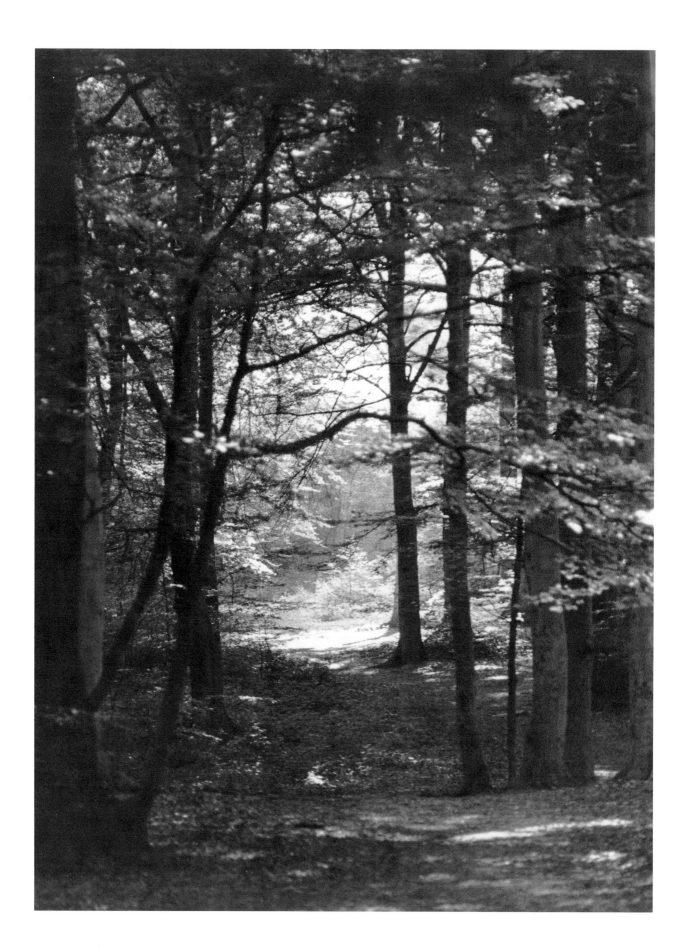

rather than the cost of publication, but you could check out your local public library for directories of grant-making bodies. You could also consider publication as postcards, which can be fun and reasonably profitable, but which obviously requires a picture strong enough to stand up to reproduction on such a modest scale. If you want colour published, you will do much better with slides than with prints, as printers can reproduce far better from transparencies, but the cost of colour publication is vastly higher than the cost of black and white, so self-publication (except for postcards or posters) is unlikely to be economically feasible.

Finally, there is the question of competitions. My own view on these is that they are hardly ever worth entering, as you could do a lot better by concentrating on producing pictures for sale through a picture library, but if you want to give them a whirl, observe the following guidelines.

Always read the rules carefully. Make sure that you do not relinquish copyright, even if you win, and follow the rules *scrupulously*. This means the right subject, the right style of presentation (slides, prints of a specified size, or whatever) with the right information (name, address, etc.) in the right place. Never send glass-mounted slides – the glass breaks as often as not and chews up the picture – and always enclose adequate return postage and packing if you ever want to see your slides again.

All of this may sound obvious, but you would be amazed at the number of people who send in pictures of people for landscape competitions, never mind pictures of France for 'Holidays in Britain' contests, and who send in black and white where colour is specified, or vice versa. As a final piece of advice, go for the pictures with *impact*: the judges may have to wade through thousands of pictures, and finesse (as Tom Paxton put it) is not where it's at. Go for something dramatic, and at least it will get noticed. After that – it's as much luck as judgement.

*Overleaf*

81 **Beverly Hills City Hall** This is a bit too 'chocolate boxy' to stand up to long display, though as a souvenir (or even as a stock shot for sale) it is very attractive. The heavy foliage in the top right-hand corner helps to 'frame' the picture, and relieves what would otherwise be an expanse of rather boring blue sky (*RWH: Beverly Hills City Hall, California: Leica M: 35/1.4 Summilux: PKR*)

82 **Tree and River** The best colour slides for reproduction are often considerably darker than those which are best for projection. This slide is far too dark to project, but the deeply saturated colours capture the wildness of the river and the bare winter branches more dramatically than a 'correctly' exposed slide ever could (*FES: Three Rivers, California: Nikon: 90mm f/2.5 Vivitar Series One: PKR*)

80 **Trees** This was shot with a pre-war Leica and a Summar lens. The resolution is not impressive, but the result is very much in the 1930s style – especially when sepia-toned, as the original was in this case (*TH: Leica III: 50/2 Summar: FP4/ID-11/ASA 125*)

# PART II
# THE SEARCH
# FOR A LANDSCAPE

# 5
# THE SEARCH FOR A LANDSCAPE

The reason why most of us take up photography in the first place is for souvenirs and family shots: what we want is pictures which help us remember happy or important times in our lives, places that we liked, and so forth. When we look at them, no matter how technically bad the pictures are, the memories and pleasant associations of the original event come flooding back, and this is a perfectly valid use of photography. For many people, this is in fact its be-all and end-all: the roll of film with a Christmas tree at each end, and the summer holidays in the middle, is still commonplace. The humble snapshot has a well-deserved place in photography, and if we are honest, many of our favourite pictures – the ones we could least bear to part with – are no more than snapshots.

Some of us, though, go on from snapshots to become interested in photographs for their own sake. Instead of trying to make a personal, particular record which is only meaningful to us, we try to capture in the photograph the emotions which the place aroused in us, so that we can communicate them to other people. Incidentally, 'the communication of emotions' seems to me to be a pretty good working definition of 'art', but the old art-and-photography argument still rumbles on. Apparently, some people cannot believe that you can use a camera to create 'art', though why it should be any more peculiar to create 'art' with a camera than with pigs' bristles tied to a stick and dipped in pigment mixed with oil I cannot see.

I have no answer to the question *why* we should try to communicate our emotions, but I suspect that it is a part of the definition of being human. On the other hand, an excellent measure of our success as a photographer must surely be the effectiveness with which we do communicate them. A 'good' photograph, by this definition, is one which moves other people to experience what we want them to experience: a 'bad' one is simply boring.

This deals with the general motivation for taking photographs, but not with the specific motivation for taking landscapes. This must surely be a matter of personal experience and taste: some of us are moved by landscapes, and some are not. My own reason for taking pictures of landscapes, and I suspect the reason which most landscape photographers would give, is a love of certain places, and certain feelings which those places evoke. At this point, we slide into the question of *what* we photograph, which is a very different matter from *why* we take landscape pictures.

Some photographers are attracted by man-made scenery: picturesque villages, landscaped fields, Palladian houses, or city streets. Others are drawn to the wild places: stormy coasts, bare deserts, the

**83 Vineyards** This picture of vineyards beside Switzerland's Zurcher Zee is little more than a snapshot. It would have a certain saleability as a stock shot, but it is hardly personal enough to qualify as a carefully considered landscape (*RWH: Leica M: 35/1.4 Summilux: KR*)

**84 Bathers by the Jumna** By contrast with the Swiss vineyards, this photograph of bathers by the Jumna is a long way from a simple souvenir shot. It was taken from the walls of the Taj Mahal, using a 200mm f/3 Vivitar Series One lens with a 2× teleconverter to give a 400mm f/6 – the image was actually shot at f/11 actual, f/5.6 marked. I found the misty landscape and the bathers a much more interesting subject than the Taj itself (*RWH: Nikon: PKR*)

106

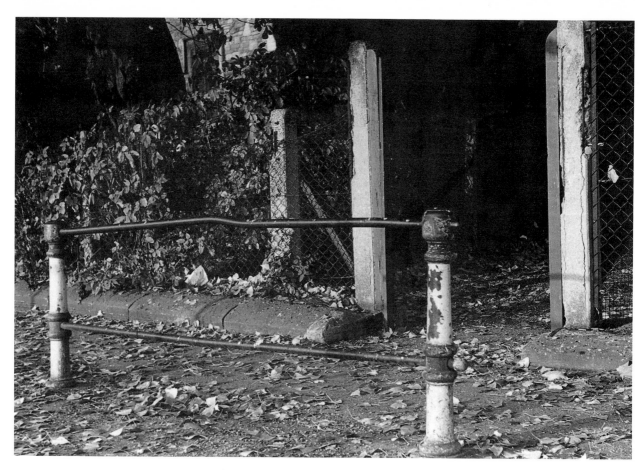

**85 Railings and fallen leaves** The mere fact that something is familiar, and rarely warrants a second look, does not stop it being a subject for a potential landscape. I used to pass these battered railings every day on my way to work; and then I suddenly saw them one day as if for the first time, and photographed them with the old Leica IIIa I used to carry in my pocket (*RWH: St Werburgh's, Bristol: 50/3.5 Elmar: HP4/ Perceptol/EI 320*)

fantastic sculptured landscape of Utah and Arizona. Some work on a small scale, concentrating on a single tree or a stand of plants, while others prefer mountains and huge panoramas. Some are drawn by heat; some by cold; some prefer blue skies, others brooding thunderheads. The essential thing is to recognise what it is that *you* like, and to concentrate on that.

This is not necessarily as easy as it might seem. To begin with, you have to distinguish between *photographs* that move you, and *places* that move you, and to recognise that the two do not always coincide. For example, much as I admire Bill Brandt's photographs of the English north, it is not an area to which I feel drawn; and much as I love Dartmoor, I have seen very few photographs of the moor that I really admire, and I have never managed to take any myself. On the other hand, on my first visit to Yosemite National Park, I fell in love with the place, and (I think) I have taken some of my best photographs there. I felt the same way when I first saw California's Pacific Coast Highway, but I have never managed to capture it quite so well.

Once you have found the place that you want to photograph, you have to muster the techniques needed to photograph it. The photographic techniques have been covered in the first part of this book: what we are concerned with here are the techniques which are no longer 'photographic' in the conventional sense, but which must be cultivated by the photographer if he is to succeed aesthetically. This sounds like a will-o'-the-wisp, but there are actually several areas in which you can make a conscious effort.

### Patience
The first and most important virtue that you need to cultivate is

108

*patience*. Only by waiting until the picture feels instinctively 'right' can you hope to get a great landscape photograph. All too often, there are pressures which stop you waiting – a meal ready at home, other people eager to leave and do something else, tiredness or cold – and giving in to them makes you miss your picture. You *have* to be prepared to resist those pressures, and to wait as long as necessary. The wait may be a matter of a few seconds, as the sun comes out from behind a cloud, or it may be a matter of minutes, while you wait for someone to walk into or out of shot. It may be a matter of hours, waiting for rain to stop, or even of days, weeks, or months until you can return again. Whatever you do, though, if you *know* that the picture is waiting to be taken, have the patience to wait until it is ready to be taken.

An example of this appears in Plate 142: the two figures reflected in the lake were not there by chance, and I had to wait for what seemed like hours while they picked their way over from the car park to the lakeside. By contrast, I saw the shot of the sky over the farmhouse in Plate 7 as I was driving along the road, and I had to stop, jump out of the car, put the 280mm lens on the camera, and climb over a railroad track before the light changed. It is an interesting thought that one of Ansel Adams's most famous pictures – 'Moonrise, Hernandez, New Mexico' – was taken under exactly the same sort of conditions, except that it took Adams and his assistants ten minutes to set up the large-format wooden camera which he favoured!

## Quality of Light

In addition to patience, you must also cultivate an awareness of

*Overleaf*

**87  Birmingham Town Hall**
Although exotic locations do wonders for the creative imagination, there are many picture opportunities in more prosaic locations. This is Birmingham Town Hall, which is virtually impossible to photograph in its own right, but which makes quite a striking picture reflected in the windows of offices opposite. Unfortunately, familiarity (I lived in Birmingham for four years) breeds carelessness: notice the discarded wrapper in front of the window. The picture has been 'flopped' for reproduction, in order to make the signs read properly: otherwise, of course, they would have been mirror images (*RWH: Leica M: 35/1.4 Summilux: PKR*)

**86  Wrecked army bus, Malta**
Normally, a wreck like this would be regarded as an eyesore – but it can also form the centrepiece of a landscape which shows how carelessly man uses his environment, even when he has so little space to spare, as on the rocky island of Malta (*TH: Nikon: 105/2.5 Nikkor: FP4/Perceptol/EI 80*)

*Previous Page*

**88   Three Rivers Reservoir** This could be a lake or reservoir almost anywhere, although in fact it is Three Rivers Reservoir in central California. The important thing is the boat: without that, the picture falls apart. Cover the boat with your finger to see what I mean (*RWH: Leica M: 90/2 Summicron: PKR*)

**89   Painted Desert, New Mexico** New Mexico's Painted Desert is full of extraordinary colours, though unfortunately (as can be seen) the day we passed through it was rather hazy, and the colours are not seen to their best advantage. Even so, it is worth taking pictures like this in case you never manage to return on a better day! (*RWH: tripod-mounted Leica M: 280/4.8 Telyt: PKR*)

**90   Kew Gardens** Kew Gardens are a familiar subject to most Londoners, but there are many different ways to see them. Shooting *contre-jour* (into the sun) has provided dramatic edge-lighting for the figures in this picture as well as emphasising the size and lightness of the hothouses themselves. Notice how foreground foliage is used to fill empty sky; this should by now be a familiar trick (*TH: Nikon: 35/2 Nikkor: FP4/ Perceptol/EI 80*)

**91   Kew Gardens** Another view of Kew Gardens, but concentrating this time on the heat and humidity. The way in which the individual panes of glass obscure or transmit detail is intriguing in itself; so is the contrast between the curving natural forms of the plants and the regular metalwork of the hothouse. This chapter is called 'The Search for a Landscape', and these two pictures give plenty of ideas on *how* to search (*TH: Nikon: 105/2.5 Nikkor: FP4/Perceptol/EI 80*)

'quality of light', a somewhat nebulous and hard-to-describe phenomenon, but one of the things which really captures a place. It really means two things. The first is the way in which, with the passage of the day, the light changes. Before dawn, the air is clear, the light is blue, and (often) there will be no one around. Then, at the moment of dawn, the sun's rays turn everything to a startling gold, with long, long shadows. As the sun moves in the sky, the shadows grow shorter and the bluest part of the sky (which is normally opposite the sun) moves, while the light itself becomes brighter and bluer – in technical terms, the colour temperature rises from maybe 5,000°K to 5,500–6,000°K – until it is at its most blue at noon.

Meanwhile, the air is beginning to get hazier and hotter, with dust and heat-haze breaking up the crystal-clear edges and shapes of dawn. Then, as the afternoon wears on, the shadows are in the opposite direction from where they were in the morning, and the opposite faces of rocks, mountains, and buildings are illuminated. At evening, the light begins to redden again, but because of the dust and heat-haze in the air – and the atmospheric pollution, too, if you are in or near a city – its quality is quite different from dawn. Finally, at sunset, you often have even more dramatic colours than at dawn, simply because there is dirt in the air, and after a final red flush the light goes blue once again.

All this, of course, assumes only a clear, sunny day. If there are storm-clouds, they move across the sky: the rain itself may wash the air and bring out all the colours in the landscape, while mist will mute them. If you are near a populated area, whether it is a beauty spot or a city, there will be very few people about at dawn (especially in the summer), but there will be peaks and troughs during the day.

The second meaning of 'quality of light' is the way in which different places seem to have different kinds of light. The light in Paris always has a steely sort of clarity to me, while in San Francisco it is clear, sharp, and bright – the light in Cornwall is rather similar – and in Shropshire and Warwickshire it has a kind of softness to it. These are very hard things to express, and (of course) they will vary according to how well we known a place, and when we see it: for example, I have only ever been to Bern once, and I remember the light as being very warm, but I am sure that it is not always like that (Plate 156 was taken on that trip; if you look at it, you will see what I mean).

## Perspective

Perspective is surprisingly closely allied to the quality of light. In a clear light, especially at dawn, you cannot rely on aerial perspective in the same way that you can on a hazy afternoon. Instead, you have to emphasise it in other ways, and the two most useful are *convergence* (which is 'classical' perspective) and *use of foreground*.

On its own, mere convergence is surprisingly ineffective unless you have a pair (or more) of *known* parallel lines. This is why shots of railway tracks and long, straight roads are so effective, especially if they are taken with a moderately wide-angle lens. If you use anything longer than 50mm, you lose the impact of the convergence, and if you use anything wider than 28mm you emphasise the foreground so much that you need something there to justify the attention that is focused upon it. It need not be much – a single plant will do very well

112

**92 Houses, Portland** Afternoon sun provided a dramatic picture, but a fairly long lens was needed to 'stack' the perspective and emphasise the repetition of the shapes. This is one of the few pictures in this book taken with a zoom, the extraordinary 90–180mm f/4.5 Vivitar Series One Flat Field: the results invite comparison with prime lenses. This was shot at 180mm (*RWH: tripod-mounted Nikon: PKR*)

**93 Dockside** Tim Hawkins haunts the river and the docks, and gets some beautiful pictures from apparently unpromising subjects such as derelict piers. (*TH: the Thames: Nikon: 105/2.5 Nikkor: EN*)

**94 Boat on Lake Tahoe** Compare this with the picture of Three Rivers Reservoir (Plate 87) and the picture of Lake Tahoe (Plate 37): in both the boat is used to complete the composition and to provide a focal point for the picture. Here, the boat appears at first to be all that there is in the picture – but the subtle gradations of tone and texture in the water are the real reason for the picture, the boat merely providing a stopping-place for the eye (*RWH: tripod-mounted Leica M: 280/4.8 Telyt: PKR*)

– but there must be something, or you will have an ugly, empty, uninformative space. Look at the snow scene in Plate 151: without the lamp-post, the picture would lose a great deal. On the other hand, if there is lots of foreground detail, you can cheerfully use an ultrawide: look at the picture of the Roman theatre (Plate 103).

Using foregrounds to emphasise perspective is an old, old trick: every book on landscape photography ever published advises you to use an arch, or the trunk and bough of a tree, to 'frame' your composition. Hackneyed though the advice may be, it still has a good deal of merit. In the first place, it emphasises the difference between near and far by means of scale; in the second, it emphasises aerial perspective; and in the third, it provides a rectilinear contrast to convergence. The use of foregrounds does not stop there, though; *anything* may be used as a centre of attention, so that the eye has something to latch on to, even if it is not the primary subject of the picture. The photograph of the fishermen and the rowing four (Plate 106) illustrates this point: the rowing four is the primary subject, but the lower part of the picture would look terribly unbalanced if it consisted simply of empty river bank – I know, I shot it that way, and it looked boring!

## Composition

By now, when we are considering the relationship of the different items in the picture, we are into the realms of 'composition'. I place the word in inverted commas in order to emphasise that the old camera club Rules of Composition, with capital letters, are not really what I am talking about. Many of my readers will, I hope, be unfamiliar with the old camera club competitions, where self-appointed

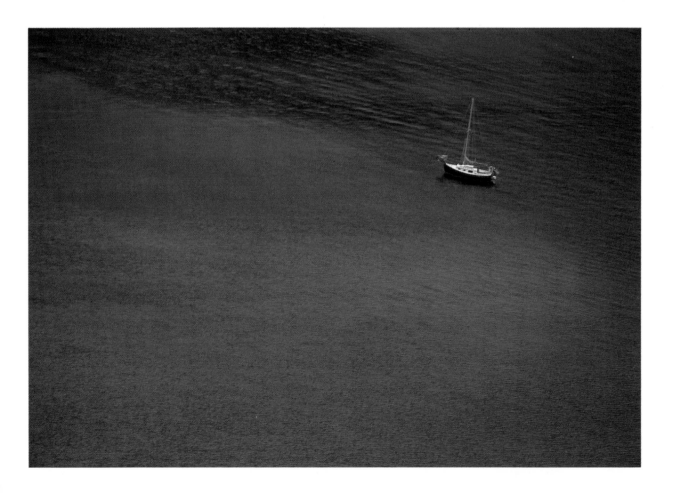

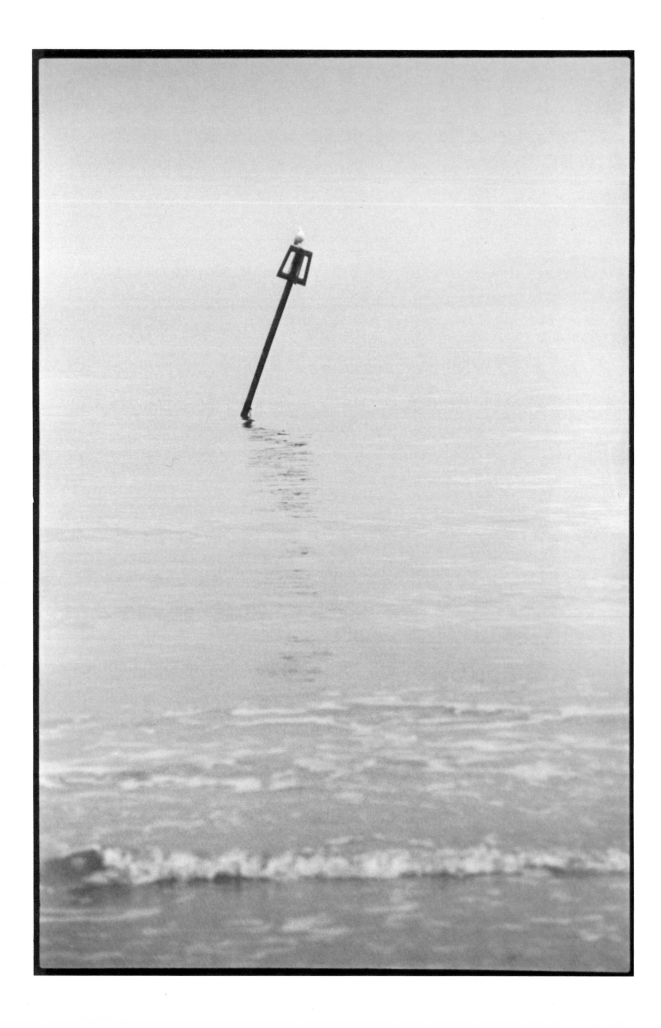

pundits waffled on about the Rule of Thirds, the S-Curve, 'dynamic' and 'static' compositions, and so forth, but completely ignored the content and photographic strength of a picture. The trouble was that although there was a great deal of truth in these old 'rules', they were so rigorously applied that winning competitions became rather like entering the Imperial Chinese Civil Service: form, not content, was all that was considered. Deadly dull photography prevailed for so long in so many camera clubs that when eventually the photographic Young Turks revolted in the 1960s, they threw out the baby with the bathwater, and 'composition' became a dirty word.

Because there *is* some truth in the old Rules, I give them here for reference; you can judge for yourself whether or not they apply to the pictures in this book, to other pictures which you like or dislike, and to your own work, and judge them accordingly.

The principal Rule is the Rule of Thirds, which states that if you divide a picture into equal thirds, vertically and horizontally, with two lines in each direction, the 'principal subject' should be on the intersection of two of those lines. In fact, this is surprisingly widely applicable, especially if you bend the lines a bit.

Secondly, we are told that pyramidal compositions (that is, pictures in which the main picture elements are 'stacked' in a triangle) are 'stable' and convey solidity, while diagonal compositions are 'dynamic' and convey movement. Vertical lines (and 'portrait' or vertical format pictures) are dynamic and represent aspiration; horizontal lines (and 'landscape' horizontal format pictures) are restful and stable. An inverted triangle (one resting on its tip) is unstable. Again, there is a certain amount in this.

Thirdly, the horizon should never be in the centre of the picture.

**96 Rubble and planks** Technically, it could be said that this picture leaves a lot to be desired; but the very high contrast reinforces the image of utter desolation, and the thin, uncertain border somehow makes it even harsher. It is not a picture that I like, but it is a picture which I think has a lot of power (*RWH: Leica IIIa: 50/3.5 Elmar: Pan F/ Kodak D19B/EI 80: printed on grade 5 Ilfobrom*)

**95 Seagull resting on marker** Many people think that the key to successful landscape photography is 'getting it all in', but as this and other pictures in this book show, it is often better to *exclude* more than you include. What does this picture say to you? There is a touch of humour in it; a hint of the transience of man's works; and a very good example of composition according to the Rule of Thirds (page 117) (*TH: Nikon: 105/2.5 Nikkor: FP4/ID11/ISO 125*)

117

**98  New York skyline** The time of day can make a lot of difference to whether you have a picture or not. In the evening, when the sun is reflected from New York's skyscrapers (and especially from the World Trade Center), you get a much more dramatic image from the Staten Island Ferry than you do in the morning. This was taken with a 90mm f/2 Summicron, because it was before I got my 135mm f/2.8 Tele-Elmarit for the Leicas: the longer focal length would have given an even more dramatic picture *(RWH: PKR)*

**99  Dawn on the Ganges** In many Third World countries, you need to be up very early indeed if you want to capture people going about their daily work in the landscape. This was taken just after dawn, from a boat in the Ganges – the very best way to see Benares *(FES: Nikon: 200/3 Vivitar Series One: KR)*

**97  Cornfield, Hampshire** The gradation of texture is the main attraction in this photograph of a Hampshire cornfield. The ears at the front are clear; as the distance increases, they blur together more and more. Because there is such strong foreground texture, there is no need for a separate 'focal point' *(RWH: Nikon: 35/2.8 Nikkor: KR)*

Once more, this makes sense: pictures with a central horizon often *do* look bisected and featureless, while those which incorporate plenty of foreground (like the Roman theatre in Plate 103, already mentioned in the context of foreground) or plenty of sky (like the picture of Alcatraz, Plate 131) concentrate the attention on the important part of the picture rather more effectively.

Fourthly, there is the distinction between curved and straight lines. Hogarth maintained in his essay on 'Line of Beauty' that the most perfect line is a curve which resembles the curve of a woman's back, though Sir Oliver Holmes countered that 'stiffness and angularity . . . have a certain manly strength and vigour'. I find that the greatest landscapes contrast the two, so this sounds like a bit of a non-argument to me.

Finally, for our purposes, there is the S-curve, vulgarly known as the S-bend. This is supposed to 'lead the eye into the picture', and the classic example always quoted is the garden path winding its way through the cottage garden to the garden gate. At one level, this is no more than a reiteration of the advice already given about foregrounds; on another, where the 'S' *had* to be continuous and (vaguely) S-shaped, it is a prime example of the evils of Rules of Composition. There are whole books on this subject – most of them now mercifully out of print – and if you want to research the subject further, easily the best that I have ever read is Richard N. Haile's *Composition for Photographers*, first published in May 1936 by the Fountain Press in London.

## Light and Shade
A closely related topic to composition is the way in which light and

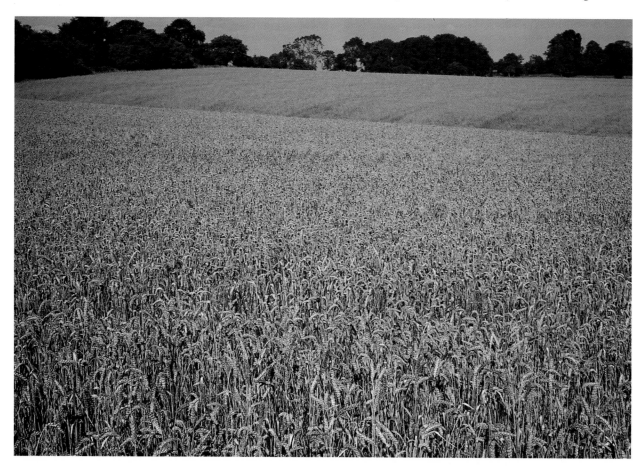

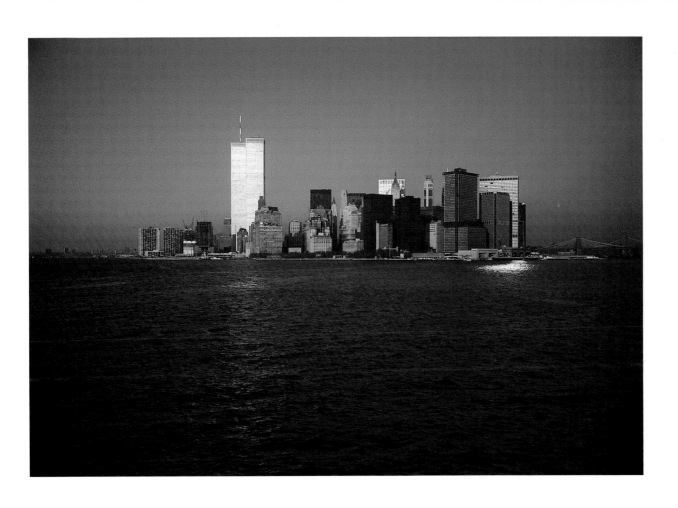

100 **Bay, Dorset** This is a general view of the same bay and natural rock arch that is shown in Plates 49 and 50; it shows that you may have to do a fair amount of walking, climbing, and scrambling in order to get a range of viewpoints – merely changing lenses is not enough! (*TH: Nikon: 35/2 Nikkor: FP4/Perceptol/EI 80*)

shade are used. In traditional Western art, we use the term (and the techniques) of *chiaroscuro*, from the Italian for 'clear/obscure'. Shadows are used as a counterpoint to clarity, in order to give roundness and modelling: this is obviously related to what was said earlier about 'quality of light'. The classic master of chiaroscuro is generally held to be Rembrandt, though Wright of Derby anteceded him and (in some art historians' opinion) used the technique more effectively. In 'Rembrandt lighting', the principal subject emerges from shadow, a technique obviously better suited to portraits than to landscapes, though the use of light to create an impression of roundness and shape may be seen (in particular) in the pictures in Plates 22 and 30.

Chiaroscuro is not, however, the only way of using light and shade. In Eastern traditions, and especially in Japan, a different technique is used: the Japanese word for it is *notan*, which means 'dark/light'. This technique, for which there is no English word, uses tone alone (with no chiaroscuro) to delineate form. Although roundness is not shown in *notan*, it is quite possible to convey shape by any of the methods already described for conveying perspective. In landscape photography, perfect *notan* is extremely rare, except perhaps on a completely overcast day, but if the elements of the picture are tied together in this way instead of by chiaroscuro, the effect can be very striking indeed: perhaps the nearest to a *notan* picture in this book is Plate 1, which is possibly my favourite among all the pictures I have ever taken. *Notan* is also applicable to those landscapes where the air is very clear, and shadows are short and jet-black, as in the desert.

120

# 6
# PEOPLE IN LANDSCAPES

The question of whether or not to include people in landscapes is a fundamental one, upon which landscape photographers are divided. One school says that you are photographing landscapes, not people, and that people are at best an irrelevance and at worst a distraction. The other school says that people give scale to landscapes, and that they are (in effect) a part of the scenery, so to exclude them makes for an oddly sterile effect.

Although at first sight it may seem to be something of a non-question, and certainly not one which warrants a chapter to itself at this point, it is actually very important indeed. The decision to include or exclude people can make an enormous difference to your landscapes, because we *always* search a landscape for people: it is probably a survival characteristic developed over two million years, looking for friend or foe. Consequently, unless you really do want a figure in a landscape, people can be distracting – and if you do want them, you want them in the right place, where they do not blend too easily with the background. This is one of the arguments for using a tripod: you can check through the viewfinder and by eye, returning to the viewfinder and pressing the release only at the appropriate moment. The 'appropriate moment' may of course be when someone walks *into* the right place in a picture, or when they walk *out* of the wrong one.

From this it is obvious that both schools of photography – those that exclude people, and those that include them – can be right. It is also obvious that for each picture, it has to be a conscious decision whether you include or exclude people, and your decision will be influenced by the kind of picture that you want. In cities, or anywhere that there are usually people, I normally include people for scale and interest. In wild country, I normally exclude them: if the attraction of a particular piece of scenery is its isolation, then it makes little sense to destroy that feeling of isolation by including people. Even so, these are not hard and fast rules. A city can be so bleak and bare and harsh and inhospitable that the photograph almost requires that people be left out: there seems to be no place for them in a concrete temple to the motor car. Conversely, where a landscape is on a titanic scale, a person can increase the sense of awe and majesty, by contrasting the tiny scale of human beings with the enormous sweep of the landscape.

Because I like to photograph people when I feel that they are important in a landscape, some of the pictures in this book border almost upon portraits: for example, the Hindu sadhu in Plate 165 is an essential part of the picture, and without him it would be nothing.

But it is more than just a portrait: it is also an image of the way that Benares looks, which to me makes it a landscape. Perhaps the point is more clearly made by the picture of the Californian coast in Plate 102, where the tiny figure of the writer Paul Bell not only conveys scale but also provides a focal point to the picture – something which I talked about in Chapter 2. The photograph is not *about* Paul Bell, it is *about* the landscape, but without him the picture would, I think, have been weaker.

Because of the tremendous 'drawing power' of a figure in a landscape, we do not always need to worry too much about compositional niceties in choosing where we position them. On the other hand, there are a few techniques – tricks, almost – which can increase or decrease the impact.

An obvious technique is to place the figure on the intersection of thirds (page 117), or to use the 'vanishing point' technique of leading the eye into the picture (as shown in Plate 128), but there are two or three other psychological techniques which also affect our perception of a figure in a landscape. One is that if someone is walking 'into shot' – that is, if he or she appears just to have walked into the picture, rather than to be just about to walk out of it – the effect is much more tranquil than if they are walking 'out of shot'. The same applies to the direction in which someone is facing; someone who is looking 'out of shot' automatically implies that something more interesting is going on outside the picture than is going on inside it. And finally, because we are conditioned in the West to read from left to right, a figure on the left of a picture will usually have more impact than a figure on the right.

This chapter is not just concerned with people in landscapes,

**103  Roman theatre, Arles**
Sometimes a figure is necessary for scale. Without a figure in it (it is Frances Schultz), it would be very difficult to guess the size of the Roman theatre at Arles. Using the 21mm f/2.8 Elmarit does, of course, exaggerate the distance from the seats to the stage, but the figure gives a clear idea of the scale of the stage itself and of the colonnade which forms its backdrop (*RWH: Leica M: 21/2.8 Elmarit: PKR*)

**101  Devil's Garden** The Devil's Garden, off California's magnificently scenic Route 88, is such a desolate and forbidding place that to put a person into the picture would alter its mood entirely. Besides, the scale is such that a person would hardly be visible! (*RWH: Leica M: 35/1.4 Summilux: PKR*)

**102  Pacific Coast Highway** A remarkable number of pictures in this book were taken in California, but that is because it is such a beautiful place. In this shot, the writer and designer Paul Bell provides a focal point for the picture; his outfit, reminiscent of a Victorian explorer, makes the scene look accessible but new (*RWH: Leica M: 50/2 Summicron: PKR*)

104 **Finsbury Park Station** This is close to being a portrait, in that the nineteenth-century railway architecture and the FINSBURY PARK sign are of little interest without the stationmaster and his magnificent Victorian beard. Even so, it is not quite a portrait: looked at in another light, the figure completes the landscape (*RWH: Nikon: 55/3.5 Micro-Nikkor: FP4/Microphen/EI 500*)

though; it is also concerned with the *evidence* of people in landscapes. People leave all kinds of traces of themselves, from litter to medieval castles, and it is worth looking at the way in which these traces affect our landscapes.

As with the people themselves, the fundamental decision is whether to exclude them or include them; somewhere inside the second alternative is the extent to which we make them the subject of our pictures, or merely use them as an element in a greater landscape. Of course, Chapter 9 is concerned almost exclusively with the works of man, but in other landscapes we may have more choice.

Those aspects which we find distasteful, we will do our best to omit. Litter can be picked up – a valuable public service, quite apart from the pictorial improvements which inevitably result – and by moving around a bit we can often find a camera position which allows us to 'lose' an unsightly sign or telegraph pole. It is quite fascinating how a sign, which we would normally never notice, suddenly leaps into prominence in a photograph. For some reason, signs advertising public lavatories always seem more plentiful and more prominent in photographs than in real life, and the ubiquity of telephone and power cables is such that my wife and I refer privately to them as 'Himalayan blight', because even in the Himalayas they seem to be everywhere. By the same token, tower cranes are 'Zurich

124

'blight', because we were on a shoot there once and the entire city seemed to be in the process of reconstruction by these giant cranes.

Learning to spot these various forms of 'blight' is a matter of practice, because our vision is normally highly selective. I can glance out of the window as I write this and see a scene which is a hundred per cent familiar; but then, if I look, I will see that there is a bag of builder's rubbish and some broken furniture outside the house opposite, where they are doing some rebuilding, and that there is one large piece of white paper in the gutter opposite (only one – the street cleaning must be improving) which would stand out like a sore thumb if I took a photograph.

All too often, we are blinded by our *intellectual* appreciation of what we see: we see a Georgian terrace, for example, and we photograph it – ignoring the scaffolding which covers one of the houses, the builder's skip outside, and the ONE WAY STREET sign which glares in the corner of our picture. By coming in closer, or changing our viewpoint, we might have been able to lose either of them; alternatively, we might have been able to hide the sign behind a tree (which always looks better than a metal post) or to 'lose' the builder's skip (if not the scaffolding) by crouching down behind some flowers and using them as a partial cover. One photographer of my acquaintance actually carried a bunch of rhododendrons around with him on one shoot, for precisely this purpose: he reckoned that a clump of out-of-focus flowers in the foreground was more attractive than an all-too-clearly focused parked Volkswagen in the middle distance.

We can of course change tack entirely and *concentrate* on these disagreeable subjects, either drawing attention to their disagreeableness or revealing their hidden beauty. This is especially true in urban landscapes; a cracked and broken door, surrounded by rusty railings, in a condemned house does not sound like a promising subject, but I

**105 Seascape with rocks** In this picture, there are at least four figures, but they are so small that they are hard to spot, though you should be able to see the couple on the extreme left, one in a black sweater and one in white. 'Losing' figures like this is easy with wide-angle lenses, though whether this is an advantage or a disadvantage will depend on your intentions in taking the picture (*TH: Dorset coast: Nikon: 35/2 Nikkor: FP4/Perceptol/EI 80*)

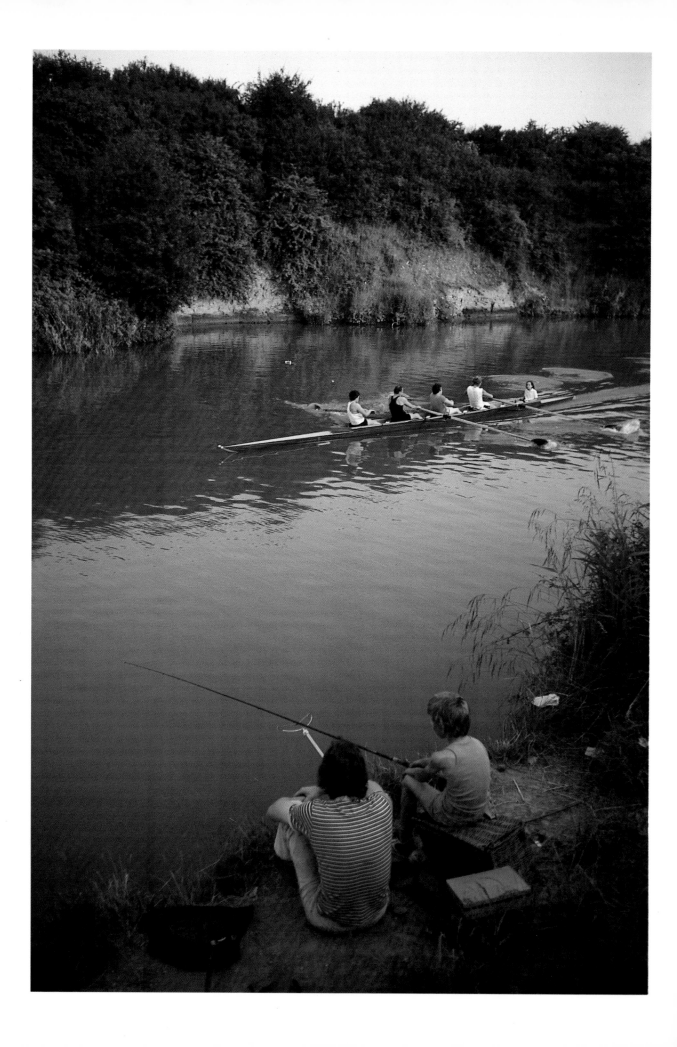

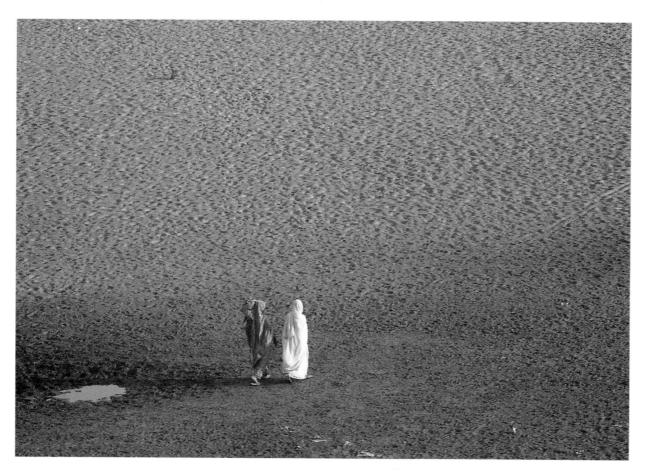

am very fond of Plate 166. Viewed properly, almost anything can be attractive: electricity pylons have a majesty of their own, and even an empty chocolate wrapper lying crumpled on the path can become a fascinating mini-landscape if photographed close enough with a macro lens.

As soon as we start concentrating on the attractions (however disputable) of man's influence on the landscape, though, we are talking about a rather different approach to the subject. There are subjects which are 'picturesque' by common consent, like the disused engine-houses that litter the Cornish moors, and there are others which have a graphic, dramatic quality to them. There are also subjects where man's hand is not immediately obvious, because we think of the subject as 'natural', such as farmland.

The most obvious effect of man is, however, *order*. 'Order' may be manifested in ploughed furrows, or in hedgerows planted in lines, or in walls and buildings, or even in huge landscaped gardens in the tradition of Capability Brown, but I would say that the difference between man's work *as subject* and man's work *as part of the wider landscape* lies in the photographer's treatment of that order. If he emphasises the order, and concentrates on it, it will achieve one effect; if he contrasts it with nature's disorder (or to be more precise, with nature's entirely different kind of order), he will get quite a different range of effects.

As with much else in this book, this may seem like a statement of the obvious, but like many statements of the obvious, it is only obvious when you have understood it. It took me a long time to realise the different ways in which I and other photographers achieved particular effects, because most photographers are so poor

**107 The Banks of the Jumna**
Without the two women going to fetch water, there is not really any picture here at all; but as with the picture of the fishermen and the rowing four, their presence says a great deal about the landscape. This was shot from the same position as Plate 84, from the walls of the Taj Mahal (*RWH: Nikon: 200/3 Vivitar Series One: PKR*)

**106 Fishermen and a rowing four**
Originally I set out to take pictures of the rowing fours and eights which practise along this stretch of river in Gloucestershire, but I was not particularly satisfied with the results. By switching from a 90mm lens to a 35mm f/3.5 Summaron, I was able to show how different groups of people share the river. Is it a landscape, or is it reportage? I think it is a landscape, because it shows how people use the countryside. Without the fishermen in the foreground, incidentally, this picture is incredibly boring; I shot a similar one a few yards up the bank

**108 Figures and tree** Figures can be used as graphic components of an image, without showing them in detail. This is a lith-derived print by Dick Painter: by removing all detail other than the figures and the sky, and printing only a thin strip of land along the bottom of the picture, he has created an image which is at once humorous and intriguing (*No technical information available*)

**109 Man in deckchair** The sunlight on the grass behind this peaceful reader reduces him to a silhouette, but because there is detail elsewhere in the picture it is not an abstraction in the way that Dick Painter's picture is. The second, empty deckchair adds an ambiguous note; on the one hand it is redolent of holidays and relaxation, and on the other it prompts us to ask what happened to its occupant (*TH: Nikon: 105/2.5 Nikkor: FP4/Perceptol/EI 80*)

at verbalising what they do, and because most people who write about photography are not photographers and indeed often seem to know very little about actually taking pictures: I have yet to meet a practising photographer who took one particular, and well-known, critic seriously. It is all very well to urge people to look at pictures, rather than to read words, in order to learn how to take pictures – but there have to be explanations somewhere. If you had never seen a camera, how would you react to *any* photograph? And if you already understood about using a camera, but had never used or encountered anything more sophisticated than a box Brownie, how would you begin to understand the technical excellence of an Ansel Adams landscape? And even if you understood all about the technical side of it, how would you understand the aesthetics of the picture?

Returning to this question of order, it seems to me that the only way we can celebrate it, and make it the true subject of the picture, is by concentrating on it: think of the Bauhaus, the Futurists, and the Russian propaganda posters of the 1920s and 30s. There is no room for nature in any of them, and graphic shapes and drama are everything. As soon as we allow nature any access at all, we immediately begin to judge things by nature's standards, not by man's, and the central question becomes the degree of integration of the two themes.

This is, perhaps, why so many people find ruins attractive, and why rich eighteenth-century gentlemen built 'follies' – imitation ruins, for the most part – in order to improve the view from their mansions. A ruin is almost by definition increasingly integrated with the landscape, and an old building which has acquired a patina of wear, weathering, moss and lichens is almost invariably more attractive than a bare, brash modern structure. On the other hand, if man borrows from nature's order in his own building, there is a degree of integration already at hand, but it must be *real* integration, not a few token flowers in tubs and spindly trees supported by posts. This is why some 'hippie' communes, living in wigwams, can appear to be at one with the landscape – and it is also why poverty in Third World countries is so often aesthetically attractive to the eye of the Western beholder. He wonders why he is being shown hideous concrete factories, and power stations, and gaudy new temples when a few miles or even a few hundred yards away there are huts with walls of woven branches and palm-leaf roofs. The simple answer, of course, is that the factories and power stations, and the ugly new concrete terraces that house the workers, represent a vast improvement in the standard of living of the people. But this is an intellectual response, and the emotional response – which is usually also the aesthetic response – usually favours the old and familiar rather than the new.

Here is the place to leave this chapter, in the realisation that for all our sophistication, we can still fall for the old, old clichés, and that good landscape photography (with or without people) is as often as not a matter of reinforcing our existing preconceptions, and of showing us what we already know, rather than showing us something completely new. If further proof were needed, just look at all the propaganda pictures churned out by totalitarian governments all over the world, depicting Progress. How many of them are anything more than laughable at best, or pitiable at worst?

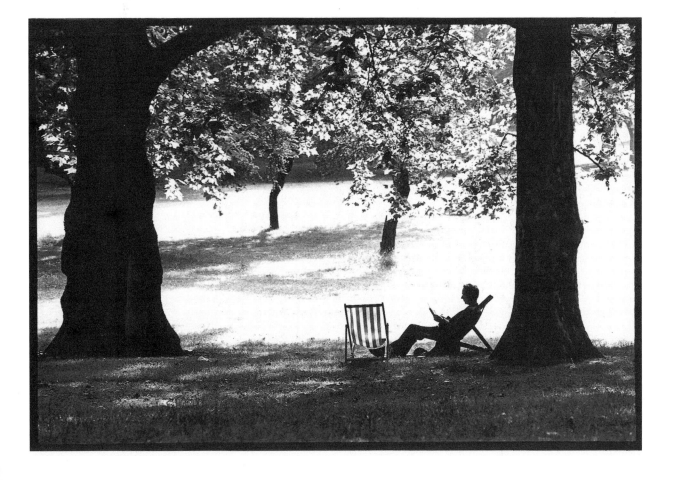

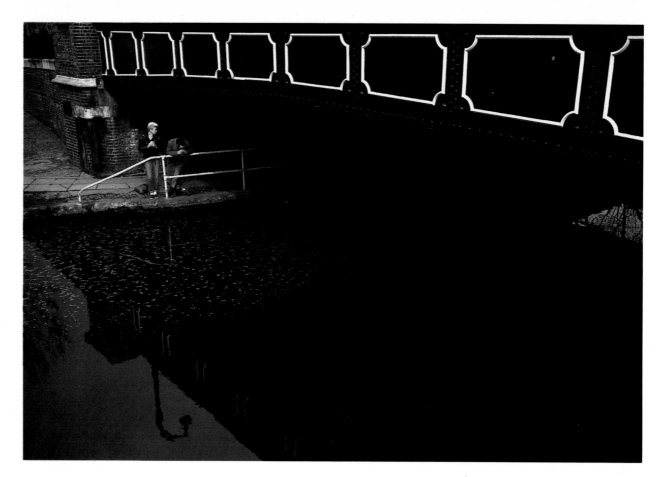

110　**Bridge, Camden Lock** This
picture is not terribly successful,
because the people and the bridge (at
London's Camden Lock) compete for
attention. You will normally have to
choose between making people
incidental – using them either for scale,
or as a 'focal point' – or making them
the centre of attention (*RWH: Leica M:
35/1.4 Summilux: PKR*)

111　**Tree and mountains, Mount
Wilson** Here, we return to my
weakness for misty mountains, as
mentioned in Chapter 3. The bare tree
in front of the mountains (shot from
Mount Wilson again) is a symbol of
death, isolation, and spiritual renewal;
even if it were possible to fit a person
into the picture, he would look wildly
out of place (*FES: Nikon: 90/2.5 Vivitar
Series One: PKR*)

# 7
# MOUNTAINS, VALLEYS AND PLAINS

'Mountains, valleys and plains' is a fairly comprehensive description of most people's landscape photography, but each of those subjects has its own special characteristics, and needs to be photographed in different ways in order to bring these out. Like most photographers, I am drawn to wild, craggy scenery, so this chapter begins with the mountains.

## Mountains

One of the most intriguing things about mountain photography is that it is so different in so many ways from what you expect before you try it. You imagine that wide-angles are going to be essential, but long lenses turn out to be the most useful. You think of mountains as being hazy blue-grey and you find that they can be more colours than you could imagine. You suppose that snow-capped mountains against a blue sky, perhaps with a few fluffy white clouds, will make the best picture and you find out that thundery weather is often the most dramatic of all.

There are some ways in which it does come up to your expectations, though. You do get tired and footsore climbing to your destination: it is hard work. You do get that sense of achievement that mountaineers talk about, even if you only scramble along a footpath and up a hill instead of defying death on a precipice. And unless you are careful, you can get sunburnt, thirsty and hungry.

Before you even consider photography, you should consider basic creature comforts and fitness. The best pictures generally require walking, and unless you can walk five or ten miles without undue fatigue, you should be reconciled to the fact that you may not be able to get the pictures you want. A pair of good walking boots is essential, with two pairs of socks; as a dedicated non-walker, I never realised how important this advice was until I started taking pictures in the mountains. At high altitudes especially, sunburn is a risk, so the more thoroughly you can cover your body, the better. Light long-sleeved shirts and trousers offer much better protection than T-shirts or short-sleeved shirts and shorts, and do not forget your head: once, after seven or eight hours at 6,000ft, I scratched at the top of one ear which was itching with sunburn and was horrified when it came off in my hand! The skin was as hard as an insect's shell, and it left the top of the ear raw and almost bleeding. In colder climates, be sure to dress warmly enough: exposure is painful at the best of times, and can be fatal. Be particularly careful if you are in an area noted for sudden changes of weather: snow on (say) the Pennines can be staggeringly beautiful, but a sudden blizzard can leave you disorien-

tated and struggling through snowdrifts. In thunderstorms, make sure that you are not the highest point around, because that is where lightning strikes: the same goes for sheltering under trees if they are the highest point. Forget dignity and comfort and lie down if necessary: last time I was in Yosemite, three climbers had been killed by lightning the previous week. They had been standing on the top of El Capitan, watching the thunderstorms play around them . . .

You will need to consider water, as mountain streams are rarely as clear and unpolluted as you might hope: taking a drink 'straight from Lord Shiva's brow' and then seeing a donkey wading through the water a hundred yards upstream is hardly settling to the mind or stomach. The same is even more true on lower ground. I normally carry a purifying straw, obtainable from camping shops, which makes the water taste vile but at least makes it safe. For food, sweets are all right if you like them, but dried meat or what the French call *saucissons secs* are better, though they make you thirsty.

If I begin to sound like a backyard survivalist at this point, I make no apologies. Getting the best pictures *does* require effort, and I have tried doing things the lazy way with no preparation and have regretted it: the extra effort is always worth it. And when it comes to putting in the extra effort, you have to know what you are doing, not only as a photographer but also as a walker. While I was learning this the hard way, I was lucky that I never got into trouble, but I have always taken care never to put myself in an unduly dangerous position and I have usually been accompanied by my wife (who is much fitter than I am), so if one of us was hurt, the other could always go for help. This may sound melodramatic, but tens of people are killed even in safe, friendly, overpopulated Britain every year by neglecting to take such simple precautions, and I'm too fond of living to want to quit yet.

Also, if you want the best pictures, you are usually going to have to be there at dawn or dusk. Dawn is usually both safer and more dramatic, as you can walk to your destination in the pre-dawn light and start shooting when the sun comes up: the air will be a great deal clearer than at dusk, and you will see the incredible and rapid colour shifts that mountains undergo. You can then walk back in daylight. This does mean getting up horribly early, which may not appeal to you if you are on vacation, but it is the only way to get the best pictures. If you can stand camping (I can't), you can of course be ready and waiting in the right location.

At the other end of the day, you can also get excellent pictures at sunset and dusk, but you do have the problem of getting back to your base again in the dark; to a city slicker brought up with street lights, it is a terrible shock to discover how dark it can get when the sun goes down! What I normally try to do is to take the shots where I have to walk at dawn; rest and eat from (say) eleven to three; and then concentrate on the shots where I can work a short distance from the car or motorcycle at dusk. The 'picture postcard' shots, which go into the picture library and pay the rent, are normally taken in the early-to-mid morning and the mid-to-late afternoon: despite the increasing visual sophistication of picture buyers, bright blue skies and happy holidaymakers still tend to sell better than moody dawn and dusk shots.

As for photographic equipment, you want the lightest camera

*Overleaf*

**112 Night on the Dhauladur mountains** The Himalayas are surely *the* definitive mountains, though the Dhauladur spur (where this was taken) is little more than half Everest's height, reaching a maximum of about 15,000ft. The camera was a Nikon EM, tripod-mounted on the roof of the Hotel Tibet in Dharamsala at an altitude of about 6,000ft. The standard 50mm f/1.8 lens was used at full bore, and the exposure – about eight seconds – was automatic. It was, however, long enough for the earth's movement to cause the stars to register as streaks, rather than points: anything much more than a couple of seconds will cause this, so I wish I had had the f/1.2 available. What I really like about the picture are the tiny points of lamplight on the mountainside (*RWH: KR*)

**113 Two children** Not all mountain-scapes are necessarily mountainous; these two enigmatic figures in a Himalayan mist are as worthy of a photograph as the mountain on which they walk. It is important to remain open to different kinds of pictures when you go out with the intention of shooting mountains, or anything else: too rigid an adherence to your original concepts can often mean missing first-class pictures (*RWH: near Gangchen Kyishong: Leica M: 35/1.4 Summilux: KR*)

**114 Bright Angel Trail** The Bright Angel is one of the few trails down the side of the Grand Canyon, which is a sort of reverse mountain – a mile-deep hole. Here people are essential for scale (*RWH: Nikon: 200/3 Vivitar Series One: KR*)

115 **Valley, Somerset** The gentleness of this landscape is emphasised by the obviously cultivated land and the road which is such a feature; only later do we notice the houses and village in the background. What really 'makes' the picture, though, is the beautiful light and the tonal range of the image. Look at the shadows: once again, this is 'snapshot light', over the photographer's shoulder (*TH: Somerset: Nikon: 35/2 Nikkor: FP4/Perceptol/EI 80*)

bodies you can find that will accept your lenses, and lightweight lenses as well: lens speed is unlikely to be at a premium, because there is normally plenty of light on mountain tops and in any case you should be carrying a tripod, as described below. I would recommend some or all of the following lenses: 85, 90 or 105mm (depending on which is available for your camera); 135mm; 200mm. If you want to frame your subjects with foregrounds of hanging trees, something like a 35mm may be useful. It helps if the 90mm (or 105mm) is a close-focusing lens, for details: invariably, if you only have long lenses, you will find something that you want to photograph close-up.

The 90mm or 105mm lens is best for general views and for panoramas, looking down from the mountains into the plains. The 135mm really comes into its own in the mountains, for picking out details while still showing context. The 200mm is perhaps the 'standard' lens, because of the way that it dramatically compresses perspective, 'stacking' mountains one atop the other like a Chinese painting; I sometimes carry my 280mm Telyt as well (or instead, if I am only using Leicas).

In order to carry your equipment – two bodies and three or more lenses – a photographer's jerkin or a backpack is essential unless you can drive everywhere. A conventional shoulder-mounted bag will be agony after the first hour or so, and a suitcase-type hard case will be useless from the very start.

You will also need a tripod. This is not a popular item when you are walking, but when you stop it is invaluable. Exertion, particularly for those who are less than fully fit, can increase camera shake to such an extent that you cannot rely on shake-free pictures even at

136

1/250 with a 90mm lens, and you will not stand a chance with longer focal lengths. In order to carry the tripod, either mount it *on top of* your backpack (not below, where the weight will be more obvious and it will bang about and get in the way), or get a rifle-style case; mine is made out of the leg from an old pair of Levis, with a strong over-the-shoulder strap and a Velcro-fastened top. I use the Gitzo, with a Kennett ball-and-socket head, and always insert the tripod *head-first* into the case so that a loose tripod screw cannot come loose and fall off. I also carry a spare screw!

Apart from physical effort and physical hazards, your biggest problems in the mountains are likely to result from aerial haze. Although the air tends to be much clearer in the high country, distances are also greater, and you can lose your image in a blue fuzz – though correctly handled, this is precisely what gives aerial perspective, and blue peaks rising from white clouds are a beautiful sight. If aerial haze is a problem, there are fortunately several ways to increase contrast. In black and white, there are the time-honoured 'sky' filters – yellow, orange, and red – and in colour you can use a 'skylight' or UV filter, a very slight warming filter such as an 81, 81A or R1.5, or a polariser. Each of these will have different effects: the UV will simply counteract excessive blueness from the increased ultra-violet levels at high altitudes, the warming filters will have a more pronounced effect, and the polariser can have the most incredibly dramatic effects at really high altitudes (10,000ft or more), turning the sky blue-black.

Another possibility for reducing haze is infra-red film. In black and white, if there is not too much vegetation around, the effects are fascinating: visibility is transformed, and peaks many miles away suddenly stand out crisp and clear with enormous contrast while still retaining a full tonal range. If there is any vegetation, though, it will record *white* on the final picture, because plants reflect a great deal of infra-red. In colour, the haze-cutting effects are much less dramatic, but the false-colour effects can be just as fascinating as the long-distance visibility in black and white.

Filtration for infra-red is something of a problem. In black and white, the ideal is a red filter so dark that you can barely see through it. A paler red will suffice, but the effects will not be as dramatic. Focus without the filter, and then put it in place, but do not forget to correct the focus using the focusing scale: reset the distance to the 'R' index if your lens has one, or to the f/5.6 depth-of-field mark nearer infinity (see Plate 119). IR filters are hard to come by and rather expensive, so a useful device may be a Kodak *porte-filtre* as illustrated in Plate 120. These forerunners of the Cokin principle accept 3 × 3in (75mm square) gel filters in plastic *montures* and can be clamped on to the front of any lens having an outside diameter of up to 70mm. Contrary to popular belief, 'gels' will last halfway to forever with careful handling – just do not touch them, which is where the *montures* come in – but also contrary to popular belief, they are not cheap any more: a 3 × 3in gel now costs nearly as much as a roll of Kodachrome. Both the *porte-filtre* (with its *montures*) and gel filters should be obtainable, or at least orderable, at any camera store with professional pretensions: they are all in the Kodak catalogue, and they are not expensive. Alternatively, you can use a Cokin or similar system, or a Sailwind or similar compendium lens hood –

*Overleaf*

**116  French Alps** Sometimes, the only way to get a picture is to wait . . . and wait . . . and wait. I saw this dramatic trick of the light while I was riding my motorcycle in the French Alps, but the fast-moving cloud meant that it was gone by the time I was able to stop. I knew (or at least hoped) that it would happen again, and twenty minutes later it did. I would have liked a stronger foreground, to offset the flatness of the picture, but there were no suitable trees available (*RWH: Leica M: 135/2.8 Tele-Elmarit: PKR*)

**117  Near Chhauntra** It is sometimes hard to draw a dividing line between the photography of mountains and valleys; and in many cases, the best pictures of the valleys are to be had from the mountains anyway . . . This is near Chhauntra in northern India, and both the mountains (the Himalayas) and the plains (the Indo-Gangetic plain) are the biggest in the world. This time, I did manage to get some foreground foliage as a 'frame' (*RWH: Leica M: 50/2 Summicron: PKR*)

**118  Bridal Veil Falls** Compare this colour picture of Bridal Veil Falls with the black and white (Plate 136). There are some subjects for which colour just seems to be more suitable, and for me this is one of them – though I suspect that Tim Hawkins would have made a first-class job of photographing it in black and white (*RWH: Leica M: 280/4.8 Telyt: PKR*)

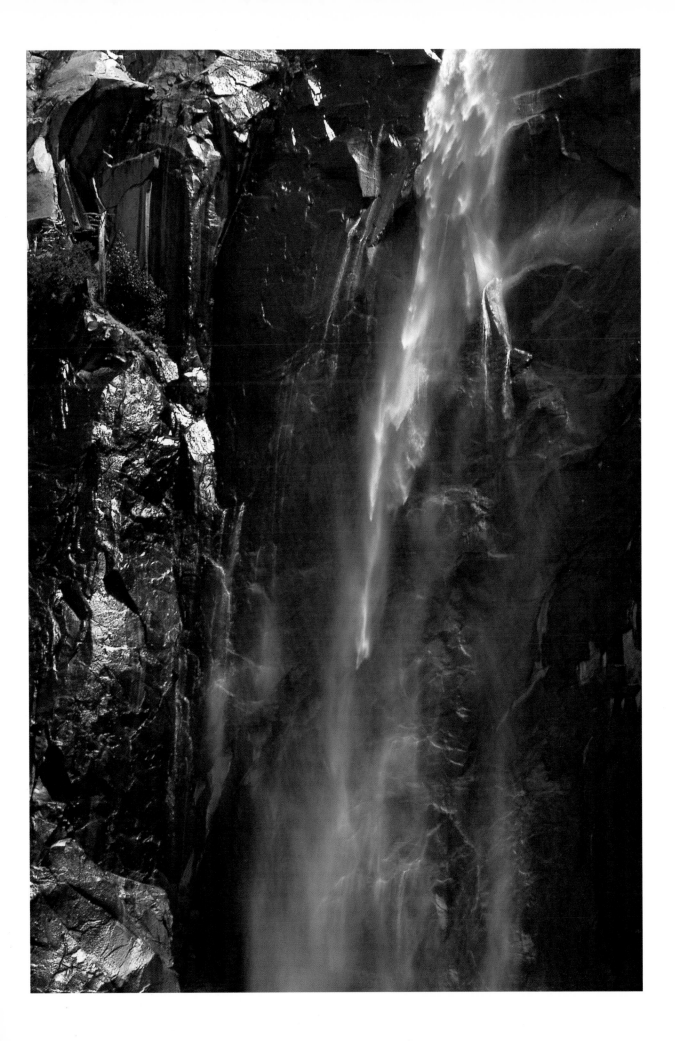

**119 Infra-red focusing mark** Most (but not all) lenses have a separate focusing mark for infra-red; after you have focused conventionally, you reset the distance against the infra-red index. On modern lenses, the mark is usually just a red dot; on this old Leica, it is a beautifully engraved 'R'

anything which can hold a gel filter. For IR colour filtration, you can try a range of filters – yellows, reds, and oranges – which will give you a number of different effects. The only possibility here is experiment.

## Hills

One man's hill is another man's mountain – there are 'mountain' landscapes (such as parts of the Austrian Tyrol) which are less craggy and precipitous than many alleged 'hills', such as those in Britain's Lake District. Although much of what has been said about mountains applies equally to hills, there are some differences.

First, there may well be more use for wide-angle lenses, *if* you can get a strong foreground. The lakes in the Austrian Tyrol, for instance, provide a wonderful foreground to the smooth hills which rise behind them, and if you can find a boat or some reeds to act as a focal point for the picture (see the comments on pages 36 and 145) you can profitably use a 50mm, a 35mm, or even a 21mm lens.

The greatest difficulty with hills, though, is likely to be getting a high enough viewpoint. Looking up will almost invariably make the hills look tiny and insignificant, and a view from the level is unlikely to be any more impressive. For a real panorama, you need to get as high as possible, and look down so as to include plenty of land: the sky should fill a relatively small part of the picture. If the hills are rolling, with each as high as the next, there is not much chance of getting a panoramic picture: you would do better to confine yourself to a single valley. You can emphasise the modelling of the hills by shooting early in the morning or late in the day, when shadows are long, rather than around noon.

140

One thing that is much easier with rolling hills, however, is to use simple, graphic silhouettes. As I have already said, Plate 1 is one of my favourites, and that was taken in the Welsh valleys – wild countryside, but hardly craggy. In order to make this sort of picture look more dramatic, do not hesitate to tilt the camera if you can do so without giving the game away. Buildings and trees will obviously look strange, but if there are no such protuberances you can achieve a result which is much closer to the way that the landscape *felt* by cheating a little.

Looking back over my own pictures of hill country, I find that most of my favourites are details of some kind: a tree on an exposed hillside, twisted and shaped by the wind, or individual outcrops of rock, framed close to show the cracks and the texture of the rock. I have never had much success with the longer shots, perhaps because I am more captivated by mountains.

### Valleys, Plains and Deserts
Deep, narrow valleys are rare in most of the British Isles, though there are exceptions; the tiny enclosed villages of the Cornish coast, surrounded by high cliffs, are one example and the Scottish Highlands furnish others. The classic examples are surely to be found in the American West: the Grand Canyon is the best known and the biggest, but other national parks such as Bryce and Zion offer an even more dramatic combination of depth and narrowness – one canyon is over a thousand feet deep at a point where it is only twenty feet wide!

In such cases, the normal rules of mountain and hill photography are turned on their heads. Ultrawide lenses – 21mm, 18mm, 15mm

120 **Kodak** *porte-filtre* The Kodak *porte-filtre* is rather crude next to M Coquin's offerings, but it works. The trapdoor on top opens to allow the insertion of 3 × 3in (75 × 75mm) gelatine filters in plastic holders called 'montures'

*Overleaf*

121 **Meadow, Yosemite** Even at 6,000ft, you can find apparently flat land – but the flowers give this away as a high valley. A 21mm lens shows how they speckle the short, high-altitude grass (*FES: Yosemite National Park: Leica M: 21/2.8 Elmarit: PKR*)

122 **Meadow, Westonbirt** By contrast with the Yosemite meadow at 6,000ft, this is at less than 200ft. It is at Westonbirt Arboretum, and the more you compare the two pictures, the more differences there are. The grass at Westonbirt is longer (though hardly less flower-speckled) and the trees are big, mature broadleaf species, which are rarely found at high altitudes (*RWH: Nikon: 50/1.2 Nikkor: PKR*)

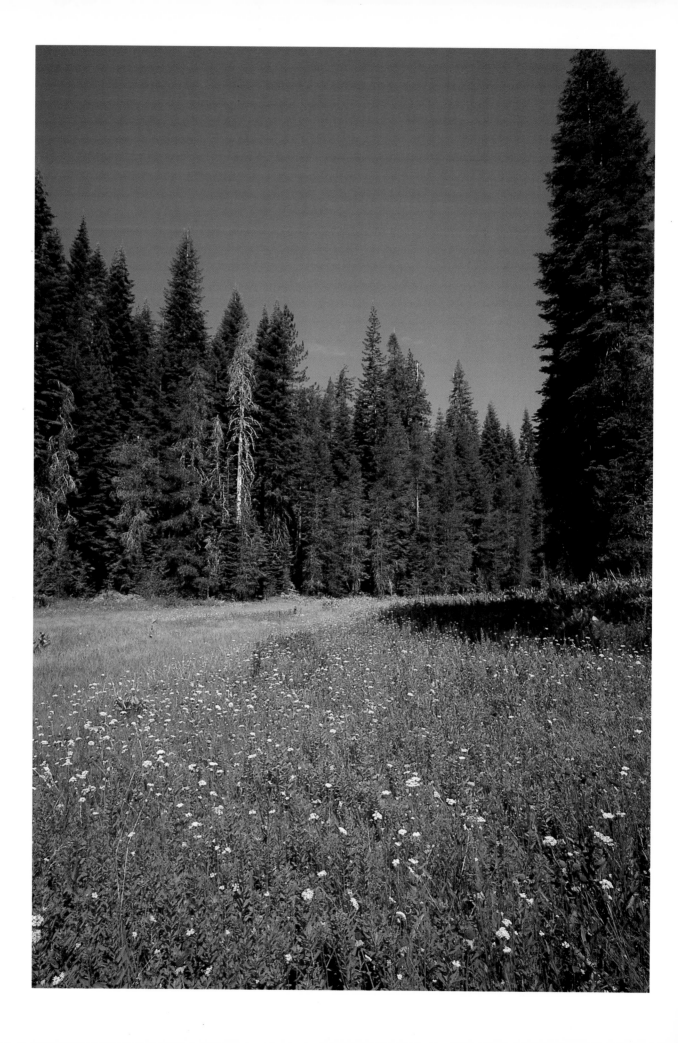

and even 13mm – are ideal, and 50mm starts feeling like a telephoto. Instead of photographing early or late in the day, the most dramatic pictures are obtained when the sun is sufficiently far overhead to penetrate the darkness, or during the brief period when it illuminates the mouth of the canyon, or the mouth of the harbour in a Cornish port. Once again, with ultrawides it is essential to have a strong foreground; blank rock or sand will not really suffice, unless there is something – a plant, a seashell, or whatever – to catch the eye. It is also useful to include something to indicate scale, whether it is a person, a boat, or anything else of a known size.

In really narrow ravines and canyons, exposure is likely to be a problem. On overcast days, exposure times are likely to be long, and a tripod may be useful. On sunny days, contrast is going to be too great for most colour films to handle. Either way, you are likely to get more impressive pictures in black and white than in colour, and you may find it useful to overexpose by a whole stop and curtail development by 20 per cent in order to compress the tonal range on a sunny day. If there is plenty of colour, then use the sun as a spotlight, waiting until it strikes a strong shape and silhouettes it against a dramatically dark background: expose, of course, for the highlights, or use an incident light meter in full sunlight.

Photographing broader valleys has effectively been covered already; it is a part of photographing hills and mountains. The things to emphasise are normally the sheltered nature of the valley, the frequently rich soil that gathers in it, and the vegetation which takes root.

Because valleys are usually so much greener and more lush than the surrounding hills, colour is generally a much easier way of conveying what you want to say. 'Alpine' valleys – the name refers to a type, rather than to the specific location – are characterised by lots of small, brightly coloured flowers, and a wide-angle shot with plenty of these in the foreground (as in Plate 121) can be very effective. Houses are also good indicators of shelter; even in black and white, a house nestling under a brooding mountain conveys the spirit of the valley.

Plains and deserts are another matter. Even if there are distant mountains or buttes and mesas with which to contrast them, as in Colorado, the need for a strong foreground or a graphic composition is indisputable. Few landscape photographers concentrate on plains, because they are boring to traverse and often photographically unrewarding anyway. The only things to do, usually, are to concentrate on those features which break the monotony of the plain, whether natural (like rivers and buttes), or man-made (such as buildings and railways). Alternatively, you can concentrate on detail – trees, rocks, or anything else that relieves the monotony. As an example of a strong foreground, there is the detail in the cornfield in Plate 97; for strong composition, there is the Kansas scene in Plate 7, though the buildings and the sky are the real subject of the picture, even if the scale and flatness of the Kansas prairies is suggested by the dead flat horizon, the line of which is reinforced by the line of the telegraph wires. For details, look at the gnarled tree-trunk in Plate 18.

It is, however, worth pointing out that few places are so flat that there is not *some* undulation of the land, though the area around Cambridge, and East Anglia generally, comes close. Even the Indo-

*Overleaf*

124 **Sierra Madre** The valleys of the Sierra Madre around San Luis Obispo in California house many ranches; this was taken in high summer, when the grass was burnt by the sun, and the cowboys rounding up the cattle kicked up dust trails just like they used to in the movies. Even with a 135mm lens, the scale of the Sierra is enormous (*RWH: Leica M: 135/2.8 Tele-Elmarit: PKR*)

125 **Misty plain, Dorset** One of the best ways to get good pictures of valleys is to get up early in the morning and capture the morning mists; here, Tim Hawkins has contrasted many textures, using the spiky winter grass as a 'focal point' for the picture (*TH: Nikon: 105/2.5 Nikkor: EN*)

126 **Tree, Dorset** Another of Tim's pictures carries the hallmark of early morning clarity – note how he has picked the twisted, lightning-struck stump as the centre of the photograph, using the healthy trees as a backdrop. Doing it the other way round would literally have meant that one could not see the wood for the tree (*TH: Dorset: Nikon: 35/2 Nikkor: KR*)

127 **Clay dump, Cornwall** Many Japanese woodblock artists printed series of views of Mount Fuji; Hokusai's are perhaps the most famous. Some day, I am going to do a similar series of pictures of clay dumps in my native Cornwall: this 'mountain' is man-made, consisting of waste from the china clay pits (*RWH: Pentax SV: 50/1.8 Super-Takumar: ER*)

123 **Earth bank with ice** This picture would not have been possible in colour: the film could not have recorded the necessary tonal range, and the white sky would have looked most unattractive. In black and white, the tonality is very attractive, and the black-border printing technique takes care of the white sky (*TH: Dorset: Nikon: 35/2 Nikkor: FP4/Perceptol/EI 80*)

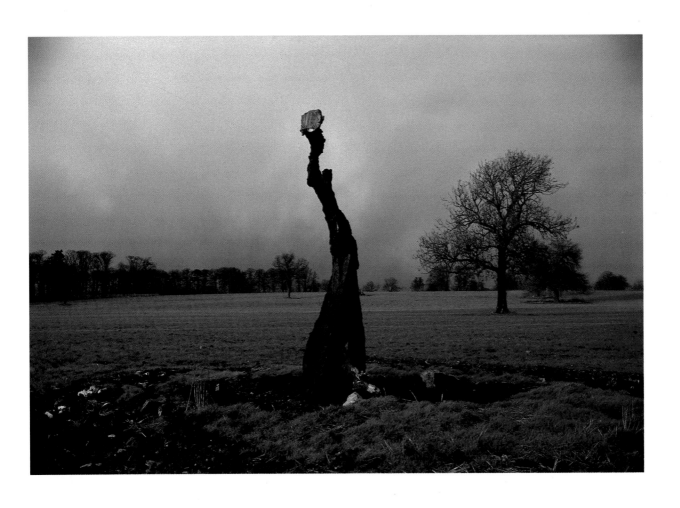

Gangetic plain, one of the biggest plains in the world, has its ups and downs, often unexpectedly if you are no geographer. For example, the huge grey rock outcrops between Mysore and Bangalore are beautiful; I look forward to the day when I can afford to go back there and photograph them at my leisure.

Finally, I must admit to a long-standing love affair with deserts. T. E. Lawrence's descriptions of the desert fascinate me, even if I do not share his admiration for the desert Arabs' way of life. Colours are so clear, so bright, that underexposing by a stop or more merely increases their saturation: it does not seem to lead to 'underexposure' in the conventional sense. There is a tremendous cleanness to the desert – another of T.E.'s obsessions – and the bizarre shapes of desert flora and desert rocks are something else again. The general observations made throughout this chapter hold good for deserts, especially the need to have a strong foreground or centre of interest; use the sharpest lenses you can get with Kodachrome 25 to give everything a wonderful clarity.

Watch out for aerial haze later in the day, and for loss of resolution caused by the shimmer of heated air; in fact, dawn is the best time for really striking clarity. But sunset, too, can be overwhelming in the desert: bands of colour can extend a full 360° around the horizon. Take care of your cameras, especially in dusty deserts such as Rajasthan, or they will rapidly become caked with dust (use self-sealing plastic bags *as well as* your camera case), and do not leave either cameras or film in the sun: a black-bodied camera can rapidly become too hot to touch, which does not do the film any good at all! I use polystyrene cooler-boxes for film storage, sometimes with 'Blue Ice' or similar gel-packs.

128 **Cycle path, Bristol–Bath** On flat or almost flat terrain, man-made features are often the most interesting things to photograph; look at the Kansas landscape in Plate 7. Here, the cyclist and the long, gently curving path make a good picture – but it would be better still if there were no pile of horse manure next to the cyclist, and if the cyclist himself were rather further away (*RWH: near Bitton, Somerset: Leica M: 35/1.4 Summilux: Dia-Direct*)

# 8
# SKY AND WATER

Both water and the sky enjoy a curious position in landscape photography, in that while they are almost impossible to photograph in isolation, their interplay with the land gives some of the most beautiful landscapes. The ancients believed that Earth, Water, Air and Fire were elements; and although we shall have little to do with fire (unless we photograph volcanoes or forest fires) the same sort of analysis feels aesthetically right in landscape photography.

It is a fair criticism that almost any landscape necessarily includes *some* sky, but the difference between a skyscape and a landscape is partly in the detail of the sky itself and partly in the amount of sky that is featured in the picture. Likewise, while almost any landscape may feature water incidentally, there is a clear difference between pictures in which water is incidental and those in which it is the principal subject.

## Skyscapes

It is very unusual for a picture which consists *only* of sky to be successful; normally, there will be a greater or lesser amount of land at the bottom of the picture, often in the form of a silhouette, to give scale and a sense of proportion. This is the first thing to remember about skyscapes. The second is that although there are people who photograph the sky in black and white, the vast majority of successful sky pictures are taken in colour: shades of grey can rarely (if ever) compete with the drama of a fiery dawn or sunset. There are black and white pictures in this book which rely heavily on the sky as subject, but they are rarely skyscapes in the same sense as the colour pictures.

Despite the differences, there are two features that both monochrome and colour have in common. One is that a tremendous range of lenses can be used: I have used everything from 21mm to 300mm, and I am sure that I could have used both wider and longer lenses if I had had them. The range of tones in a desert sunset (or dawn) is so extraordinary that a 15mm or even 13mm lens would probably be usable, while concentrating on a particular cloud formation in a sunset could be done with a 200mm, a 300mm, a 400mm, a 500mm or even longer. I would, however, avoid mirror lenses, both because of the out-of-focus 'doughnuts' to which I have a personal aversion and because you cannot stop most mirror lenses down at all, which makes sunsets so bright as to be dangerous. It is not true, though, that looking at the setting sun through most SLRs will instantly strike you blind, despite countless warnings to the contrary, unless you have an aerial focusing screen with no ground-glass.

**129  Sunset, Himalayas** Sunsets are a perennially attractive subject, and there are plenty of them in this book. But a sunset without any foreground is usually very unsatisfying; usually, as here, there is some silhouetted land at the bottom of the picture, to 'tie down' the sunset. Longer-than-standard focal lengths are often desirable, though the increase need not be great; this was shot with a 90mm f/2 Summicron (*RWH: near Gangchen Kyishong in the Himalayas: Leica M: ER*)

150

The other obvious feature which is common to both monochrome and colour is the difficulty of metering. In colour, where the effective tonal range of the film is so much less, you can usually get good results for sunsets and sunrises by pointing a reflected light meter straight at the light (or away from the camera, if you are not reading a sunrise or sunset) and using the indicated exposure with perhaps a one-stop bracket each way; alternatively, take an incident light reading from the direction of the light, and *underexpose* by two and three stops. In any case, bracketing is essential; with a sunset I particularly want, I have been known to bracket a full two stops either side of the measured reading. This technique will inevitably reduce the land to a silhouette, but this is the only real possibility with colour *except* when you are photographing something at 180° from the sunset, as in the picture of Long Beach (Plate 154). In that case, an unmodified incident light meter reading is sufficient.

Although you can use the same approach with black and white, the very much wider tonal range that the film can record allows you to modify your technique somewhat. If you point the reflected light meter straight away from the camera, towards the sky, you can usually use that as your base exposure and bracket with two or three stops *extra* exposure (ie open up) in order to capture land detail, whereas if you point the incident light meter straight away from the camera, you can usually get away with using that as your base exposure and bracketing with one or two stops *less* exposure (ie stop down).

With either type of film, metering rainbows is next to impossible. They record much more weakly on film than we see them, and in black and white you will be extremely lucky if they record at all, unless you can get a *very* bright rainbow against a bank of *very* dark cloud. In colour, an exposure based on an incident light reading, or one stop *less*, will give the best results, but the overall greyness of the picture will not be too attractive: you need something bright and white as a focus of interest, or the overall effect will be depressing rather than magical.

This is really about all you need to know about colour transparencies, apart from the techniques of using either a polarising filter or a graduated filter to add interest to the sky. The polarising filter will deepen the blue of the sky because it cuts out light which has been polarised by water vapour in the atmosphere, and the graduated filter simply compresses the effective tonal range of the picture, thus ensuring some tone (and colour) in the sky when the foreground is correctly exposed. The only graduated filter I would consider using is grey; as far as I am concerned, as soon as it becomes obvious that a filter has been used, the picture has failed. There are, however, those who like skies every colour of the rainbow, and Cokin panders to them. For colour prints, if you make them yourself, you can try burning in the sky (the technique is described below, under black and white), but otherwise the techniques are much the same as for colour transparencies.

Black and white is another matter. In colour, you can do very little about altering relative tonal values, apart from the tricks already mentioned, but you can do a great deal more manipulation with monochrome.

An obvious place to begin is by stating that 35mm can *never* hope

to reproduce a clear sky without grain: as a light, uniform tone, the sky shows up grain more mercilessly than any other subject. Of course, if you print the picture very small, and look at it from a great distance, you can produce an apparently grainless sky, but if you make even a 10 × 8in picture you are more than likely to see the grain at normal viewing distances (10in/25cm), and you will certainly see it if you look any closer. My own view is that it is as well to accept this, rather than to try and get a totally grain-free picture: indeed, I believe that grain can add to the drama of a skyscape, the degree of grain depending upon the type of sky and the effect you want. In general, the heavier and more dramatic the clouds, the more grain you can use.

Apart from this, there are three things you can do in order to increase the impact of the sky in a black and white print. You can use filtration; you can adjust exposure and development in order to get a greater differentiation of the critical tones; and you can 'burn in' the sky while printing.

Filtration is well understood; a yellow filter is often known as a 'sky filter', and orange and red filters produce a more dramatic version of the same kind of tonal differentiation. A lot depends, though, on the altitude, the colour of the sky, and the type of clouds. As a rule, the higher the altitude or the deeper the blue of the sky (and the two often go together), the more effect *any* filter will have: whereas on a smoggy day in Los Angeles you might need an orange filter to get a given effect, driving out to the higher, clearer air of Mount Wilson will mean that you can get the same degree of differentiation between clouds and sky by using a yellow filter. If there is no blue sky, just variations in grey, then no filter is going to make very much difference. As for the cloud *type*, I generally find that the smaller, lighter clouds (such as cirrus and nimbus) benefit more from the stronger filters, while the more massive varieties such as cumulus and cumulo-nimbus look almost too solid if a red filter is used; an orange or yellow is more appropriate.

It is also worth pointing out that graduated filters of the Cokin type are as useful for black and white as for colour, and that you can use graduated yellow, orange, and red filters as easily as the more usual graduated greys. If you use a large enough aperture, you can also use part-filters (in other words, filters cut off at a certain point), but gelatine or acetate filters will be less likely to cast a sharp edge than thick plastic ones; at smaller apertures, of course, the cut-off line will be too pronounced.

Adjusting exposure and development in order to get a clearer separation of tones is applicable whether there is any blue sky or not. The important thing to do is to overexpose quite heavily – by at least a stop, based on an incident light reading on the ground – and then to decrease development time slightly in order to expand the tonal range of the picture. Alternatively, overexpose by only one stop, and develop normally; the clouds should still be well differentiated, but the land will all be on the toe of the *D*/log *E* curve (see page 89), so the tones there will not be as well separated as they would be if development had been cut. Looked at in terms of the Zone System (page 72), what you are doing is placing the clouds on a lower tone than they would normally occupy.

The last technique, that of burning in the sky, will be almost

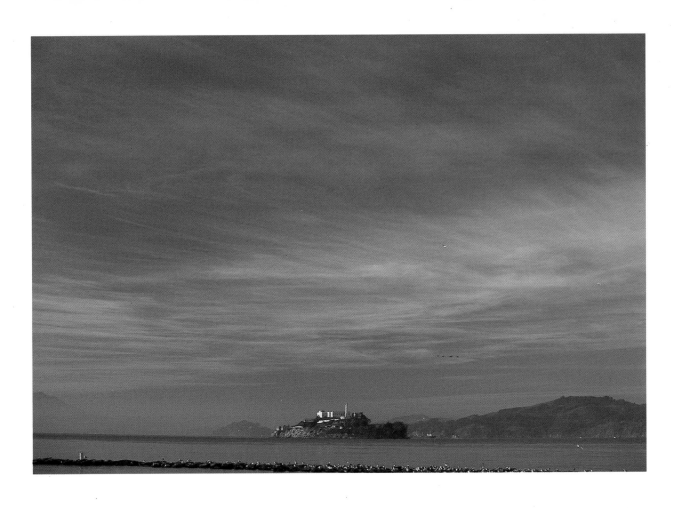

essential if you have followed the shortened exposure/longer development route and still want to represent an apparently full range of tones in both land and sky. Base your print exposure on the land, which will probably give you an almost blank white sky, and then give the sky at least double the exposure which you gave the land. If you have an automatic enlarger exposure timer, simply repeat the same exposure once or even twice, shading the land area with your hands or with a cut-out piece of black card. Keep the card moving constantly, in order to avoid too sharp an edge, and aim to darken the edges of the land mass rather than lightening the edge of the sky. The effect of this technique is similar to that obtained by using a graduated filter, except that you can control the edge between the earth and the sky much better, instead of being stuck with a straight line. You are also likely to get very much better definition!

## Water

It is said that there are Native American tribes who have different words to describe water in different forms. Water in small quantities – a cup or jug – has one name, water in large quantities such as a lake or sea has another, and running water has yet a third name. This is a useful way of looking at water from the photographer's viewpoint, too: a mountain stream obviously requires a different treatment from the sea, and a calm lake is different from either.

As with other subjects, it is important to think about precisely what it is that you want to convey when you photograph water. For example, you can emphasise the purity and clarity of a mountain stream; the majesty and power of the ocean; the calm and serenity of a lake. Put verbally, like that, they sound like clichés, but the advantage of this sort of analysis is that you can go on to examine the individual aspects of your subject, and to apply the appropriate techniques. To show clarity, for example, you need to choose a viewpoint where you can see through the water to the stream bed; but if you wanted instead to show the speed with which the water was flowing, you would need to show either what the canoeists call 'white water', or a reflection off the surface which conveyed the turbulence of the flow.

The broadest distinction, for our purposes, is between still water and moving water – though the distinction is often blurred, because 'still' water can have waves, and 'moving' water may be flowing so smoothly that it can appear in a photograph to be still. Before we start on the differences between the two kinds, though, there are several similarities.

The first is that water and photographic equipment make a bad combination – especially *salt* water and photographic equipment. A camera that is dropped into salt water will almost certainly cost more to repair than it is worth, unless it is an extremely valuable mechanical camera (such as a Leica) in which case the following sequence *may* be worth while. First, rinse it in fresh water immediately: leave it in a plastic bucket (metal buckets can cause electrolytic damage, as well as being generally dirtier and flakier) with a tap running for at least half an hour. Then, either dry it fairly gently in a stream of warm air (stand it over a radiator or use a hair drier) or put it in a snap-top plastic box and cover it with distilled water until you can get it to a repairer. Either way, get it to a repairer *fast*.

**133  Sunset and tree, Somerset**
Black and white sunsets as successful as this are rare. You need a very dramatic sky and a strong focal point, such as the tree in this picture. Avoid using too strong a filter; there should be plenty of contrast between the sky and the clouds to begin with, and a yellow filter should provide all the emphasis that you need (*TH: Somerset Levels: Nikon: FP4/ID-11/ ISO 125*)

156

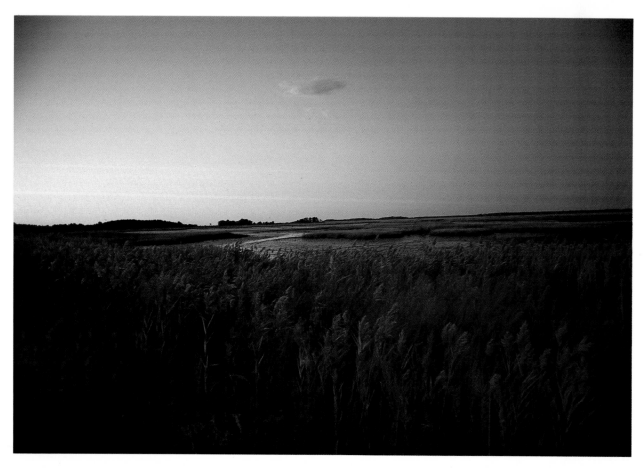

**134 Bombay Hook** One of the never-ending fascinations of colour photography is that it forces us to *see* what colours the world brings us. These are the same swamp grasses as in Plate 78, with no filtration other than a polariser, but the colours are completely different. The two photographs were taken less than an hour apart (*FES: Bombay Hook, Delaware: Nikon: 50/1.2 Nikkor: KR*)

**135 Three Rivers Reservoir** Three of the ancient elements – earth, water and air – are beautifully combined in this picture by Frances Schultz. The differing effects of the ripples on the surface of the water also furnish a textbook example of how unpredictable wind and water can be together (*FES: Nikon: 90/2.5 Vivitar Series One: KR*)

Although there are stories of people drying out their cameras and having them work perfectly afterwards, neither I nor a repairer I consulted on the subject had ever known this to happen; we both suspect that it might be an old wives' tale. Dousings in fresh water are likely to leave the camera repairable, but the repairs will not be cheap. Salt water, on the other hand, is such ferocious stuff that even splashes can be dangerous: wipe them off *immediately*, especially on lenses, and consider using a UV or other filter to protect your lens's front glass. Salt water will write off anything electronic, and even such simple things as tripods must be washed as soon as possible with lots of fresh water if they are not to corrode and seize up; this is especially true of *any* light alloy, which is what most tripods are made of nowadays. This is, incidentally, one of the advantages of the sealed-leg Benbo design (see page 49): it can be used with confidence in salt water up to about 15in deep, with only a rinse afterwards.

A consequence of this is that although you can use a tremendous range of lenses to photograph water, you will generally be safer if you use longer-focus lenses, simply because you are further from danger. On the other hand, one of the great advantages which 35mm enjoys over larger cameras is that you can always pick up the camera and run, or tuck it inside your jacket, if you realise that you are going to be splashed with spray!

The second thing about water concerns its colour. There are two things which give water colour: material suspended or dissolved in it, and light reflected from it. Blue seas, and most blue lakes for that matter, take their colour from the sky – so if you use a polarising filter, you will lose the blue, and get anything from clarity to green or muddy brown. If you want to show clarity – as in our example of the

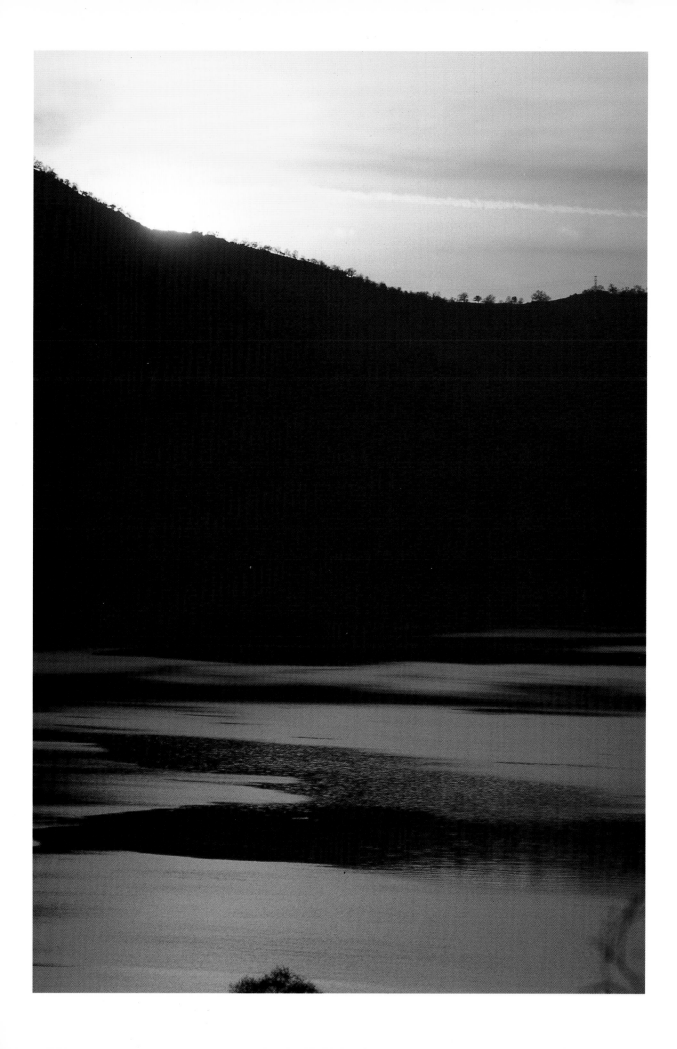

mountain stream – a polariser is great, but otherwise they should only be used near water with extreme reservation. In black and white, of course, this is less critical, and what sort of film you use to photograph water is very much a matter of personal preference: I prefer colour, but Tim Hawkins shoots predominantly black and white. I admire his work very much, but I still shoot in colour because that is the way I 'see'.

The third thing concerns the length of exposure. Usually, this is more important with moving water than with still water, but unless still water is absolutely glassy calm, even the tiniest ripples will be enough to destroy reflections and give the whole surface a slightly oily effect. With moving water, especially with a fast-flowing stream, you can get anything from 'frozen' flying droplets to a continuous smooth-flowing blur. Each has its own special effects, and the speeds you will need to achieve them are roughly 1/1,000sec or less for 'frozen motion' and roughly 1/8sec or longer for blur. At the fast end

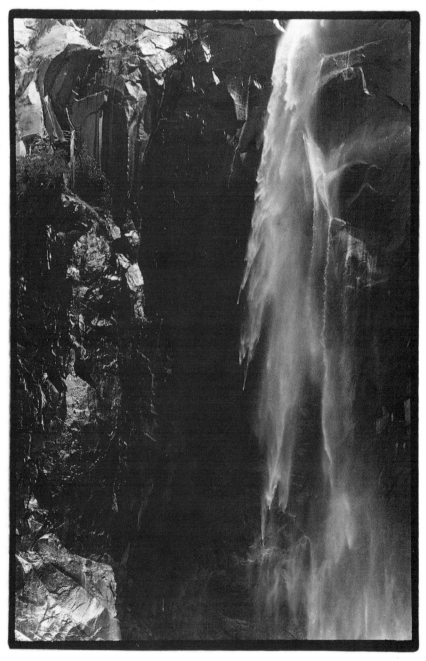

136 **Bridal Veil Falls** Paradoxically, it is often easier to photograph thinner and more wavering falls than to capture the majesty of those like Niagara. This picture is deliberately printed dark to give a range of tones in the water and in the wet rock beside it, but the effect is very different from the colour picture (Plate 118) where both tone and colour differentiate the water from the rocks (*RWH: Yosemite National Park, California: Leica M: 280/4.8 Telyt: HP5/ Perceptol/EI 320*) .

of the scale, 1/500sec or even 1/250sec will give some degree of 'freezing', while 1/2,000sec and 1/4,000sec can give some truly memorable effects, and at the slow end you will get some movement with 1/15sec or even 1/30sec, but can go to 30 full seconds or longer if you want to even the flow as far as possible. 'Frozen motion' normally shows individual sparkles, while blur shows the water as a continuous white stream; the whiteness is caused both by the accumulation of individual highlights and by air bubbles – the same effect that gives 'white water' in fast-moving rivers.

The fourth and final similarity between photographing still water and moving water is that the fluidity and mobility of water are often contrasted against the massiveness and immovability of land. With still water, we are normally more concerned with the land rising out of the water, with water as *yin*, the female principle; with moving water, we may also be concerned with the conflict between water and land – the battering of waves on the shore, for example – and this is the less familiar *yang* aspect of water, its dominant side. With moving water, long exposures tend to emphasise the *yin* and short ones emphasise the *yang*. The terminology may look a bit hippie, but it is a useful way of analysing things!

Moving on to the differences now, one of the attractions of still water is often its very stillness: tranquillity and calm are words that are used as readily of water as of the emotions, and a lake can be a very peaceful place.

Conveying stillness is usually a matter of using the appropriate shutter speed, and using reflections. The shutter speed should always be faster than about 1/60sec, or even small surface ripples will have a chance to create the sort of oiliness already mentioned; it is not really possible to choose too *fast* a shutter speed.

Reflections in glassy calm are always attractive, though they can of course tip over into sentimentality or empty technique, but with anything less than a glassy calm it is worth remembering that the accuracy of the reflection is a matter of scale: the scale of a building is so much greater than the scale of a person in relation to the size of the ripples that the one may be quite recognisable while the other may break up completely. 'Riffles' in water will destroy reflections entirely; Plate 135 shows how local surface breezes can have this effect on some parts of a reflection and yet leave others unaffected, while Plate 158 shows how bigger ripples can give reflections which are quite recognisable without actually being clear.

Conveying movement is another matter. The effect of shutter speeds has already been mentioned, but conveying movement in a stream which is flowing fast enough to create eddies but not fast enough to create 'white water' can also be done by using reflections from the surface of the water to show its unevenness. We know that the only way that water gets uneven is if it is eddying and swirling, and Plate 40 conveys this rather well.

For really dramatic movement – waves smashing on a rock, or a tumbling river breaking against boulders – you have to *anticipate* and to shoot for the percentages.

Anticipation on this sort of scale is not usual in landscape photography: even rapidly changing light gives you a leeway of a few seconds in which you can actually press the release. With fast-moving water, though, the delay between pressing the shutter release and the

*Overleaf*

**137 Log on river** When I made a print of this for myself, I 'flopped' it (reversed it left to right). I preferred this composition, because in terms of our Western left-right conventions, it became a 'rising' line instead of a 'falling' one. As used here, I prefer it printed naturally; this is an example of book layout, as compared with single-picture presentation. Check it in the mirror and see what you think. (*RWH: Yosemite National Park: Leica M: 35/1.4 Summilux: PKR*)

**138 Reflected bridge** When I was going through Tim Hawkins's files, looking for pictures, this one was actually filed upside-down. It is an unusually perfect reflection, which you normally only get on a hazy day: otherwise, the blue of the water is usually much deeper than the blue of the sky (*TH: South of France: Nikon: 105/2.5 Nikkor: KR*)

161

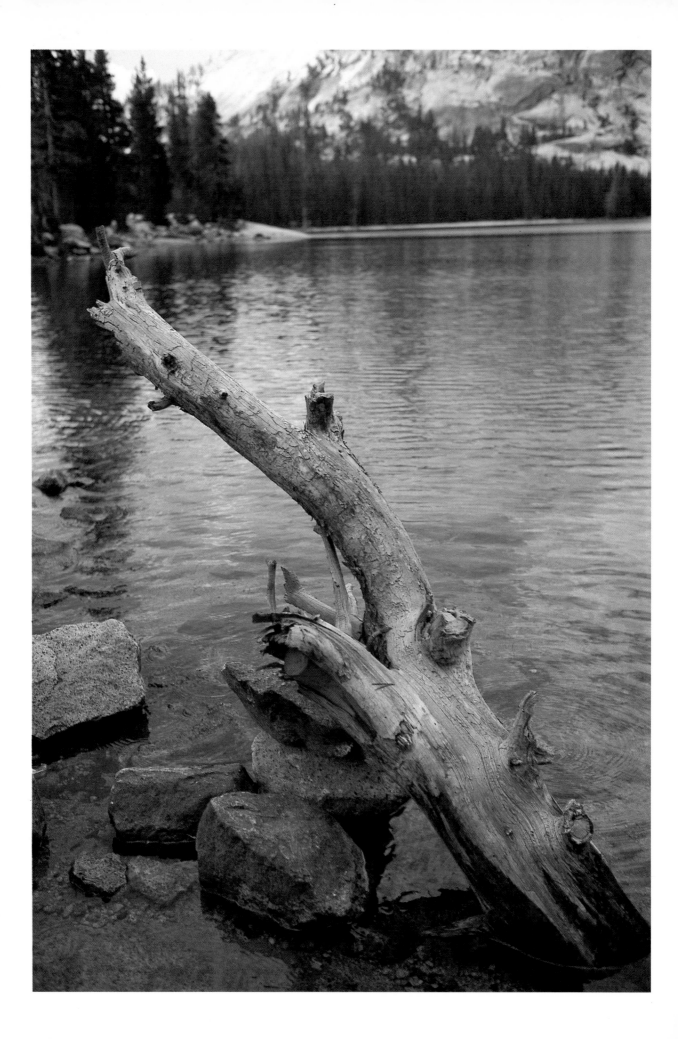

139 **Twin bays** The sea has many moods. Here, late evening sun and a gentle calm combine to provide a tranquil scene, but the picture owes a lot to careful composition. The two curving bays draw the eye into the calm of the image, while the rocks on the right and centre right 'balance' the cliffs visually (see page 117) (*TH: Dorset coast: Nikon: 35/2 Nikkor: FP4/ID-11/ISO 125*)

140 **Rock arch** In more turbulent mood, the sea crashes against the Dorset cliffs. As remarked elsewhere, two of the great advantages of 35mm are its lightness, which makes it easy to scramble up and down cliffs carrying it, and the ease with which it can be covered and protected from flying spray (*TH: Nikon: 105/2.5 Nikkor: FP4/ Perceptol/EI 80*)

141 **Couple on beach** Meanwhile, on the beach, the last two visitors are walking home. Look at the footprints; we can see that this was taken late in the day, instead of early in the morning, from their number. The 'portrait' (upright) format of this picture, the pose of the walkers, and the inclusion of so much well-trodden beach, gives an impression of a long walk (*TH: Dorset: Nikon: 35/2 Nikkor: FP4/Perceptol/EI 80*)

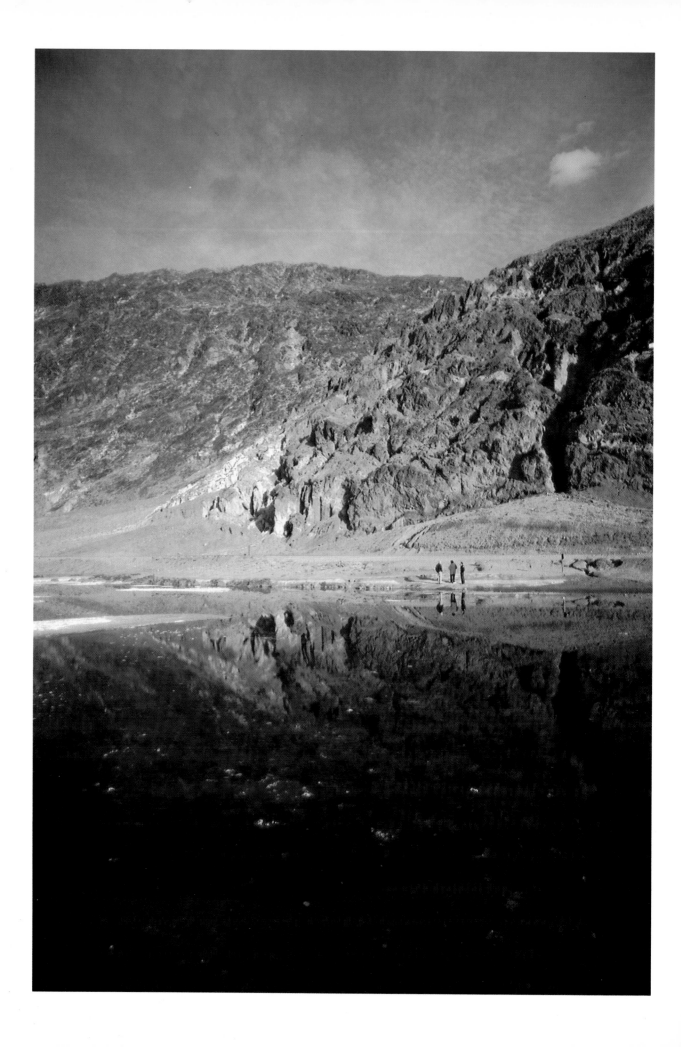

Previous Page

142 **Death Valley** Reflections in the bad-water lakes of Death Valley are spectacular, but I needed a 'focal point' for the picture. A long walk across extremely lumpy mud, plus a ten-minute wait, brought me the obligingly red-clad gentleman. Bright red rain slickers are a cliché in some places, but not in the desert! (*RWH: Leica: 35/1.4 Summilux: ER*)

143 **Tree and river** A 600mm lens on a winter's afternoon reduced the Thames to an abstraction and the bare tree in front of it to a charcoal sketch. This is about as close as you can get to an abstract photograph while still being able to recognise the subject (*TH: tripod-mounted Nikon: 600mm Nikkor: EN*)

shutter's actual opening may be significant. This is one of the many ways in which 35mm scores over rollfilm cameras: the delay for a typical non-auto 35mm SLR is of the order of 1/30 to 1/40sec (say 25–30ms), while for a rollfilm SLR it can be as much as 1/10sec, 100ms. Automatic SLRs are a little slower, but modern electronic ones add very little to the delay; the real delay comes with autofocus, where the delay can be as long as with a rollfilm SLR. Otherwise, non-SLR cameras (of any format) respond very much more quickly, typically in 1/60sec or less – around 15ms. Only experience with your own camera will tell you just when to press the release in order to capture the action which you can see is coming.

'Shooting for the percentages' is necessary because you can never tell *precisely* how the water is going to behave; the photograph of Bridal Veil Falls in Plate 136, for example, is one of a series of almost a dozen taken from the identical viewpoint of the same subject. As with bracketing, there is nothing to be ashamed of in doing this – it is something which professionals do all the time.

Waterfalls are very interesting to photograph, and surprisingly difficult; Bridal Veil Falls, because of the way that the water is silhouetted against the dark rock, is actually one of the easiest. Conveying the size of the Niagara Falls, on the other hand, is very much more difficult, because the sheer scale of the volume of water removes all the little details and textures which make waterfalls so attractive. Small, wavering, wobbling falls are a lot easier!

So far, we have only really considered water *without* people; but water is also an integral part of our lives in many ways, whether for work – as for a sailor or fisherman – or for pleasure. As with any other sort of landscape, if attention is concentrated too much upon people and too little upon the landscape, the picture becomes a portrait or at least a form of reportage instead of a landscape, but equally, there are many occasions when people and in particular the evidence of people (boats, nets, and so forth) are an integral part of the landscape. The criteria are broadly the same as those laid down in Chapter 6, and the only point worth adding is that you *must* decide what you are trying to show, whether it is the contrast in scale between fragile humanity and mighty waves; the way in which a surfer masters the sheer power of the sea; or the tranquillity of the angler by a calm lake.

144 **Swan on Thames** Water lends tranquillity to many a harsh subject. Industrial buildings, a heavy crane and a gasholder are not the most promising material for a picture, at least at first sight, but some water, a few gentle reflections, a swan and a grounded boat transform the mood (*TH: Nikon: 35/2 Nikkor: FP4/ID-11/ISO 125*)

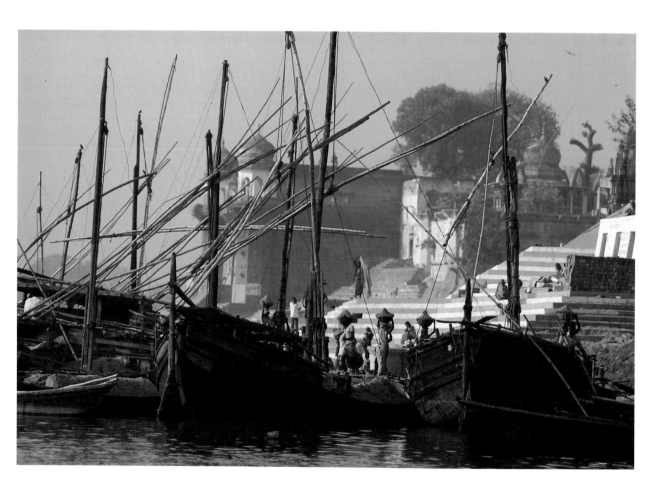

# 9
# THE URBAN LANDSCAPE

I have deliberately left the urban landscape until last, for a variety of reasons. The most obvious is that it is the odd man out, at least if you think of 'landscapes' as most people do, as attractive and (above all) natural scenery. Equally important to me, though, are two other reasons. One is that the urban landscape was the one with which I was most familiar for the first thirty or more years of my life. The other, closely related to this, is that until a few years ago I could not seriously imagine living outside a big city – at least, not too far outside one. Even when I was forced to do so, as a child, I always identified with the nearest big city: when I lived in Gourock, on the other side of the Clyde from Loch Lomond, I automatically thought of Glasgow as being the only place worth going to, and in Bermuda I went to Hamilton whenever I could. Hamilton may not look like a big city to outsiders, but in Bermuda it is the nearest you get! The result of all this was that I took a lot of pictures of urban landscapes; I was only a little more at home in the country than Doctor Johnson or Oscar Wilde.

What has always fascinated me about the urban landscape is that there seem to be so many more ways of interpreting it than are possible in the countryside. Because there are so many people around, and so much evidence of people – buildings, carefully laid out public gardens, cars, garbage – you can say a great deal about the interrelationship of man and his environment. You can choose to emphasise the history of a place; its eccentricities; the bleakness of some of its more modern areas; the variety of, say, its shops and eating places; or the downbeat side, with its skid row, tramps, and slums. There is just one little rider to this: you must have a good idea about *which* aspect you wish to emphasise. Just to photograph 'the city', without deciding which *aspect* of the city you are photographing, will usually result in pictures which are either indecisive or clichéd.

'Indecisiveness' may seem a strange label to attach to a photograph, but it is easier to understand than to explain; if you ask yourself, 'What is this photograph actually saying?' or the rather kinder question, 'What was the photographer trying to say when he took this picture?', you get no answer. Try it, literally, with some of the pictures in this book: even with the captions, you are likely to find some much more decisive than others, and the same will apply to your own photographs. Likewise, clichés are easier to spot than to describe: the photograph of the man beside the ruined warehouse in Plate 158 is most assuredly a cliché, and it is included in the book as an example of one.

145 **St Brandon's Hill** The stream here is all that saves this photograph from disaster. Without it, the picture would look like a frame from a super-Technicolor film of the 1930s, but the water unifies the whole thing, cools it down, and explains the profusion of autumn colours in one place (*RWH: St Brandon's Hill, Bristol: Nikon: 55/3.5 Micro Nikkor plus polarising filter: ER*)

146 **Boats on the Ganges** Boats are often worth photographing; when massed like this, they form a sort of landscape of their own. This is the Ganges again, at Benares (*FES: Nikon: 200/3 Vivitar Series One: KR*)

171

**147  Motorway construction** This is a good example of what I mean about 'hostility'. The city is supposedly geared to the needs of people – but destruction on this scale looks more like a war than a public service. Fields, roads and houses were destroyed in order to extend the M32 motorway a few hundred yards nearer Bristol's city centre. Was it worth it? (*RWH: Nikon: 21/4 Nikkor, red filter: HP5/Microphen/EI 650*)

**148  Private property** In this picture, the impersonality and greed of the city verges on the surreal. Of course, the sign is to stop children playing there, and possibly hurting themselves – but the landowner is more concerned with possible insurance claims than with their health. I am no socialist, but this scene brought out the anarchist in me (*RWH: Nikon: 21/4 Nikkor: HP5/Microphen/EI 650*)

Something which surprised me when I was selecting pictures for this chapter, though, was the thread of hostility, or of being threatened by the size and impersonality of the city, which seems to run through so many of my urban pictures. For some reason, I don't feel this about the country, which is (after all) even bigger and more impersonal. But in the country, the impersonality is the impersonality of nature; the sky and the trees do not know or care of man's existence, and as soon as man stops defending his patch of earth, the weeds will invade it again. As Horace put it, *Naturam expellas furca, tamen usque recurrit*: you can drive out nature with a pitchfork, but it will always come back. In the city, the impersonality is (paradoxically) man-made. *This* is where the hostility comes in.

Admittedly, I do not feel equally threatened by all cities. Paris never threatens me; San Francisco never has yet. But in (say) Amsterdam or New York City, there is always such a feeling of suppressed violence in the air that I leave as soon as I can. As I get older, I feel more and more at home in the country – or at least, in small towns and villages. There is nothing unusual in this; it just fascinates me to see it happening in myself.

The relevance of all this autobiography is that we are not neces-

sarily up to date (or accurate) in our appreciation of our own feelings. It was only as I was selecting pictures for this chapter that I realised how long this thread of hostility had been in my urban landscapes – as far back as when I started photography, in my teens. I have not shot many urban landscapes, except as 'bread and butter' pictures for stock photography, for some years; now I know why. What really intrigued me when I asked some of my friends to read the manuscript was that three of them independently commented on this section; two of them felt exactly the same way as I did, and the third argued at great length that I was completely wrong, and that he never felt at home or secure except when he was in the city. He was the youngest of us; I wonder if his views will change too . . .

I also found it interesting to compare my black and white urban landscapes with the ones that I have shot in colour. The black and white images tend to be primarily 'intellectual' – that is, photographs in which you can give a clear verbal answer to the question, 'What is the picture about?' – whereas colour always seems much better suited to 'emotional' pictures, where it is equally clear what the picture is about, but it is much harder to put it into words. Although there are frequent exceptions in both directions, I also find that with colour I tend to concentrate much more on people, whereas with black and white I concentrate on things.

Because I see the city as fundamentally hostile – possibly because competition, in the Western sense, is very hard to separate from aggression – the techniques I use for photographing the city tend to be dramatic. In particular, I use very wide-angle lenses to give looming perspective, and I often accentuate this by tilting the camera deliberately in order to get dramatically converging lines. Even where there is humour, as in the PRIVATE PROPERTY photograph in Plate 148, this sense of threat is still present. Again, I will sometimes use *deliberately* empty foregrounds to emphasise the sense of emptiness and bleakness, as in the picture of the ground ploughed up for an urban motorway in Plate 147. By the same token, I frequently used to use an orange or even red filter to give stark contrast and dark, almost black skies – the motorway picture shows this, too. The film is usually HP5 (I used to use HP4) developed in Microphen for a small speed increase (EI 500–650) and noticeable grain, as well as a higher gamma (contrast). Frequently, I will print the picture on a harder grade of paper to give still more contrast.

Regardless of my prejudices or yours, though, there are three main types of urban landscape. The first concentrates on people, and on their relationship to their surroundings; the second concentrates on buildings themselves; and the third is concerned with details. It is worth looking at each in turn.

## People

The people in my cityscapes are frequently dwarfed by their surroundings, or even absent altogether, as if the streets had driven them away by their inhospitableness; look at Plate 153, of St Nicholas's Market in Bristol. Believe it or not, this is a busy marketplace – but late on a rainy Sunday afternoon in winter, the old stone setts and flags look bare and cold, the gates on the market itself look like a prison, and the shuttered shops look like some post-war city

*Overleaf*

149 **Sacré Coeur, Paris** Paris is one of my favourite cities, and the Sacré Coeur is a place I have tried to photograph many times. Here, a deep blue sky and brilliant sunlight allowed me to underexpose by a stop for extremely saturated colours; indeed, it was necessary to underexpose in order to stop the stone from being blindingly white. This was shot from the very bottom of the hill, using a 90mm lens, as this produces less extreme perspective effects than using (say) a 35mm from two-thirds of the way up the hill or a 21mm from the terrace (*RWH: Leica M: 90/2 Summicron: ER*)

150 **Mosque, Delhi** My feelings about Delhi are rather more mixed than my feelings about Paris, but there are some truly wonderful buildings there, and some charming people. I climbed high over the gate of this abandoned mosque, and waited until the custodian crossed the yard; he provided the 'focal point' that the picture needed (*RWH: Leica M: 21/2.8 Elmarit: KR*)

151 **Easton, Bristol** For me, this picture sums up both the bleakness and the cosiness of the city in winter. Ideally, I would have preferred to be another foot to the right, but (as you can see) the wall stopped that. Alternatively, I might have taken a better picture with a 28mm lens – but I don't own one. There are always compromises to be made. This is another picture which I prefer 'flopped'; I think it is because the right–left movement of the path is more satisfying than a left–right movement (*RWH: Leica M: 35/1.4 Summilux: PKR*)

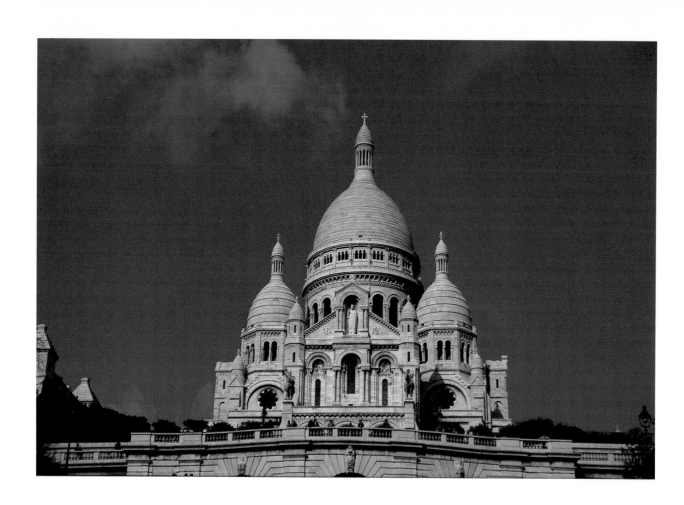

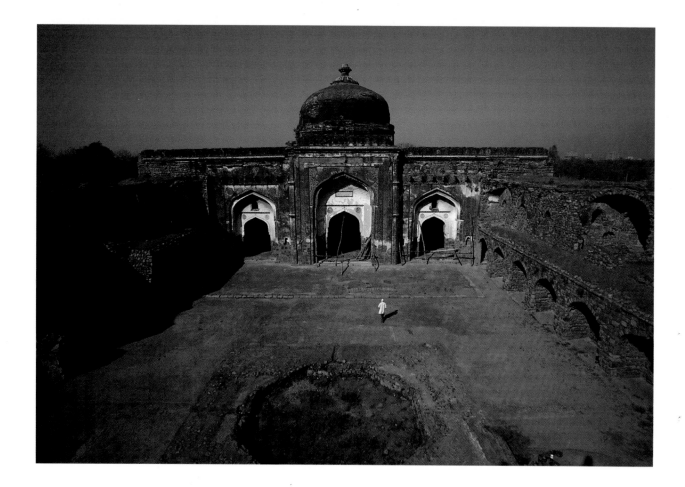

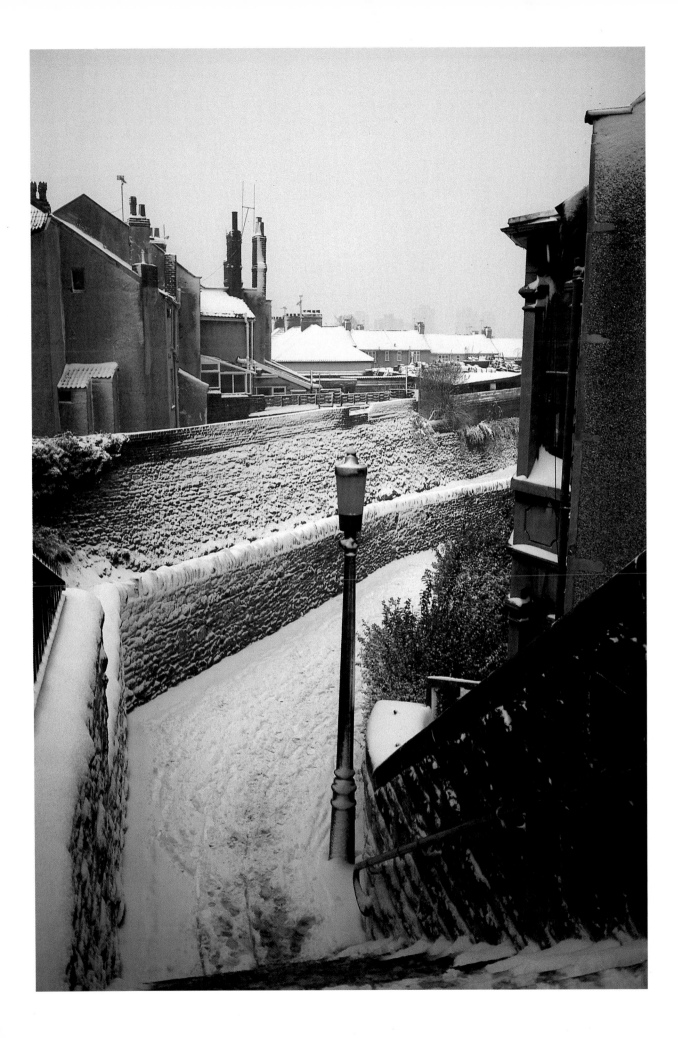

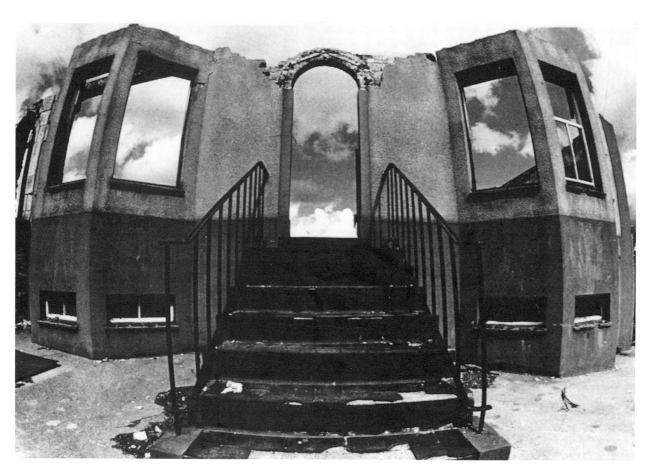

152  **Fish-eye shot of ruin** This is about the only time that I felt I really needed a fish-eye lens, so I borrowed a 16mm f/2.8 Fish-Eye Nikkor. The ruin, which is no longer there, reminded me of a child's playhouse, with its façade and steps and complete lack of roof or interior, and the fish-eye emphasised the dream nature: 'Let's pretend it's a house . . .' (*RWH: St Werburgh's, Bristol: Nikon: HP5/Microphen/EI 650*)

struggling to refill its shops after the looting. All totally inaccurate, and (curiously enough) one of the areas of Bristol that I like most – but there is still that undercurrent of fear.

Even where the picture concentrates on the dynamism of the city, rather than its threatening aspects, I still tend to go for drama: look at the 'aerial' shot of New York City in Plate 160, or the picture of San Francisco's Pier 41 (Plate 25). If I slip away from drama, as often as not I find myself sliding into cliché, as in the picture of the man staring into the water in Plate 158: the image of a man in middle age, perhaps reflecting on better days, in front of an obviously decaying Victorian warehouse (which has subsequently been torn down to build apartments) is one that I find almost embarrassing to look at nowadays.

Curiously enough, the only times when I feel that I have been able to concentrate on people in cities and *not* show them as victims of their surroundings is in the poorer parts of town, where people improvise upon their environment: instead of being regimented into relentlessly 'modern' lives, they make their compromises with the city. And of all the places I have been, this is most true in India. The city cannot overcome the people; they are like the grass that forces its way through the cracks in pavements and flourishes in old gutters, an irresistible reminder that cities are made for man, not vice versa. There are ox-carts in the streets, and lean-to shacks against the walls. Precarious scaffolding made of wooden poles lashed together surrounds a modern multi-storey office block under construction, and in the older parts of town woven mats of *tatti* are strung across windows to keep out the too-harsh Indian sun – windows that are often in big, impressive Victorian Gothic buildings which are a legacy

176

of the British Raj. There is a cosiness, a humanity among the squalor, which is lacking in (say) New York City. Of course, India's warmer climate helps, but there is more to it than this.

Your own interpretation of people in cities may differ drastically from mine, and indeed I hope for your own peace of mind that it does, but at least you can get an idea from what I have written of how I see them, and why I photograph them the way I do. If you look at your own pictures, and examine your own motives, you may see why some of your own pictures seem more successful to you than others.

## Buildings

To me, if there are people in an urban landscape, they almost invariably dominate it. This is true even if they are only a tiny part of the picture; in fact, it may be that it is even more true in this case, for the reasons I have already given.

It is, however, possible to show buildings on their own, almost as a form of sculpture; and if you are clearly concentrating your attention on the building, it is sometimes possible to relegate the people to a secondary role. More than most kinds of landscape, buildings may be photographed either to show their beauty, or their ugliness.

There are a few modern buildings which are immediately (if not universally) acclaimed as beautiful as soon as they are built; the Sydney Opera House, even though it is a nightmare from an engineering point of view, is perhaps one example. More often, though, we need to take time to get used to buildings: many a Victorian Gothic edifice which is now the darling of the conservationists was reviled when it was built. If we want to praise any building, old or new, there are two main things we have to do.

First, as with any landscape, we need to choose our time of day and indeed (if we can) our time of year: a building which looks fresh and spring-like in the spring can look dirty, dreary and depressing in the winter when all the leaves on the artfully planted trees are gone. Likewise, golden Bath stone bathed in sunlight is a very different proposition from the dull grey-yellow of the same stone in shadow. For colour, blue skies are almost a *sine qua non*, as white or grey skies make the building look bare and bleak.

*Overleaf*

**154 Long Beach** Reflections from skyscrapers at sunset are often dramatic; this is downtown Long Beach, shot from the other side of the water, beside the *Queen Mary*. A straight incident light reading established the moody exposure (*FES: Nikon: 200/3 Vivitar Series One: PKR*)

**155 Rooftops of Paris** This recalls what was said earlier, about the 'quality of light'. The steely blue light of Paris has an astonishing clarity: this was taken from one of the towers of Notre Dame, looking towards Montmartre, at about 9am. It also shows the advantages of using 35mm: there are no lifts to the top of those towers, and you have to carry your camera up interminable flights of stairs (*RWH: Leica M: 35/1.4 Summilux: ER*)

**156 Bern** In the evening, at the right time of year, the sun shines straight down one of the main streets of Bern. The effect is very dramatic indeed, but it lasts for only two or three minutes at this intensity. This is plenty of time to shoot a whole roll of 35mm, but a tripod-mounted camera would need to be set up in advance, and you would be limited to a very few exposures from a single viewpoint (*RWH: Leica M: 35/1.4 Summilux: KR*)

**153 St Nicholas Market** This picture reminds me of Cath Milne's song 'You Never Know', with its memorable chorus of 'Oh/it's . . . paranoia time in the town, yes it's paranoia time in the town . . .' An attractive part of Bristol has been transformed into something out of Kafka, by a determined combination of bad weather, deserted streets, low-key printing and comparatively high contrast (*RWH: Nikon: 21/4 Nikkor: HP5/Microphen/EI 650*)

177

Second, we need to be able to show as much or as little of the context of the building as our purposes require. If it is a part of an attractive street, we can show plenty of surroundings, but if it is next door to an eyesore we shall need to exclude the eyesore unless we specifically want to draw a contrast. This means that we need both a tripod and a fair range of lenses, including several wide- and ultra-wide-angles: it would not be excessive to own a 15mm, a 21mm, a 28mm, and 35mm, though few of us have budgets that will run to this. Ideally – and these really are hard on the budget – we shall need a 'shift' or 'PC' lens. These have been mentioned before in this book, and this is the place to describe their versatility fully.

The most basic of all view camera 'movements' is the *rising front*. All that it consists of is a facility for moving the lens parallel to the film plane – and of course, if you move the lens, the image also moves. Rising fronts are commonplace in monorails and other large-format cameras, and extremely rare in medium format (except among the baby Linhofs), but shift lenses for 35mm SLRs make them available in the miniature format.

The most obvious use for the rising front is the 'correction' of converging verticals, which is why some manufacturers call these lenses 'PC' (for 'perspective correction') lenses, although of course 'correction' is not the right word: there is vertical perspective, just as there is horizontal perspective, but for some reason we do not see it. In any case, shift lenses allow us to keep the camera level while moving the 'window' that constitutes the image. The net result is that we lose unwanted foreground, and gain extra space at the top of the picture, *without* the 'falling over backwards' effect.

Although an ordinary 35mm lens may seem like a very modest

**157  Child and stairway** More and more cities are constructed for the benefit of the motorist, leaving the pedestrian dwarfed among slabs of concrete and forced to climb Brobdingnagian flights of stairs just to cross the road. By contrasting the scale of the city with the scale of a child (who is not allowed to drive anyway), the point is made still more strongly (*RWH: Froomsgate House, Bristol: Nikon: 50/3.5 Micro Nikkor: FP4/Microphen/EI 160*)

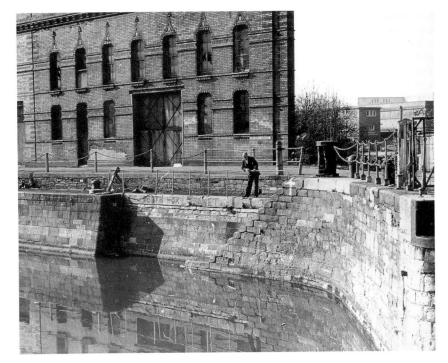

158 **Old man by dockside** The parallel between the old man and the disused warehouse with its broken windows is admittedly a cliché, but in all fairness the picture was shot when I was testing a new lens (my 50mm f/3.5 Micro Nikkor). This sort of cheap reportage coloured my photography for many years, but if I catch myself taking the same sort of picture nowadays I remind myself that no one really wants to see it. It is included here as an example of what not to do! (*RWH: Bristol: Nikon: Pan F/Perceptol/EI 32*)

wide angle, a 35mm *shift* lens is another matter; 'shift', incidentally, is a generic term covering lens movements parallel to the film plane. As a general rule, the ability of a 35mm shift lens to 'get things in' is more like having a 28mm or even 24mm lens, while a 28mm shift lens is more like a 24mm or 21mm lens, and one manufacturer even makes a 24mm shift lens which must be like having a 15mm or 17mm. It is hard to explain how this is so, but it assuredly *is* so.

The difficulty with shift lenses, though, is that as retrofocus-design wide-angles with an unusually large angular field, they are *very* difficult to design. Their sharpness is almost invariably inferior to that of a comparable non-shift lens of the same focal length and aperture, and as the focal length grows shorter, they become ever more difficult to design. This is why a 35mm lens should be regarded as the normal standard, and never used wider than f/5.6 if you can help it; one photographer I know who owns both 28mm and 35mm shift lenses reckons that he habitually stops down to f/11 to get the best definition, and I have never met anyone who has used a 24mm shift lens. It also explains why these lenses are expensive: designing them is expensive, and when you combine this with expensive manufacturing (because of the shift mount) and relatively limited demand, a 35mm f/2.8 shift lens can easily be three or four times the price of a 35mm f/2.8 non-shift lens. Their usefulness, on the other hand, is reflected in their rarity on the second-hand market – people only buy them when they are sure they need them, and then hang on to them when they find that they are even more useful than they imagined. If you can afford one, they are well worth having.

Although most shift lenses offer a shift and nothing else, there are two very specialised lenses from other manufacturers which offer even more. One is Canon's TS shift lens, and the other is Minolta's VFC shift lens.

The particularly ingenious thing about the Canon lens, which distinguishes it from all other shift lenses on the market at the time of writing, is that it also incorporates a provision for moving the lens at an *angle* relative to the film plane: this is the 'tilt' facility which

*Overleaf*

159 **Statue of Liberty** There are plenty of clearer pictures of the Statue of Liberty, but few as evocative as this one. It puts the statue in context – part of a big, sprawling city with severe air pollution problems. Compare the light here with the light in Paris! (Plate 155) (*FES: Nikon: 200/3 Vivitar Series One: KR*)

160 **New York** Like the picture of the Statue of Liberty, this was shot from the top of the World Trade Center: you can see the Chrysler Building and the Empire State. Dusk was falling in winter, and the only way to hold the camera steady was to use a miniature table-top tripod, to which no one objected, despite the fact that tripods are banned on the observation decks (*RWH: Leica M: 35/1.4 Summilux: KR*)

161 **Times Square** If you want to try your hand at hand-held night shots, like this one in Times Square, you will need a fast wide-angle lens and either a steady hand or fast film – or possibly all three. The classic trick of using wet roads to reflect the colours from the neon signs has been used to good effect here; on a dry day, the picture would be much less dramatic (*RWH: Leica M: 35/1.4 Summilux: KR*)

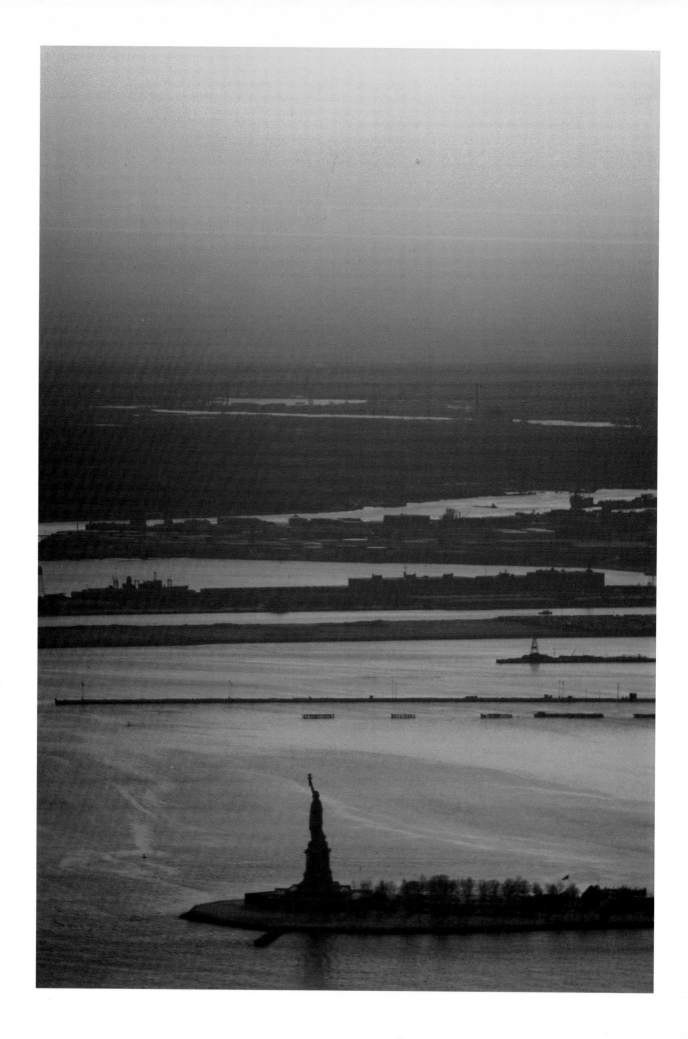

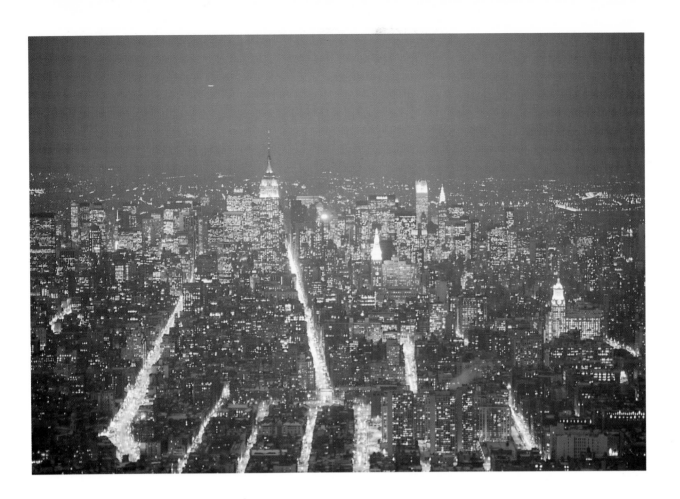

162 **Poolside** Rather than going for the 'set pieces', it is often more enjoyable to concentrate on the characteristic but minor details of a place. This rather 1950s concrete-and-austerity swimming pool seems ideally suited to the angular but casual composition which Tim Hawkins has employed (*TH: Nikon: 35/2 Nikkor: HP4/ Perceptol/EI 80*)

accounts for the 'TS' name, the 'S' being shift. The main use for this is that it allows you to take advantage of the *Scheimpflug rule*, which states that if the projections of the image plane, the subject plane, and a plane at right angles to the lens axis and passing through the nodal point of the lens all meet at a single line, then everything in the subject plane will be in focus at the image plane *at all apertures*. Although of much less use than the shift facility, the tilt is well worth having – but you have to own a Canon to get it!

Minolta's VFC lens also uses initials to describe its unique feature, which is Variable Field Curvature. Once again, this does exactly what its name suggests. Most lenses are made with a deliberately flat field, so that they can focus on a flat surface; but a VFC lens allows the 'plane' of focus to be bowed in or out, like the inside or outside of a rubber ball. Although this is less useful than the Canon's TS feature, it can sometimes be used to perform much the same function – especially if you remember that when the VFC and the decentring

184

movement are used together, the field curvature is not symmetrical with respect to the image on the film.

I mentioned the advantages of a tripod earlier, and the point is worth enlarging upon. For 'people' shots, I normally find that hand-held photography is perfectly adequate and indeed adds to the feeling of foreboding that is a feature of so many of my photographs of this sort of subject. For buildings, though, I prefer to use a tripod, as it gives me plenty of time to check details like weathercocks, signs, and so forth, as well as allowing me to use slow film, medium apertures, and (relatively) long shutter speeds for maximum sharpness: Koda-chrome 25 on a sunny day calls for 1/60sec at f/11 (probably the optimum aperture for a shift lens). In black and white, the added precision of composition that a tripod gives is the only reason: I still use Ilford HP5, so there is no trouble with camera shake, but for these pictures it is rated at EI 250 and developed in Perceptol. This gives much more subdued grain and a softer gradation, and I print on grade 2 or 3 paper instead of the grade 4 that I use for my 'paranoia' shots.

Of course, if you *want* your buildings to look unattractive, you have only to reverse the advice already given for making them look good: choose an ugly day, an unfavourable angle of the light, and use grainy, contrasty film again. Use ultrawides to increase the 'falling over backwards' effect, and you too can have pictures like mine!

## Details

Again almost paradoxically, I find that if I shoot details of buildings, the result is rather more peaceful than when I shoot whole buildings or streets, and indeed I often achieve a somewhat lyrical quality. Perhaps the most typical example, and one of my favourite urban landscapes to boot, is the broken door, decaying paintwork and peeling paper of an abandoned house in Bristol, reproduced in Plate 165. With these pictures, I once again use tripods, sharp lenses, and the same film and development technique already described for making buildings look good.

The lenses I use are mostly of modest focal lengths – 35mm, 50mm, and 90mm – though there is also a long-established school of thought which delights in picking out architectural details such as gargoyles, curlicues and carvings with long-focus lenses. I have never been particularly interested in this myself, but if you want to try it, your biggest problem is usually going to be lack of contrast. In colour, there is not much that you can do if the light is not sufficiently glancing to give you good modelling, but in black and white it may well be worth underexposing and overdeveloping slightly in order to get the differentiation of tones that you need. You may also be surprised at just how long your lenses will need to be: 200mm is normally the very minimum for picking out gargoyles and the like, and 300mm or even 500mm is by no means out of the way. Of course, many of these lenses are also somewhat lacking in contrast (a charge which may particularly readily be levelled against zooms), and if you resort to a teleconverter in order to get a bit more pulling power, your contrast plummets again. A tripod is of course essential for maximum sharpness.

*Overleaf*

**163 Zurich** Compare this picture with the one of Times Square (Plate 161), which was taken a little too early. The elements are substantially the same – lights, and water to reflect them – but by shooting while there was still light in the sky the result is very different. Once again, the amount of time during which you can shoot is very limited (*RWH: Leica M: 35/1.4 Summilux: KR*)

**164 Gargoyle, Notre Dame** Normally, you need at least a 300mm lens in order to photograph gargoyles and similar details. If you can climb the church towers, though, you can get much better pictures with very modest focal lengths: this was shot with a 90mm F/2.5 Vivitar Series One (*FES: Notre Dame de Paris: Nikon: KR*)

**165 Benares** The positioning of the tubby gentleman behind the Hindu sadhu (holy man) is a little unfortunate, but between them these three characters say a great deal about Benares. Is it a landscape, or is it reportage? Does it matter what you call it? (*FES: Nikon: 135/2.3 Vivitar Series One: KR*)

# POSTSCRIPT

I learned a lot about my own landscape photography while I was writing this book. This may sound like an odd thing for an author to say, but like most professionals I had always regarded landscape photography as something to do for pleasure, not for profit – there is not much money in landscapes, unless you can sell them as stock pictures (where landscapes tend to be two a penny), or unless you can tap into the 'fine art' market, which is often pretentious and tiresome.

Because so many of my 35mm landscapes were taken for their own sake, I had never had to think very hard about what I shot: if I liked it, that was enough. But for a book like this, I could hardly say, 'I like this picture, so there!'; I had to think about why I liked it, and why I had shot it, and which techniques I had used to get the effect in question. Many people will tell you that the creative process (whatever it may be) is essentially non-verbal, and in a sense they are right; but in another sense, few of us can learn non-verbally (except kinaesthetically), and almost by definition we need words to explain our feelings.

I know that there are places where you will have disagreed with me, and that does not worry me in the slightest. What I have done, I think, is to explain two things. One is why I take landscapes, and the other is how to achieve technical quality when you take them. The first is not in the least important, except insofar as it gives you something to agree with, or something to react against – in other words, a way of thinking about why *you* take landscapes. The second is not important when compared with, say, abolishing war or even keeping a happy marriage going, but there is a certain satisfaction in something well done, and there is an even greater satisfaction in knowing that you can successfully communicate your feelings to someone else: as I said earlier in the book, that is part of the definition of being human. I hope that you have as much fun with your landscapes as I do with mine.

**166  Door and railings** Decay often produces a tremendous range of very subtle textures and tones, and careful exposure and printing are necessary to capture them. This was shot on HP5 rated at EI 320 and developed in Perceptol; even FP4, I find, cannot represent tones in quite the same way, though it represents detail more clearly. Of course, a very sharp lens helps: I used my 55mm f/3.5 Micro Nikkor (*RWH: Bristol: Nikon*)

*Overleaf*

**167  Dome and palm trees** This biblical-looking landscape is actually at Riverside in California; by shooting upwards, all the confusion of ground level was lost. Like so many of my favourite pictures, this was taken with the simplest equipment: a Nikon EM with a standard 50mm f/1.8 lens (*RWH: KR*)

189

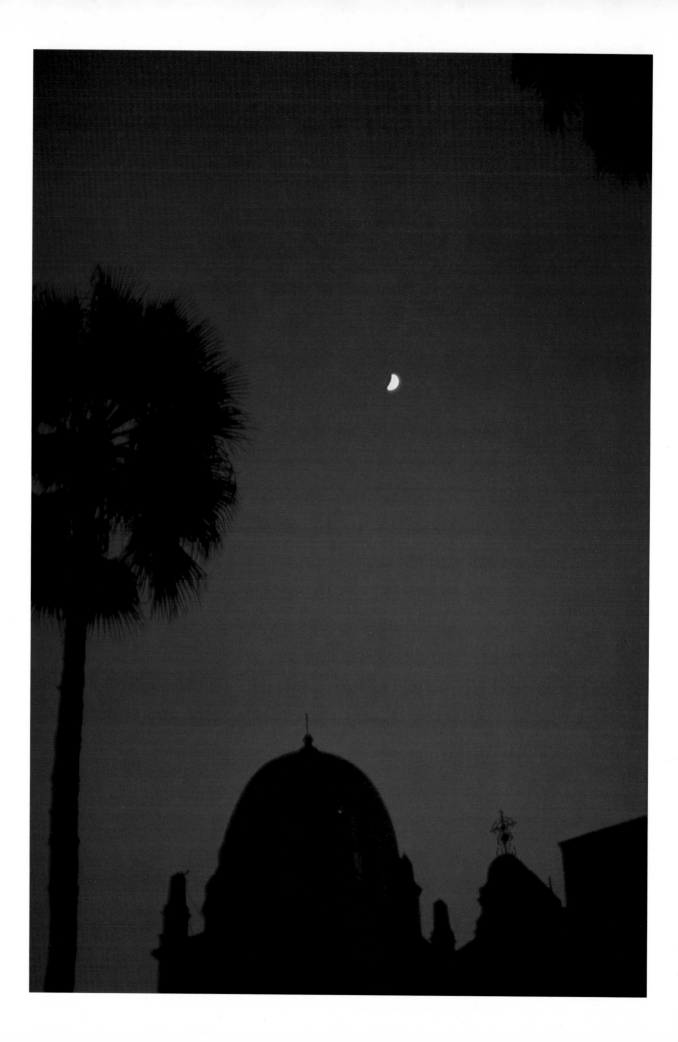

# BIBLIOGRAPHY

*Books of Pictures*
This is a limited selection of books actually on my
shelves, which I have found useful for inspiration in
my own photography.

Adams, Ansel: **Yosemite and the Range of Light,**
New York Graphic Society, Boston 1979
**Amerique. Les annees noires** (Farm Security
Administration photographs 1935–42), Centre
National de la Photographie, Paris, 1983
Bond, Fred: **Westward How,** Camera Craft, San
Francisco 1947
Christians, George: **Don't Shoot In The Oilfields
Carelessly,** Capra Press, Santa Barbara 1973
**Deutschland, Olympia-Jahr 1936,** Volk und Reich
Verlag, Berlin 1936
Duncan, David Douglas: **The World of Allah,**
Houghton Mifflin Company, Boston 1982
Gia-Fu Feng and English, Jane: **Tao Te Ching,**
Wildwood House, London 1972
Kertesz, Andre: **Landscapes,** Mayflower Books, New
York 1979
Kertesz, Andre: **Americana,** Mayflower Books, New
York 1979
Lann, Hieronymus: **So photographiert die Welt,** Im
Apollo Verlag, no date, ?1948
Maeda, Shinzo: **Nippon Alps,** Kodansha, Tokyo,
?1979
Neuer, Roni and Yoshida, Susugu: **Ukiyo-E,**
Windward, London 1978
Nomachi, Kazuyoshi: **Sahara,** Grosset & Dunlap,
New York 1978
Porter, Eliot: **In Wildness is the Preservation of the
World,** Sierra Club, San Francisco 1962

Porter, Eliot: **Baja California and the Geography of
Hope,** Sierra Club, San Francisco 1967
Russell, Terry and Renny: **On the Loose,** Sierra Club/
Ballantine Books, San Francisco, 1969
Shirakawa, Yoshikazu: **Eternal America,** Kodansha
International, Tokyo, 1975
Shirakawa, Yoshikazu: **Himalayas,** Abrams, New
York 1976

*Other Books on Photography*
Blake, Peter: **God's Own Junkyard,** Holt, Rinehart
and Winston, New York 1979
**British Journal of Photography Almanacs,** Henry
Greenwood & Co, London, various years
Cox, Arthur: **Photographic Optics,** The Focal Press,
London, 15th ed, 1974
Daffurn, Ray, and Hicks, Roger: **Pictures That Sell,**
Collins, London 1985
Deschin, Jacob: **35mm Photography,** Camera Craft,
San Francisco 1959
Dunn, J. F.: **Exposure Meters and Practical Exposure
Control,** The Fountain Press, London 1952
Freeman, Michael: **The Manual of Outdoor
Photography,** Macdonald, London 1981
Gaunt, Leonard: **Practical Exposure in Photography,**
The Focal Press, 1981
Haile, Richard N,: **Composition for Photographers,**
The Fountain Press, London 1936
Hicks, Roger W.: **A History of the 35mm Still
Camera,** The Focal Press, 1984
Lipinski, J.: **Miniature and Precision Cameras,** Iliffe,
London 1955
Nordhoeck, Wim: **Composition in Colour
Photography,** Fountain Press, London 1982

# INDEX